THE RENAISSANCE ARTIST AT WORK

BOOKS BY BRUCE COLE

The Renaissance Artist at Work
Masaccio and the Art of Early Renaissance Florence
Sienese Painting from Its Origins to the Fifteenth Century
Agnolo Gaddi
Giotto and Florentine Painting 1280–1375

THE RENAISSANCE ARTIST AT WORK

From Pisano to Titian

BRUCE COLE

Icon Editions

1817

HARPER & ROW, PUBLISHERS, New York

Cambridge, Philadelphia, San Francisco, London
Mexico City, Sao Paulo, Sydney

For Ulrich and Gloria Middeldorf

FIRST EDITION

Designer: Charlotte Staub

Library of Congress Cataloging in Publication Data

Cole, Bruce, 1938–
 The Renaissance artist at work.

 (Icon editions)
 Includes bibliographical references and index.
 1. Art, Renaissance. 2. Artists—Social conditions.
3. Artists—Economic conditions. 4. Art patronage.
I. Title.
N6370.C56 1983 709'.45 82-48102
ISBN 0-06-430902-9

83 84 85 86 87 10 9 8 7 6 5 4 3 2 1

CONTENTS

PREFACE

Renaissance art was made in a culture vastly different from our own, so different in fact that most of our ideas about art would have been unintelligible to those living during the period. Yet over the years I have discovered that students of art, and a great many of the books they read, tend to treat the works of Renaissance artists as though they were produced for twentieth-century eyes. This is of course quite permissible—the appreciation and enjoyment of art are not bound by rigid rules. But it seems to me that a fuller, more basic comprehension of Renaissance paintings and sculptures may be gained by trying to put them in their context.

I have attempted to do so by devoting sections of this book to the environment of Renaissance art, to artistic education, to the function, location, and patronage of art, to the physical structure and construction of the works, and to some of the types of art made during the period. I hope that the following chapters will provide a foundation for further study of the history of Renaissance art, but I will be well pleased if this book helps the reader only to regard that art as a product of its own time.

The term "Renaissance" is a flexible one and each author uses it in a different way. Here I shall discuss works (mainly from central Italy, because I know them best) made in the three centuries between 1250 and 1550. Mine is certainly a long Renaissance, but it is also one that allows a wide time span, something desirable in an introductory book of this nature.

Because this is a text for nonspecialists, I have addressed it both to the student of art and to the interested general reader. Detailed investigation into many of the topics covered may be initiated by consulting the books and articles cited in the notes.

As usual, I owe thanks to friends. Heidi Gealt was always a steady source of encouragement and advice. Barry Gealt patiently taught me

much about painting. In Florence, Helen Ronan took time away from her own work to help with a number of problems. Linda Baden, Cynthia Coté, Mary Davis, Charles Mitchell, Julia and Peter Bondanella, Patricia Harpring, Pamela J. Jelley, and Diane Vatne all gave much aid. I am also grateful to my family, who patiently put up with many inconveniences while this book was being written. For time to look and write in Florence I am indebted to the John Simon Guggenheim Foundation, the Samuel H. Kress Foundation, and the American Council of Learned Societies.

Cass Canfield, Jr., my editor at Harper & Row, supported this book from the start; my debt to him is, once again, incalculable.

B.C.

Piazza Santa Croce, 22
Florence

INTRODUCTION

F rom the window of the jet, the visitor gets the first glimpses of Italy—the snow-covered Alps, their brown foothills, and then the green plains strewn with deep, glistening lakes. As the aircraft continues southward toward Rome, it passes over the high Apennines, running like an enormous spine down the boot-shaped peninsula bounded by the azure Mediterranean. This is the topography of Italy: the alternation of steep, stony hills, rugged mountains, and fertile plains. Such a land makes for arduous travel and difficult communication between centers of population. To reach the nearest town, often one still has to creep up one mountain and descend another; off the new superhighways, travel time doubles and triples.

The physical character of the peninsula has had a profound effect on the development of the civilization within it. Originally settled by the still shadowy Etruscans and seafaring Greeks, the country became one of the great ancient civilizations under the Romans, who conquered and colonized it. The Romans brought peace and prosperity to the peninsula and founded many of the cities that were to become important during the Renaissance. Under their rule, the peninsula for the first time was pacified, unified, and governed by a central authority. But order and tranquility were not to last, for beginning in the third and fourth centuries, the Roman Empire started to disintegrate. Growing pressure from the Barbarian tribes abroad and moral exhaustion and political mayhem at home resulted in the breakup of the old Roman hegemony and eventually the end of the ancient world.

Lacking the stability and organization of Roman rule, faced with economic and political crises, the cities rapidly began to decline. The garrison town of Florence, for example, could no longer fill even the small area circled by her Roman walls. Citizens fled the foundering, besieged cities for the relative safety of the countryside.

By the fifth century, trade and commerce had almost disappeared.

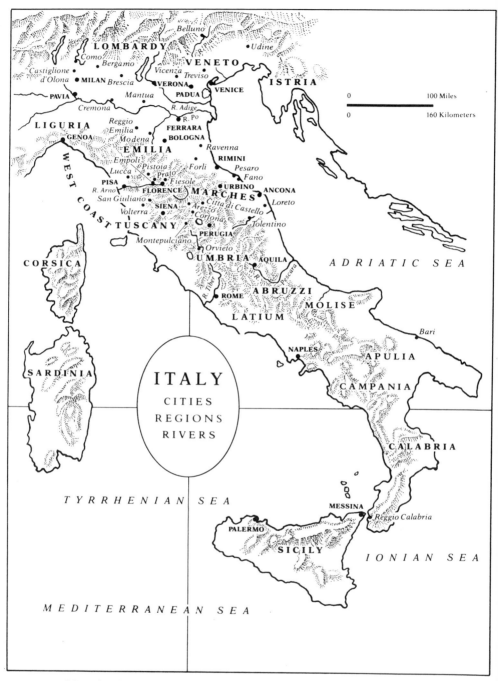

1. **Map of Italy Showing Principal Mountain Chains and Important Artistic Centers.**

Clinging to the hills or hidden in the valleys and plains, groups of people scratched a living from the land. Frightened, suspicious of outsiders, these fragmented rural groups became increasingly isolated and provincial. The easier, safer travel possible under Roman rule was gone. Wild and dangerous, the forbidding land now harbored not splendid cities and a bountiful countryside but a splintered civilization.

But by the eleventh century there were the first stirrings of a new urban era.[1] People began to return from the land to the under-populated, run-down cities. The gradual growth of commerce, the formation of town government, the establishment of city churches, the birth of rudimentary industry, and the rise of the construction trade all furnished employment for the recent emigrants from the country-side.

Soon the burgeoning towns were engaged in a life-and-death battle with the powerful old families who laid claim to the surrounding land. After prolonged struggle, most of these rich and dangerous nobles were beaten and forced to live, at least part of the time, in the cities. Their castles and forts were pulled down, and trade, agriculture, and travel again became possible on a considerable scale.

Early town life was extremely difficult. There was much urban violence as various factions fought for economic, political, and territorial power.[2] The extended families of the most powerful citizens lived in tall, stone towers whose fortress-like shapes were testimony to the vendettas raging between the clans.

The rise of the Franciscans and the other mendicant orders did much to calm city life, but in the early communes some of the danger and hostility of the countryside remained. The continuing warfare be-tween families was eventually quelled by the communal government, which, from the first, strove to establish its authority over the factions. Not until well into the thirteenth century did city government finally become the controlling force in many Italian towns.

There were two basic types of authority in Renaissance Italy. The first, and most common, was the rule of the prince or pope. States under the direct control of one man or one family ranged from power-ful Milan and the Papal States to the modest duchy of Urbino. Rulers varied from the benevolent to the tyrannical, from the famous to the nearly unknown. Around these men, courts sprang up that attracted artists and writers who often worked on projects meant to glorify and immortalize the prince: Dante, Petrarch, Ariosto, Giotto, Michelan-gelo, and Leonardo da Vinci all spent time in the service of princes and popes.

The second type of government during our period was the so-called republic or commune. Citizens, usually strictly limited to a select, wealthy group, held the crucial posts of power. Most of the republics were really oligarchies controlled by several significant clans, guilds, or professions and their allies, who traded the important government posts among themselves, excluding outsiders. Sometimes the myth of a more democratic government was developed by a particular city, but seldom, if ever, did this myth become a reality.

There was always much warfare among the city-states; as they became more cohesive they also became more territorial, a development that brought them into increasing conflict with neighboring towns. The idea of war, and the act of war itself, were integral parts of Renaissance society. War figured prominently in the life of almost every citizen; its major protagonists were among the greatest heroes of the age. The soldier, the warrior-prince, and the adventurer were immortalized in words, paint, and stone; no wonder the icon of the mercenary (condottiero) was created during this period.[3]

Hundreds of cities—either under the sway of a prince or the rule of a more representative government—existed in Italy during the period covered by this book. For the most part their long isolation and particular, individualized development gave them a sense of national identity that set them apart from even their close neighbors. Their speech, customs, dress, and many of their beliefs were indigenous. Inhabitants of the city-states did not think of themselves as Italians, but as Florentines, Romans, or Venetians. The concept of a united Italy was only a dream in the minds of a few—it would have to wait until the nineteenth century to be realized. Even today, the visitor to Italy finds profound regional differences that have not been eradicated in over a century of unification. Localism is one of the most pronounced Italian characteristics.

In many ways, this localism was crucial for the development of art during the Renaissance. Just as the isolated evolution of the various cities in the peninsula caused the formation of particular customs and institutions, so, too, it created various indigenous styles and symbols. In reality, there was no single Italian Renaissance style, but, instead, a whole series of styles co-existing in the peninsula.

It is important to realize that the styles of the Italian city-states were not variants on a single idiom, but independent ways of seeing and setting down pictorial ideas. Throughout the Renaissance these styles retained their independence, although they were often influenced by other idioms from within and outside the peninsula. Stylistic interchange, in fact, frequently was the result of the continual wanderings of artists and works of art; but although an outside influence might

often modify an indigenous style, seldom, if ever, was it allowed to dominate.

Life in the cities of the Italian peninsula was organized around a number of institutions, of which the most important was the family. Each family was not the simple nuclear structure we now associate with the word, but an extended group or clan that shared a house or tower, or adjoining buildings. In periods of danger the family banded together for self-defense, while in peacetime it often worked cooperatively—in a single business or in related enterprises—for mutual economic benefit. This was as true for the families of painters and sculptors as it was for those of bankers and bakers. As in so many other parts of Italian society, cooperation characterized the family's public and private existence.[4]

The life of the family was directly tied to the Catholic Church, which became an increasingly powerful urban institution as the city-states developed. Each of the two major mendicant orders—the Franciscans and the Dominicans—attracted thousands of adherents who filled their huge churches. Families from the neighborhoods surrounding the churches founded, built, decorated, endowed, and were buried in their own chapels in these imposing structures.

Between baptism and last rites, the Church was a major, persistent force in the life of the town dweller. It played a fundamental role in the education of children, the process of dowry and marriage, the conduct of business, the regulation of interest rates, the formulation of economic and political theory, and scores of other basic activities. It touched almost every moment in the ordinary citizen's day in a way we now find hard to imagine.

In our period there was, in fact, no real separation between the secular and sacred world, and, consequently, no division between Church and State. Town halls, courts of justice, police headquarters, and other governmental buildings were furnished with altars and altarpieces before which religious rites were performed frequently. The walls of town halls and palaces of princes were decorated with Christian stories and images. Conversely, public funds were used to erect and embellish churches, especially the great cathedrals (built under civic supervision and management) that were the pride of many Italian cities. The guilds, which played a decisive role in the governing of scores of city-states, put themselves under the protection of patron saints and paid for the building and decoration of churches. Almost every sphere of human experience was infused with religion, so much so, in fact, that one cannot speak with accuracy of either a truly secular or a wholly religious activity.

Town life during the Renaissance was better organized and regu-

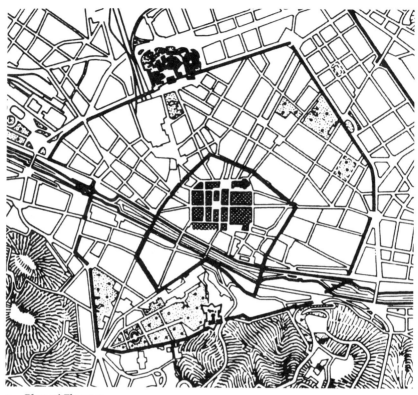

2. Plan of Florence.

The small crosshatched area in the center shows the original Roman settlement—note that the streets meet at right angles. Enclosing the Roman city and spanning the river to the south are the thirteenth-century walls. The last, and largest, walls testify to the rapid growth of the city by the time of their construction in the fourteenth century.

lated as the early communes developed into city-states during the Quattrocento. It is impossible to find a *typical* city of the period because strong regional and historical differences made each unique; yet the character and texture of present-day Florence—one of the major centers of population in the Renaissance—still evokes the period.[5] The walls, now partially destroyed, traced the limits of the city, a space that appears quite small to modern eyes. The imposing height and width of these walls, and their constant presence in all the quarters of Florence, made them both a safeguard and a symbol of the city. The last line of defense, their construction and maintenance were a matter of vital concern.

In Florence's center, the movement of traffic is ordered by the grid

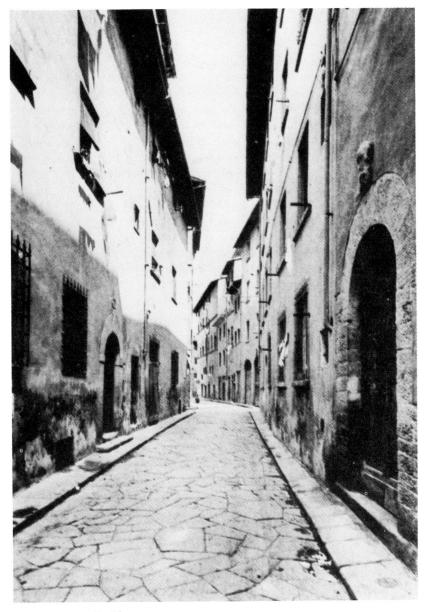

3. Via Toscanella, Florence.

Narrow, often dark, hemmed in by modest dwellings, devoid of trees or grass, such streets were the environment of the Renaissance artist. On the Via Toscanella multifamily houses built of brick and stone alternated with small shops, some really not much more commodious than the proverbial hole-in-the-wall.

pattern of the streets, which dates from the Roman settlement. But outside this regular area, chaos reigns. The streets of the commune were not, for the most part, planned—they simply grew, as palaces, houses, and shops were erected during the periods of population expansion. Instead of running in any discernible pattern, streets twist, turn, start, and stop in an irregular and often illogical fashion.

Most Renaissance streets are narrow, dark canyons bordered by houses and shops that begin right at the street itself. Yet everything is within human scale; the streets and buildings are seldom overpowering. This scale and the small population of the cities made for personalized communities, in which the citizens knew each other and were aware of even the most minor events occurring within their walls. In these small towns there was considerable contact between members of the various trades and professions. Ideas, information, and rumors were quickly disseminated. Cooperation was the watchword.

Wandering through Florence or the other Renaissance towns, one is always aware of the dominance of human activity over nature. The streets and squares are entirely the work of man: no tree, bush, or other greenery intrudes into the stony cityscape. It is true that there were sometimes considerable amounts of open land within the walls, but these were either fields for crops or simply unoccupied land. In the built-up sections nature has been obliterated, because it was still associated with the uncivilized and dangerous life of the countryside.

Stone, brick, and wood were the materials of the Renaissance town. As the communal government asserted itself over the nobles and other factions, the tall towers were leveled to a prescribed height (scores of tower stumps are still to be seen in Florence) and gradually replaced by less fortress-like and hostile dwellings. While still retaining some of the imposing appearance of the towers, these new homes were more open to the street, had bigger windows, and were architecturally graceful. By the middle of the fifteenth century, large private houses had become works of art designed by the most important architects.[6]

Often the ground floor was open to the street through a series of large arches. Here the family's business was located and conducted. The ground floor also had private rooms and a courtyard with a well. On the next floor, or *piano nobile,* lived the most important members of the family, with the floors above inhabited by the various aunts, uncles, cousins, and in-laws who formed part of the extended family. The uppermost story, which had the smallest, most uncomfortable rooms, was given to the servants. Sometimes there was an open loggia on the top of the house, a place to get a breath of fresh air in the evening.

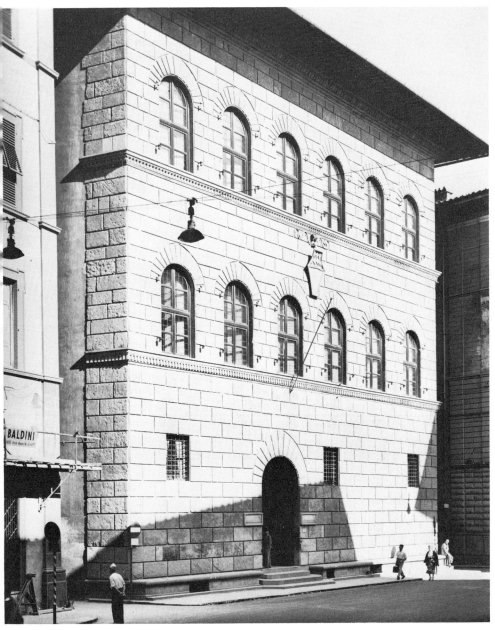

4. Palazzo Antinori, Florence. c. 1460.

This modest but elegantly proportioned palace is one of the earliest ancestors of the
townhouse, a type still found in every major European and American city. Built in the
style of Giuliano da Maiano, it is one of the several Renaissance palaces of Florence to
preserve its original facade. Note the coat of arms above the window.

In Florence, the houses of the less wealthy were much smaller; many exist still in the Santa Croce and Borgo San Frediano districts, the city's poorer quarters. The population density of these areas was great and the living conditions uncomfortable and unsafe. Much wooden construction was used and the danger of fire was always present. The urban crowding and the city's small size made for a high mortality rate. Plague was a real and constant threat.

Certain crafts and industries tended to be located in the same parts of the city. There was, of course, no heavy industry comparable to today's, but a considerable work force was employed in cloth manufacture, the building trades, and other large cooperative enterprises. There were also scores of craftsmen at work in shops scattered all over the town, to fill every conceivable need from saddles to candles. Another large group was concerned with the procurement, storage, and sale of the food and wine needed for the urban population. Many farmers lived (as is still the case in southern Italy) in the security of the city and traveled long distances to their fields outside the walls. The ranks of notaries, physicians, civil servants, astrologers, and other educated people roughly corresponded to our professional classes. But real power resided in the hands of the princes or wealthy merchants and bankers who, in many of the cities, held the reins of government.

All of these people lived in a world physically, intellectually, and spiritually different from our own. Their very perception of reality was radically diverse from ours. When they looked at the sky and saw the stars, they believed they were standing at the very center of the universe and that around them revolved the sun and a cosmos encased in crystalline spheres. They also thought themselves to be in a continuum of Christian history, which began with the birth of Christ and would end with the Last Judgment. The prospects of Heaven and Hell were taken seriously, and the physical world was infested with sin and evil: the possibility of eternal damnation was ever present and imminent.

Their view of their historical position and their ideas about the future were also very different from ours. They did not believe in the idea of progress, nor did they see the world in evolutionary or psychoanalytic terms. The theories and ideas of Darwin, Freud, Newton, and Einstein—which so condition all our thinking—were unknown to them. Magic, mystery, and the supernatural will of God were woven into the fabric of the everyday life of those who inhabited the cities of the Renaissance.[7]

The role of the supernatural can be illustrated by the created image. Carved and painted images were everywhere. In an age that understood but did not fully trust the written word, a picture of the Ma-

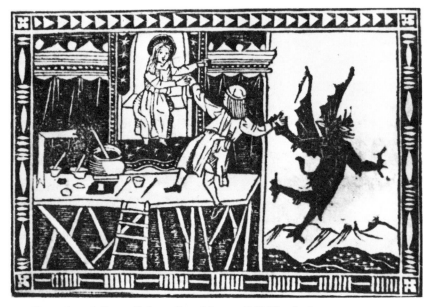

5. Florentine, *A Fresco Painter Saved from a Fall.* Woodcut. 1500.

This woodcut, from the *Miracoli della gloriosa Vergine Maria,* illustrates the supernatural power of the image the painter has just finished. Pulled from the scaffold by a devil, the artist is saved by the Virgin's hand, which has been miraculously transformed from paint to flesh. The seated Madonna is placed in an outside tabernacle. Especially interesting is the painter's equipment: a T square, paintpots, and brushes.

donna, the coat of arms of a noble family, or the emblem of a saint carried with it a cargo of associative meaning. It embodied some of the essence or being of whatever it represented or symbolized, holding a magic of the same order that informs the prehistoric cave paintings of game animals or the masks of African tribesmen. These images carried with them fears, and hopes that we find hard to imagine today. Lacking such potent visual symbols, we have constantly to remind ourselves that every image made by the Renaissance artist was seen through the powerful lens of its own time. Our distanced, dispassionate historical view simply did not exist when the objects were new.

It was in the environment of the Renaissance city that the art which concerns us was made. The hundreds of artists who created paintings and sculptures that we often see so far removed from their original context were a vital and necessary part of society. It is to these artists and to the products of their hands that we now must turn our attention.

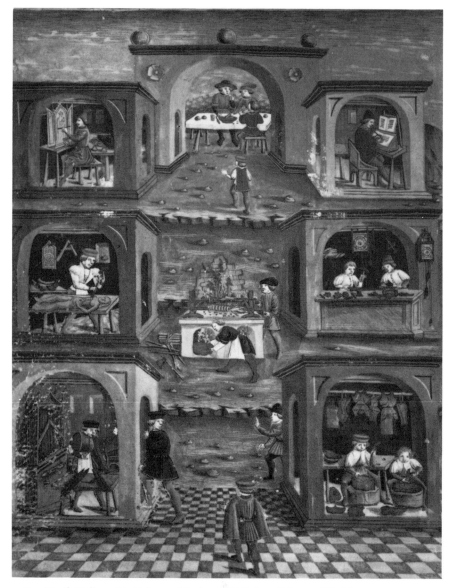

6. North Italian, *De Sphaera,* Modena, Biblioteca Estense. Miniature. c. 1450.

By an unidentified North Italian artist working around the middle of the fifteenth century, this miniature depicts occupations under the influence of the planet Mercury. Armorers, clockmakers, a scribe, an organ-maker, and a painter and sculptor all appear. The miniature graphically demonstrates the Renaissance view of the artist as craftsman. Not only are artists classed with clockmakers and armorers, but they dress alike and work in nearly identical shops.

❧I❧

THE ARTIST IN
SOCIETY

The Social World of the Artist

The physical appearance of artists' shops of the Renaissance was no different from that of many other crafts. The word "artist" as a generic term was almost never used: a painter was called a painter, a sculptor a sculptor, and so on. They were seen as members of a particular occupation, not, as in our day, as people with a vision and a calling. They had no special title which implied that, either by vocation or inspiration, they were different from any other group of craftsmen.

Often located together in the same area of town, the shops of Renaissance artists were usually small rooms opened to the street by the raising of heavy wooden shutters. Several illustrations from the fourteenth and fifteenth centuries depict craftsmen at work in these humble, semi-public shops. A number of similar structures still survive on the Ponte Vecchio in Florence, although these are now filled with the stores of some of the world's most exclusive jewelers. In Italian cities one can still get an impression of what these artists' shops, or *botteghe,* were like by looking at the small shops of carpenters or gilders, which are usually open to the street and filled with the same kind of hurly-burly that characterized their Renaissance forerunners.

The production of art was, first and foremost, a cooperative venture.[1] Within the shop there was an organization and working procedure developed through long experience to allow maximum efficiency. At the head of the organization was the master, who obtained the commissions and oversaw all the shop's activities. It was his reputation and his ability to attract work that kept the shop going. Some work was done for the market without commission, but probably not enough to keep the shop in business full time.[2]

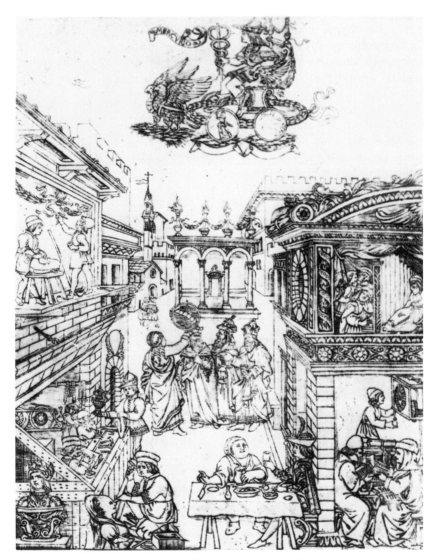

7. Florentine, *Occupations Under the Influence of the Planet Mercury.* **Engraving. c. 1460.**

Like the illumination in fig. 6, this engraving depicts craftsmen born under the influence of Mercury. It also gives us a glimpse into the atmosphere of the workshop. At the left, fresco painters work on the decoration of a palace; one paints a swag, while the other grinds color on a stone. Below is a goldsmith's shop open to the street. Such shops, which could be closed by the shutter held open on a hook, must have been almost identical to those used by painters and sculptors. In fact, a sculptor works on a portrait bust directly in front of the goldsmith's shop.

Looking at the works themselves, we can tell that the master was usually in charge of the overall design. The consistency of design and iconographic interpretation by Giotto, Donatello, Raphael, or scores of other well-known artists indicates that the genesis of the work and its earliest development were most often products of the master's mind and hand.

The master (apparently always a man, for there are few secure records of women artists until the seventeenth century and then their names appear only infrequently) had the final say on everything that went on in the shop. He was himself an experienced independent artist, who had to arrange for the rent of the shop, negotiate commissions and check the contracts that went with them, keep the books, pay the bills, and (it was fervently hoped) make a profit. He was a craftsman-businessman who, except for his product (and he most definitely would have considered it a *product*) was no different from any of the other craftsmen who lived and worked near him.

Under the master's charge were the apprentices. We do not know much about the mechanism whereby a boy became an apprentice, other than that it was bound up in both legal procedure and social custom.[3] Because many of the artists were related either by blood or marriage, the family must have played an important part in predisposing many young men for artistic careers.

Apprentices seem to have entered the artists' shops in their early teens. Several contracts of apprenticeship have survived, but such a small sample does not really tell us much. Certainly, the master agreed to teach the boy, to provide for his safety, and, sometimes, to pay him a small salary. This pattern of apprenticeship appears to have been common to all the crafts.

There seems to have been no rigid limitation on the time apprentices spent in the shop: we have reports of their stay lasting anywhere from two or three months to several decades; the fourteenth-century artist Cennino Cennini recommends at least six years. The relationship between master and apprentices seems to have been extremely flexible, geared to the economics of the art market. When an artist was fully trained and experienced, he would find, if he could, customers and commissions, set up a shop for himself, and eventually take on his own apprentice or apprentices. The number of apprentices appears to have been directly related to the master's popularity: the busier he was, the more apprentices.

It was the apprentice's task to assist the artist in the preparation of materials and, once the design had been formulated, to help him execute the work.[4] On occasions when the master was absent, the appren-

tices executed the whole work. More often they did the less important and quite tedious decorative parts of frescoes or statues. Their relation with the master was truly collaborative; pure artistic individuality in the twentieth-century sense did not exist.

Each shop was an *ad hoc* organization, expanding when there was much work, contracting when few or no commissions were obtained. When the shop was very busy or when it had a very large commission (a fresco cycle or a series of statues), extra employees were taken on. These might be independent artists who had no work of their own at the moment, or they might be less skilled helpers who assisted with many of the difficult, tedious jobs involved in the making of art. Sometimes both types of temporary help were hired at the same time. Materials and equipment, needed in considerable quantities, were seldom purchased in their finished state; their procurement and preparation were hard, time-consuming jobs that were often delegated to apprentices and helpers.

Naturally, the structure of each artist's shop and its working methods and materials were dependent on its particular specialization. We do not know which of the various mediums was the most popular, but painting was certainly always in demand. We tend to think of painters as producing only pictures, but this was definitely not the case during most of the Renaissance, a period when artists worked on many tasks we would not now normally associate with them. The shop of a Renaissance painter might make painted shields and armor as readily (and willingly) as altarpieces. Decorated banners, beds, chests *(cassoni)*, plates, and drapery were, in many cases, the objects that kept painters in business. In fact, it appears that only a small portion of the total production of many painters' shops was given over to what we would classify as paintings. The altarpieces, portraits, and other work we think of as typical may really have been rare in comparison to the painted coats of arms, banners, and chests.

A hierarchy of painting types does not seem to have existed; there was no distinction between what later periods were to term the "decorative arts" and "figurative painting." Renaissance artists, with few exceptions, were happy to paint almost anything. They did not consider such work beneath them nor outside their trade. Decoration, whether of a house or a church, was a vital, integral part of the art of the period. The painted wainscot, decorated chest, or design of a geometric marble floor were highly valued; in truth, such things are often major works of art in their own right. The concept of the minor art, of *crafts* in our sense of the word, had not yet been born.

Much figurative religious painting also issued from the painters'

shops: altarpieces of various traditional shapes and sizes, portable triptychs and diptychs, special votive panels, and many other types made up the considerable pictorial repertoire. These same shops also were often involved in the complicated process of fresco painting, which, though based on the master's design, was a task requiring many hands, great cooperation and skill, and, above all, the smooth working of the shop.

The whole process of design was an important one during the Renaissance. Painters seem to have been the most active designers. Of course, they designed their own panels, frescoes, and the objects produced in their shops; but they were also responsible for designing works done in other mediums. Sculpture, for instance, was often designed by them and only later carved or cast by a sculptor.[5] This working procedure—which was most frequent at the beginning of our period—seems strange to us, but it was quite common. What, exactly, each type of design looked like and how it was then utilized to fashion stone or bronze or some other material remains unknown.

On occasion, painters were also called upon to do designs for colored windows. These were sometimes executed by specialized window painters who were often monks.[6] The painters' designs were quite faithfully followed, and we can attribute certain windows to known artists on the similarity of design between the glass and their other surviving works.

Sculptors provided a number of objects for Renaissance society. Today, we tend to think of them as the makers of statues only, but then their production encompassed a wide range of objects. Altar tables, altar rails, ciboriums to cover the altar, and tabernacles to set upon it were all vital to the rituals of the Church. The sculptors also carved architectural decoration, furnished tombs, and made pulpits, statues, and reliefs for churches. The Renaissance home had portrait busts, medals, private altars, and fountains all made by sculptors. Public fountains (and sometimes their hydraulic systems), which so grace the Renaissance city, were also their responsibility. The variety and usefulness of the sculptor's trade made him a necessary and important figure in society.

The miniaturist, too, was a valued craftsman. Whole shops were involved with the production of books highly prized both for their content and their pictures; the hundreds of extant manuscripts testify to their popularity and beauty. Religious tracts, commercial manuals, chronicles, humanistic writings, and scores of other texts were illustrated. In a world without photographs, the pictures in these books played an important part in shaping the readers' ideas and perceptions.

Often artists, and especially sculptors, were given larger-scale jobs. There appears to have been no group of professional architects during our period; the design and supervision of the construction of buildings, even the most important, were traditionally carried out by men trained in one of the other arts.[7] A large number of artists—from Giovanni Pisano to Michelangelo and Raphael—were employed as architectural designers and superintendants, although in many cases they seem not to have had any specific training in the profession. Probably these men learned much on the site; in any case, the technological aspects of building were less complicated than they are today.

Other commissions were awarded to painters and sculptors for fountains, bridges, and walls. A number of artists were also kept busy designing fortifications and machines of war; it was in this capacity that they were often most necessary to the scores of warrior-princes who ruled much of the Italian peninsula.

Occasionally, artists worked in more than one medium. A number of goldsmiths became sculptors and at least one—Brunelleschi—became something close to a professional architect. The Florentine Andrea di Cione, called Orcagna, was a building designer, painter, and sculptor. In Siena during the Quattrocento several men practiced both the arts of painting and sculpture, as did Michelangelo during the next century. Yet, although artists often made designs for mediums other than their own, the works they executed in their shops were mainly in the material in which they were trained.

All these shops, each specializing in some aspect of art, employed a considerable number of people. Reliable statistics are hard to find, but we do know that of the 25,000 or so people who lived in Siena in 1363, there were 30 painters and 62 master stonemasons, many of whom were probably sculptors. In the next decade, the total of painters had risen to 64, and by the early Quattrocento, it had reached nearly 100.[8] A similar painter-population ratio probably existed in Florence and the other major Renaissance cities. Art was not a luxury, but something that society wanted, needed, and used; consequently, there had to be enough artists to satisfy the considerable demand.

One has to think of Renaissance art as the product of a sizable industry. It was, of course, more a primitive industry rather than a modern one, but it was a collective economic enterprise nevertheless. Art was produced by many people, all working on different but interrelated tasks. The work force, brought into the business at an early age, received a long, intensive training. The result of all this labor was not a single product but a multitude of images, decorations, and other objects, all of which had some function. Artists geared themselves to

the manufacture and sale for profit of utilitarian but beautiful objects of great variety.

These artists and their wives came generally from what might now be termed the craftsmen and small tradesmen class. They did not move in the elite, powerful circles of society (except as employees of powerful patrons). They were, instead, the sons of fathers and mothers who came from families with limited social standing, and on the whole they remained men of the middle rank.

With great frequency, artists came from artistic families. The vast network of artists' interrelation has not yet been charted, but we do know that a high percentage of artists were related, either by blood or marriage, to other artists.[9]

The extended family was the foundation of Renaissance society; its role in the arts was crucial. Although we have no records proving it, workshops, and much of the equipment in them, were probably passed down from one relative to another. One case, that of the famous Sienese artist of the Trecento, Duccio di Buoninsegna, illustrates some of the family relationships between artists. Duccio, who lived until 1319, had a brother, Bonaventura, who also seems to have been a painter. Three of Duccio's sons, Ambrogio, Galgano, Giorgio, and possibly a fourth, Giovanni, were painters. Segna, Duccio's nephew, followed his uncle's footsteps—and Segna's two sons, Niccolò and Francesco, were painters.

Duccio's contemporary, Simone Martini, after marrying the daughter of a painter, went into partnership with his painter brother-in-law. The daughter of Simone's painter brother married another painter. These interlocking relationships were extremely common and probably ensured a source of income as son succeeded father. There can be no doubt that many men became painters simply because painting was the family business. Talent must have often been a secondary consideration. This father-son pattern was common in Western art until quite recently: to realize what it has sometimes produced, we need only recall Raphael or Picasso, or Bach or Mozart, all artists' sons.

Family connections, either by blood or marriage, were helpful in many ways. They probably facilitated entry into the guild, just as today membership in some unions is helped by family ties. Access to workshops and guaranteed apprenticeship were privileges that tended to go with the right connections. And sons probably inherited some of the reputation and much of the trade built up by their fathers. Shops were a family business. This was also true of the other crafts.

Other boys—outsiders, so to speak—probably went into the shops simply because the profession was chosen for them by their parents,

who thought it would be the proper life's work for their offspring. It is likely, in other words, that youths were selected for an artistic career solely because their elders wished it. There can be no doubt that some entered the shops because they had already shown talent in drawing or carving, but these boys may not have been in the majority. This surprises us, for we consider the making of art something quite extraordinary and far removed from business, not taken up simply because one's parents are connected with it or because they think it would afford a good livelihood for their children. These conflicting ideas—one perceiving art as a calling, the other as a trade—indicate the vast chasm between our conception of art and that of most of the Renaissance.

The trades and much of Renaissance life in general were regulated by law and tradition; every citizen was caught up in a maze of institutions and rules governing most aspects of his world. The artists were no different. Artists' guilds existed in many of the Renaissance cities;[10] each was at least slightly different in structure and the artists played various roles within them. Sometimes they were just one among several groups in their guild. Sculptors often belonged to the same guilds as stonemasons and carpenters, while the painters sometimes joined the guild of the pharmacists from whom they bought colors. This integration with other occupations did not always work to the artists' advantage. In Florence, where the painters were in the *Arte dei Medici e Speziali* guild, they were dominated by other professions much higher on the economic and social scale.

Again, our lack of knowledge prevents us from describing exactly how the guild aided and controlled the artists, but some idea can be inferred from the few relevant documents that survive. It appears as though membership in the guild was a prerequisite to the execution of any important commission. The guild must have functioned much like a closed shop where work is impossible without a union card. Artists matriculated when they embarked on their careers, for without guild membership one could not find employment. Foreign artists were also required to enroll in the guilds.

The guild must have helped the artist by giving him a certain status and certification as a member. It may also have provided financial help in times of need. Often it was equipped with its own courts, where problems arising from conflicts among artists themselves and between artists and their patrons (who could be demanding indeed) were arbitrated. The guilds provided a religious and social service through their patronage of various churches. Guild membership, like everything else in Renaissance society, had strong religious overtones.

By belonging to a guild, artists also played some part in the governing of their cities. In the oligarchical republics, the guilds were important power blocks in communal government. Membership in them probably gave artists a sense of participation in the affairs of the city-state and a strong professional identity. There are numerous records of artists holding guild positions of some authority, even in those guilds where they were in a decided minority.

Artists also associated in some of the many religious confraternities found in all Renaissance cities.[11] The confraternities served both as mutual aid societies and as vehicles for collective religious expression. Usually attached to a church or an order, they were of varying character and purpose, from groups founded to sing laudes before images of the Virgin to societies devoted to self-flagellation. Many of them, such as the famous *Misericordia,* which still functions in many Italian cities, provided much-needed social and charitable services. They were yet another manifestation of the cooperative character of Renaissance society.

In Florence the painters founded the confraternity of St. Luke, named after the patron saint of their trade. This organization gave them a voice that they did not have in their guild, dominated by the doctors and pharmacists. Artists did not belong to one confraternity only; like their fellow citizens, they could, if they wished, join several of these organizations. Many of the confraternities also actively patronized artists.

Artists sometimes traveled extensively. Their livelihood was based on obtaining commissions; consequently they were willing, and indeed eager, to work almost anywhere. Of course, the great majority of them obtained commissions only in their home cities; but a fair number found employment farther afield.

There seem to have been several artists who were much in demand in the small towns surrounding the larger metropolitan centers. The Florentine painters Bicci di Lorenzo and his son Neri di Bicci, for instance, worked for numerous villages scattered throughout Tuscany.[12] Basically conservative, their style seems to have been much appreciated by the more traditional inhabitants of the smaller towns, who wanted to avoid the up-to-date (and probably more expensive) fashionable painters of Florence. In fact, Bicci and his son made these commissions such an important part of their careers that today scores of their sturdy, slightly old-fashioned altarpieces are still found in provincial churches.

Conversely, a very up-to-date and sometimes revolutionary artist might receive commissions from major, but distant, cities. The young

Sienese, Duccio, was called to Florence at the end of the thirteenth century, and just several decades later Giotto was to achieve great fame and many commissions; Giotto not only sent paintings long distances but went to work himself from one end of the peninsula to the other. Gentile da Fabriano and Pisanello, in the Quattrocento, were constantly on the move in search of commissions. For the next century, the frequent peregrinations of Michelangelo and Titian come to mind.

The wandering of painters and sculptors and their work helped disseminate knowledge not only of foreign artists' individual idioms but also of the style of their cities. We must remember, however, that the intense localism of Renaissance civilization meant that total transformation of style by outside influence was very difficult.

Much of our knowledge about Renaissance artists' travel, and indeed most other aspects of their lives, comes from documents, of which considerable numbers survive. These vary widely in type and in the amount of information they disclose, but a survey of a few of the records demonstrates what they reveal about the artist and his place in society. Surviving records suggest that artists had about the same rank in society as goldsmiths, shoemakers, or tailors. They were certainly below the powerful, wealthy bankers and traders, but they were many steps above the poverty-stricken manual laborers and wool workers.[13]

Many artists engaged in moneymaking ventures outside their shops; some invested funds in interest-bearing communal bonds. In Florence, their investments corresponded to those of their fellow tradesmen. Occasionally, as in the case of Giotto (who leased out looms), they had a small business on the side. Many of the artists, along with scores of their fellow citizens, had some land in the country, usually of modest size, worked for the olive oil, wood, and wine that it provided the artist and his family. Sometimes the land was rented to a tenant farmer.

If the tax returns or tax assessments of the artists are studied (and this can be done best in the very complete Florentine archives), one sees that they were not financially well off.[14] The long lists of creditors that appear with alarming frequency are usually not counterbalanced by the artists' meager assets. But this picture of men just making a living, which the documents often present, must have been common to most of the craftsmen and tradesmen of what we would now call the middle class.

The archives also reveal that artists served in some communal offices, in the government of their guilds, and in other official capacities. In Siena and elsewhere, they were sometimes sent on diplomatic missions and represented their city in several of the towns it controlled

or strongly influenced. But, in general, artists seldom rose to offices of great power. They were by birth not part of the noble or oligarchical power structure that really ran the cities. The exceptions to this statement—such as the several Sienese painters from noble families—are rare.

Much valuable information is found in the tax returns that Florentines were obliged to file from 1427 on. These are often our primary source of information about an individual painter or sculptor. They had to list the taxpayer's age; because birth dates are usually not included in other documentation, the tax returns are often the sole record for this precious bit of information. On occasion the artists were unsure exactly how old they were; occasionally they lied about their age, claiming to be older and less able to pay their fair share of the tax. Sometimes the tax returns also list, under the heading of debtor, an artist's patrons who still owed him money. On several of the forms, works the artist had not yet finished or delivered are mentioned.

Artists, like almost everyone else, had trouble with tax collectors. The whole process of tax collection seems to have been somewhat flexible and open to arbitration. Some artists—the Florentine Trecento painter Agnolo Gaddi, for example—claimed that they were paupers or very poor and not taxable; but these claims must have been viewed with extreme skepticism by the tax officials who read the returns.

Another type of document the artist himself wrote was the will.[15] These legal instruments, often modified by several codicils, are helpful in discovering who the artist's relatives were, with what particular church he was associated, how much money and property he had, to whom he wished to leave it, and other useful practical information that helps to place the artist in his time. Most of these wills confirm what is known from other documents: the artist often possessed only a meager amount of capital and property, and his will and the inheritance he left were like those of the hundreds of other craftsmen and tradesmen of his social and economic standing.

Judicial records, which survive in great number, are another invaluable source of information on artists. Like many of their fellow citizens, artists often ran afoul of the complicated and omnipresent legal system endemic to every Renaissance city. Few artists seem to have been habitual lawbreakers or, indeed, criminals, although several (such as Duccio, who had a record) appear to have had more than their fair share of trouble with the authorities. There are a number of cases of violence recorded, but artists seem to have been no quicker to use this traditional form of social behavior than any other group or class of citizens.

Court records also show that there were often bitter feelings between artists and patrons. Long, sometimes hostile legal battles between offended parties over broken contracts or missing wages occurred. Some of these disputes were probably heard in guild courts, while others were settled by the time-honored method of compromise outside the halls of justice.

It appears that many artists kept what might be called shopbooks. The few remaining examples demonstrate that they were a sort of private work diary in which the artist entered daily the business of the shop; he also recorded summary drafts of contracts for works of art and set down transcriptions of other legal matters. The most famous of the several of these to survive is by the Florentine Quattrocento painter Neri di Bicci.[16] This book, which covers the events of the years 1453–57, gives the most complete and interesting picture of the day-to-day activity of a shop that we possess. Its brisk, businesslike tone must have been common to many artists' shops.

Neri's book is quite long—the printed edition runs to over 400 pages—and surprising in its detail. Everything from the acceptance of an apprentice to the purchase of grain is meticulously recorded, including the commissions for a number of surviving paintings.

Also recorded are many business transactions (for instance, the purchase and leasing of land) that have nothing to do with the artistic activities of the shop. Reading through Neri's detailed shopbook reinforces the impression one receives from all the other documentary sources: the making of art was a craft engaged in for profit; it was not a calling or a spiritual or quasi-religious vocation. Books similar to Neri's must have been kept by nearly every goldsmith, draper, and shoemaker in Florence.

Another form of contemporary book on the artist, his education, and his shop, which survives in just a few manuscript examples, might be most conveniently termed a shop manual. The most famous is by the late fourteenth-century Florentine painter Cennino Cennini.[17] Cennini's manual is aimed at preserving and passing on much of the accumulated knowledge and technique of the workshop. As such, it is one of the most valuable sources for our understanding of the way Renaissance art was made.

Cennini lists, in great detail and with considerable skill, many pigment recipes, scores of techniques, and much other practical information ranging from where to find eggs to what to eat. Most of the technical training of the apprentice must have been done by example, the young man watching the master and then trying to learn the skill himself. There may not have been much demand for a textbook like

Cennini's. In the shops, education was not theoretical; skills were not gleaned from books, but from the handling of the material itself.

We also know something about the shops from several surviving inventories. One of the most fascinating, that of the Sienese artist Neroccio di Landi, was drawn up in the year 1500 and lists the artist's possessions, over 200 items in all.[18] Aside from household objects, it mentions a number of things that must have been in the artist's shop: pieces of Carrara marble of various sizes; heads and figures of terracotta; heads and hands of wax; pieces of wood for painting; and numerous other objects connected with Neroccio's painting and sculpture business. According to the inventory, other items were at the pawnbroker—an important figure in Renaissance society. At Neroccio's death a few years before, some of his possessions had been taken from his shop, but one can still see that a considerable number of tools, materials, and works of art, probably in various states of completion, remained.

Another of these scarce catalogues of artists' possessions, this time an auction list, is known for the Venetian painter Jacobello del Fiore.[19] Among Jacobello's things in 1439 were a parrot cage, a bed curtain, several panels of the Virgin, a mirror, and a fancy candlestick. It is hard to know how many of these were wares destined for eventual sale, but the list nevertheless gives a rare glimpse of what an artist owned.

Information about artists is also found in their letters and other writings.[20] The former are seldom of extremely high literary quality; rather, they are concerned with such practical considerations as the landing of a commission or the need to clarify a point with a patron. Quite a number of these letters have survived, and some of them reveal much about the artists' relationships with society, especially with those people who were paying him. On occasion one sees a glimmer of independence in the artist's dealings with his patrons, but usually the tone is one of servility, as the artist maneuvers, and sometimes cajoles and pleads, for a commission or payment. More personal (and therefore more interesting) notes appear with less frequency.

There are examples of artists' writings that go beyond the need to find a commission or pass on the working methods of a shop. One of the most famous of these is *On Painting* (1435), by the Florentine writer and architect Leon Battista Alberti.[21] This is not a book that arose from the usual hectic, workaday atmosphere of the shop; rather, it stemmed from the more theoretical interests of its author, who did not go through the apprenticeship system and was not a professional painter. Judgments on perspective, light, color, and other stylistic components of paintings, ideas for the fashioning of coherent narrative, and com-

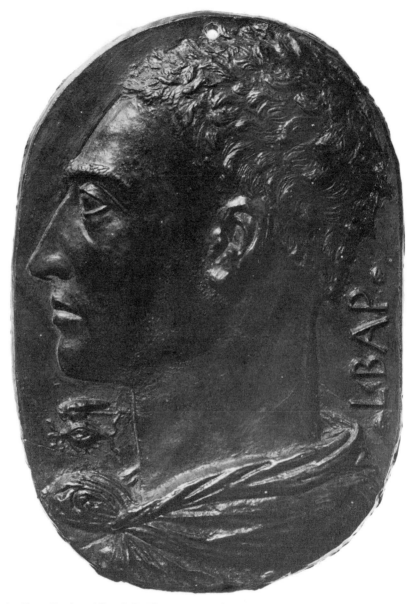

8. Leon Battista Alberti (?), Plaquette, Washington, D.C., National Gallery of Art. Bronze. c. 1450.

It has been argued that this is a self-portrait by the Quattrocento architect and art theorist Leon Battista Alberti. While the question has not been resolved, the plaquette certainly represents Alberti and carries, below the chin, his device of the winged eye. The forceful depiction with close-cropped hair and bull neck is remarkable.

ments on how the painter should behave all appear in Alberti's tract. Although he knew and admired some of the most distinguished Florentine artists of his time, Alberti wrote something entirely different from their shopbooks or shop manuals. *On Painting,* even though it contains a number of practical suggestions, is one of the first theoretical works of the Renaissance. It is a bird's-eye view of art rather than a how-to book, and its author must be classified as one of the first truly gifted amateur theoreticians of painting.

Several artists' books are combinations of the theoretical and practical. One of the earliest is *I Commentari* by Lorenzo Ghiberti, who wrote this fascinating work—part autobiography, part history of art, and part theoretical manual—around 1450.[22] In some respects, the book is a forerunner of Giorgio Vasari's *Lives of the Painters, Sculptors and Architects,* which was written in the mid-sixteenth century.[23] Vasari's collection of artists' biographies, prefaced by a long discussion of material, methods, and theory, runs to many volumes and for centuries has been the single most influential work on Italian painting. Often called the first art historian, Vasari was an idolator of Michelangelo, the artist who emerges as the hero of the *Lives.* The work could be said to contain the first historical schema of the entire Florentine school of painting from Giotto to Michelangelo.

Benvenuto Cellini (1500–71), who wrote perhaps the most famous, the finest, of all artists' autobiographies, was a goldsmith and sculptor whose career and conduct point toward an important shift in the way some artists began to perceive themselves and their relationship to society.[24] The creator of a number of superb bronzes, Cellini (who also wrote treatises on sculpture and goldsmithing) portrays himself as something more than the successful craftsman. His ego, temperament, and, above all, his belief in his divinely inspired virtuosity place him in a special category, prophetic of our modern ideas about artists. However, this is not yet the portrait of an artist outside of society, but one who moves easily within it and is admired and sought out even by princes and popes.

A number of self-portraits mirror the growing self-awareness of some artists. The tradition of the self-portrait inserted in an altarpiece or tucked into a fresco seems to date back only to the late fourteenth century. During the Quattrocento, however, a series of self-portraits appear that have no other purpose than to confer a degree of immortality upon the artist. Both in medalic and painted versions, these portraits (and others of artists by their colleagues) testify to the desire of a minority of artists to rise from the collective anonymity of the workshop system. This desire was shared by the Renaissance histori-

ans, biographers, memorialists, and rulers, all of whom began to concern themselves with the individual personality and its place in history.

This changing self-concept of the artist, especially noticeable in his relations with patrons, is most apparent in Vasari's life of Michelangelo and in the latter's letters and behavior.[25] A poet with a deep and abiding interest in philosophy and theology, Michelangelo had an easy familiarity with literature, a familiarity foreign to almost all of his predecessors of just a half century earlier. Many of his interests were shared by a number of his contemporaries, including, of course, Leonardo da Vinci, the author of several remarkable treatises and notebooks.[26]

Although most artists still lived within the confines of the workshop, a few—Michelangelo and Cellini among them—were moving in another direction that would help shape the modern conception of the artist as the inspired lonely creator, a person apart from regular society.

The houses of several artists illustrate some of these new attitudes. Titian, Leonardo da Vinci, and Vasari lived in dwellings that were palaces compared to the typical humble artist's home. They and a number of other artists adopted, or pretended to adopt, a style of life that was more like that of a wealthy burgher or nobleman than the craftsman-artist.

It was during the early sixteenth century that the notion of the artist as someone endowed with a special, quasi-divine calling arose; but the vast majority of artists still made no special claim to greatness, nor did they consider themselves geniuses or in any way extraordinary. Instead, they and their descendants for generations lived very much within the craftsman's tradition. It should be emphasized that in their attitude toward art, in their economic and social standing, and in their self-image, they still securely belonged, as did their fourteenth- and fifteenth-century predecessors, to what we might call the middle class. This is worth remembering because the early sixteenth century is too often seen as the period when *most* artists began to disassociate themselves from the craftsman's social standing and intellectual interests. In fact, it was only a small group of artists (albeit some of them of the greatest importance) who started to rupture the artist's established position. Nothing could have been farther from what most Renaissance men and women thought about the artist.

As we have seen, the great percentage of Renaissance artists lived lives that were, in every aspect except their trade, nearly identical to those of their fellow craftsmen. A very few, however, were touched by fame.

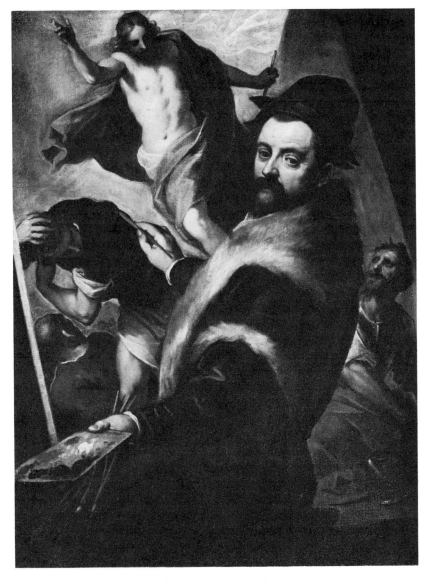

9. Palma Giovane, *Self-Portrait*, Milan, Brera. Oil. c. 1590.

This portrait by the Venetian painter Palma Giovane wonderfully documents the importance the artist's persona had achieved by the sixteenth century. Dressed in furs—hardly suitable clothes for painting in oil—Palma occupies center stage. The canvas of the *Transfiguration* on which he works is nearly eclipsed by the painter. Even the levitating Christ seems to be giving the worldly, dandified Palma his personal blessing.

Giotto was the first living artist to be regarded as an important figure in his city's history. The Florentines not only honored him with the superintendency of the works of their cathedral, but also, in the document authorizing his appointment, called him an expert and famous man who should be welcomed as a great master in his native city. Moreover, he was one of just several artists accorded the rare honor of a mention in the *Divine Comedy* by Dante. Yet from everything we know about Giotto's life, this fame did not translate into any particular personal, political, or economic power. Giotto's fame seems rather to have centered exclusively on his works. The documentary descriptions of him by his contemporaries depict him as an ordinary, quite humble man. He was, however, honored by the commune with a burial in the cathedral he had helped to build, an act of homage indeed.

Contemporary fame was accorded to artists who executed important commissions for the major figures of their time: Cellini, Michelangelo, Titian, Leonardo da Vinci, and Raphael, to name just a few, were in the service of popes, dukes, kings and emperors, and other personages of renown. Their art, whether the portrait, the altarpiece, or the tomb, was in many ways propagandistic. In other words, artists played a crucial role in the shaping of the public image of the ruler. These valuable servants of the court now began to acquire, by association, some of the fame of courtiers. And when they did, they were sometimes given tombs worthy of nobles: one only has to visit Michelangelo's tomb in Florence or Raphael's in Rome to see that this is true.

But these artists were a mere handful; for each of them there remain a thousand forgotten others whose fame went not much farther than their own neighborhood. Often their only surviving memorial is an altarpiece or sculpture hidden away in the corner of some provincial church. Their anonymity is a result of their harmonious integration into a society that valued them most as co-citizens. Even their training urged them to suppress their individuality.

Artistic Training

Almost all our ideas about making art are of recent origin. Today, when we look at a contemporary picture in a gallery, we assume that it is the product of a single mind and a single hand from start to finish. This is a received idea we sometimes wrongly apply to the art of the past. Yet quite the opposite was true in Renaissance painting, where several members of the workshop might collaborate on a single altarpiece. And what was true for painting held for almost every other medium and type of art. In bronze sculpture, the master made the

object in clay. It was then cast by a foundry and, finally, chased by the artist and his helpers. Illuminated books were also the products of several hands.

All this artistic cooperation demanded a uniformity of style: it was necessary that the work, whether it was a fresco, a bronze relief, or marble statue, look whole and seamless, not a jumble of disparate styles. And it was toward this uniformity that much of the artistic education of Renaissance artists was directed. From the moment the artist walked into the shop as an apprentice, he was urged (perhaps compelled is the more correct word) to make the master's style his own. The fledgling artist should not experiment with his style until he has fully learned the idiom of his teacher, advised Cennino Cennini in his late fourteenth-century shop manual.[27]

This emphasis on copying, on learning by imitation, comes as a surprise to us. We are, after all, imbued with the notion that originality in art is a prerequisite of worth. Art that merely copies, we call derivative and petty. But this notion is at variance with the basic premise of Western artistic education from its beginnings to the twentieth century.

Art into art, the acquisition of style by imitation, is the way almost all artists learned their skills until very recently. Certainly they worked from life, taking inspiration wherever they found it; but the fundamental techniques of design, of drawing and modeling, were gained from other art. The study of plaster casts, the visit to the church or, in later centuries, to the museum to copy the works of others, the examination of illustrated books, these were part of the experience of every Western artist. Copying was the right and logical thing to do. It was the way one learned, and it kept the artist in touch with the wellsprings of the past.

Nowadays, when plaster casts have been destroyed or banished to the basement, in most circles copying the work of other artists is frowned upon, considered derivative and retrogressive. What is prized is originality of form and idea, the product of the avant-garde. But the very notion of the avant-garde, or the idea that originality is in and of itself a worthy thing, would have made no sense to the Renaissance artist. Feeling part of a vital artistic tradition, firmly fixed within the society surrounding him, and the product of a workshop education that demanded imitation of the master's style, he would have felt that it was correct to imitate openly and learn from other works of art. He would have had no need to shock, to establish a theoretical base for his work; nor would he have wished to hide his debt to the past. Perhaps this was because he was not yet an *artist*—that man of special

name and calling who stands outside the workaday life of the shop.

Copying, education by imitation, created a particular type of stylistic development in the Renaissance. The sharp, swift changes in style (and in content) of the twentieth century were, of course, unknown. Instead, one finds the slow, gradual transformation of one style into another. Whole generations of artists, in retrospect, can be seen pursuing similar stylistic and iconographic goals. From generation to generation, from pupil to master, there is change, but it is modulated and slow. There are certain exceptions to this—Giotto, who created a new dramatic language; Donatello, who in his later works soared out of his own time; and Titian, who forged the syntax of oil painting—but these are rare indeed.

However, one should not think of the great majority of artists as drones, simply duplicating their masters' styles. There was, in fact, much change, a great deal of invention, and considerable experimentation. But it was all done within the bounds of a firmly established artistic convention, and with considerable respect and admiration for the works of art by the artist's ancestors and contemporaries.

Before an apprentice could even begin to think about style, he had to learn how to make art. From the very first, Renaissance apprentices were introduced to the materials and craft of art. To become artists, they had to master a variety of substances and techniques. Present-day artists buy many of their materials at the art store; in the Renaissance, most of the things used in the shop were made by the artist and his helpers. Instead of buying tubes of standard color, they made their own. Brushes and the scores of other necessary tools of their trade did not come off the shelf, but were a product of their own hands. This early—and lasting—knowledge of the material, physical aspect of his craft (a knowledge also possessed by every potter, shoemaker, and draper of the time) endowed the artist with an almost instinctive feeling for the most basic properties of a picture, a sculpture, or an illustrated book. His understanding of materials and his skill in using them were extraordinary.

Whatever the artist made had to be well conceived, well wrought, and long-lasting. His creation was perceived not only as a *Virgin and Child* or a *Resurrection of Christ* but as an object with a function, a thing made by a skilled craftsman for a specific commission. It is not debasing to the Renaissance artist to say that his product was looked at, in part, the way we might view a fine watch or a beautiful pair of boots. He himself would have taken such a comparison as a compliment.

Any careful, first-hand examination of Renaissance art reveals that craft is of remarkable importance: paintings and sculpture from the

period are among the most beautifully made objects in the entire history of Western art. For instance, the carpentry of panels, the quality of pigments, the manner in which the paint is applied, the gilding, the skill of the punch work, all clearly demonstrate that the *craft,* the masterful and appropriate use of materials and tools, was highly valued. No work of art was worthy without it. Like a beautiful Stradivarius violin (also the product of nearly incredible skill), whose sound and use are not fully understood without a knowledge of its construction, a Renaissance work of art is not totally comprehensible without an understanding of the craft that formed it. There was no separation of arts and crafts; rather, art was achieved only through craft.

The Renaissance concept that all works of art were functional and skillfully made objects renders the apprenticeship system more understandable. The need to master techniques and materials encouraged and perpetuated the workshops. Painting and sculpture were complicated, intricate, laborious tasks. Just to learn how to do them well took a considerable amount of time. The exalted role of craft made the workshop necessary.

Today, art is a manifestation of the artist's creative spirit. Certainly the sale of art is an important element, but thousands of artists who have little hope of ever selling their work still continue to paint and carve with great energy. Art is their calling and catharsis; financial rewards, most of them believe, are important but considerations of a lower order. One debases art by talking about how much it costs.

This attitude was foreign to the Renaissance, when art was made on demand for commissions. The idea that a work was simply a personal expression of the artist would have been alien to the mentality of artists and their public alike. From Masaccio to Mozart, supreme works were made with their commercial value very much in mind.

Remember that most boys probably entered artists' shops because they were members of families already engaged in the trade, or because their parents had decided that, for economic reasons, their son should become a painter or sculptor. Previously demonstrated talent, it appears, was not an overriding factor.

The apprenticeship system, with its long period of study, early acquaintance with varied materials, copying, and collaborative work, somehow allowed boys who were probably quite ordinary in every respect to be turned into men possessing a high degree of artistic skill. Art—so the Renaissance believed—could be taught by a series of progressive steps from grinding colors, to making copies, to work on the master's design, to inventing one's own paintings or sculptures.

All this may appear incredible to those who feel that the role of the art school is to encourage and train the already gifted. We do not believe that education alone can create a good artist: some kind of talent, of inspiration (divine or otherwise) marks a person for further artistic study. In fact, students are not admitted to most art schools unless they give some indication in their portfolio of artistic ability. The idea that almost anyone, given enough time and enough experience, can give a creditable artistic performance would sound like nonsense to most art school teachers.[28]

Yet the vast majority of drawings, paintings, and sculptures produced in the Renaissance give clear evidence of the acquired skill of their authors. In every aspect of art—from the basic understanding of how to use a brush to the ability to foreshorten a hand correctly—the Renaissance artist achieved a level seldom attained in Western art.

It appears that it was indeed possible to train boys, who may or may not have had much talent, to a remarkable proficiency. Of course, the question remains: Could the Renaissance system of artistic education not only train most artists to be highly competent but also teach some of them to be great? Our immediate answer is no. We believe that extraordinary artists are inspired by some inner force, which no amount of study or effort can create. This notion, which started to gain support at the end of the Renaissance, is a romantic one. It would not have found wide acceptance during most of the period covered by this book.[29] However correct it may be, it remains alien to the mentality and the training behind most of the works of art produced in the Renaissance.

But in the early sixteenth century, new attitudes began to form in some of the more intellectual artistic circles: Vasari, for example, looking into the history of Florentine art, calls Giotto divinely inspired. The idea that the artist was a special creator standing apart from society, above the guild-workshop system, was being born. Artists were encouraged to read history and literature, to be gentlemen, to live in a style more suited to their new self-image. This was the period of the development of the first artistic academies; it was the beginning of the institutionalization of artistic education. This new attitude, which was not at first widespread, would lead eventually to our present concepts of the artist, his education and place in society, but also to the end of the unchallenged supremacy of the cooperative workshop and all that it stood for in the world of the Renaissance.

Renaissance Art: Its Function, Location, and Patronage

Our notion of a work of art would have been unintelligible to someone living in the Renaissance. The idea that a painting or a sculpture was something to be valued and appreciated mainly for its dematerialized, aesthetic and intellectual content would have made no sense to the Renaissance worshipper, patron, or artist.

The Renaissance altarpiece as we see it today, for example, is in many ways a specimen. It hangs on the walls of a gallery, often lit by electric light, surrounded by works of art from different times and places, identified by a label, and categorized according to art historical concepts. Like some rare butterfly, it has been removed from its environment, mounted, and displayed.

The idea that a Renaissance altarpiece would be looked at in such an anthropological and historical manner was never part of its artist's original intention nor, for that matter, his understanding. It was, he and the patron thought, destined to stand forever on a particular altar in a particular location. Its size, shape, color, and content were often calculated for that place. Indeed, it is not fully understandable without reference to its original setting and function, a function—religious, ritualistic, and supernatural—that was the very reason for its existence.

Often the altarpiece was part of a larger pictorial scheme, which included frescoes and sculpture. For instance, an altarpiece with the Nativity might form the centerpiece of a chapel whose walls were painted with frescoes depicting the life of Christ. The altarpiece was never meant to be seen in isolation. It was just one part, although a very important one, of a larger pictorial unit; consequently, a great deal of its original meaning is lost when it is seen alone.

The altarpiece stood on the altar table with the holy bread and wine. Standing before the altar table, the priest said the Mass, the central rite of the Catholic faith.[30] For the believer, a miracle occurred during the ceremony: the eucharistic wafer (the host) became the body of Christ, and the sacred wine was transformed into his blood. Christ lived again and was present among the worshippers. The dogma of transubstantiation, the miraculous rebirth that held out the possibility of resurrection and salvation, was at the heart of the Mass.

The sacred figures depicted in the altarpiece were intertwined with this miracle. Christ, either as infant or adult, was almost always represented. He and the other holy beings were seen as icons; like the bread and wine, they too were capable of transformation from the symbolic

10. Sassetti Chapel, Florence, Santa Trinita. 1483–91.

With its frescoes of the life of St. Francis by Ghirlandaio and its tombs attributed to Giuliano da Sangallo, this remains one of the best preserved Florentine chapels. Still in place on the original altar table is Ghirlandaio's splendid *Adoration of the Shepherds* altarpiece, flanked by frescoes of the kneeling, supplicant donors, who are buried in the sacrcophagi set within the arches. The entire chapel—frescoes, altarpiece, tombs, donor portraits—was planned as an integrated whole. The chapel is of considerable historical interest because a number of clearly recognizable Florentines of the late fifteenth century are portrayed throughout the frescoes.

to the living, from stone and paint to flesh. Scores of records from the Renaissance describe how Christ and the saints left their pictures and intervened in the life of the worshipper. The altar itself was considered as the supernatural tomb of Christ and always contained the relic of a saint. In a world invested with magic, the religious image was an object directly connected with the miracle of the Mass and imbued with the same divine power. Like the vessels for the wafer and wine, or like the altar itself, the altarpiece played an active, vital role in the central religious ritual. It was most definitely not a "work of art" in our sense of the term.

In a society based on sacred premises, almost all that occurred was viewed as a manifestation of Providence. Every painted and carved figure or narrative carried with it miraculous overtones. Thus the modern visitor to the Renaissance chapel must continually remind himself that during the Renaissance people did not stand in front of these objects with guidebook in hand, nor did they discuss their place in the history of art, nor read about them in art history texts. Rather, the worshippers regarded images as vital forces in their own lives. The world still saw paintings and sculptures as supernatural.

Present-day tourists seldom realize that the beautiful objects at which they gaze were closely tied to death. This fact is the reason for the existence of many of the painted chapels, altarpieces, and of course tombs of the Renaissance.

For over two centuries, Renaissance sculptors were engaged in the construction and decoration of tombs. The statues and reliefs attached to tombs were certainly decorative, but they were also bound up with the Requiem Mass. For the worshipper, they often illustrated the promise of salvation by the example of the Resurrected Christ (who was reborn during the Mass), or by another figure or symbol that held the promise of resurrection and then eternal life. No one who lived during the Renaissance would have looked at a tomb and failed to feel many of these things, none of which have anything to do with the work as an archeological or historical specimen.

Renaissance churches are also Renaissance cemeteries. Under the floors of these structures rest the remains of thousands of those who built, decorated, and maintained the buildings. When the Renaissance worshipper stood in church, he must have been acutely conscious that he was not only in a sacred structure where miraculous rites took place but in a burial ground. Even before he entered the church, he saw the tombs around its walls and the memorial plaques in its cloisters. Once inside, the floor and wall tombs, which in the larger churches numbered in the hundreds, were always before his eyes.

Scores of images found on the tombs and paintings (the Resurrection, the pelican, the egg, the Madonna and Child, and countless restorative miracles of Christ and the saints) were symbols of rebirth and resurrection, images of hope offering the possibility of life after death. The tomb, the altarpiece, the fresco, held many diverse levels of meaning and symbolism; they were bound up with great issues: life, miracles, and death. The Renaissance audience saw them not only as beautiful things but, more intensely, as the embodiments of a range of hopes, fears, beliefs, and sentiments that today we can just barely discern.

Some modification occurred around the early sixteenth century. One sign of change was the acquisition of pictures, statues, small bronzes, and medals in considerable quantities by collectors. These objects were not intimately connected with religious rites or places, nor were they purely utilitarian things. Rather, they were more like works of art in our sense: objects to be valued for their physical beauty, their ideas, and their cost. Artists were themselves becoming admired, special members of society whose names and works lent prestige to collectors. Even solely religious things—altarpieces and statues in churches—were now perceived as works of art as well as religious objects. The iconic, miraculous nature that so marked art in an earlier period was slowly giving way to a more dispassionate attitude. It was becoming possible to see painting and sculpture through the intellectual vehicles of aesthetics and art history. In this period an attitude toward art more characteristic of our own century was forming.

The art that played such a vital spiritual and intellectual part in Renaissance society was found in many places, but the greatest concentration appeared in churches.[31]

Today, when we step into most churches of the fourteenth and fifteenth centuries, we see rather bare structures. To be sure, there are usually additions (sometimes many) from succeeding eras; nevertheless, there is not the clutter and variety of art one would have found during the Renaissance. Fire and flood have destroyed much, restoration has removed or altered a great deal. But the major culprits have been changing styles and tastes, which have swept away much more than has been preserved.

One of the most common features of the Renaissance church was the private chapel. This was often owned by a family or individual who could, and did, sell it to others. Inside the chapel, the owners hung their coats of arms, banners, and sometimes armor. Usually they and

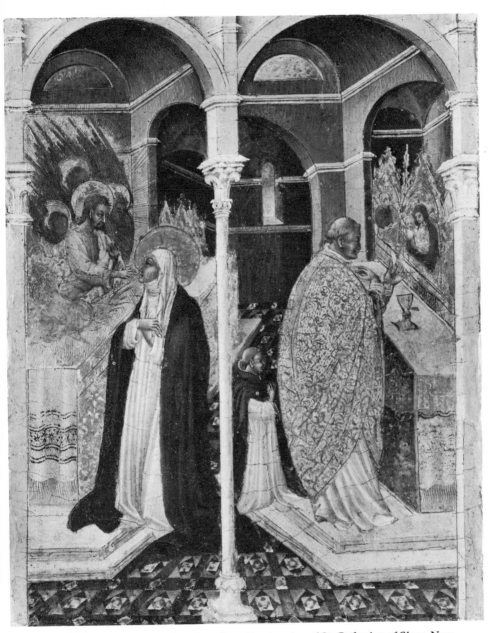

11. Giovanni di Paolo, *The Miraculous Communion of St. Catherine of Siena*, New York, Metropolitan Museum of Art. Tempera. c. 1460.

Giovanni di Paolo's painting, once part of a larger altarpiece, depicts a church interior where a priest celebrates Mass before an altarpiece (a triptych) set upon an altar table covered with a cloth. At the left, St. Catherine receives communion from Christ himself, who appears miraculously in the location normally reserved for an altarpiece.

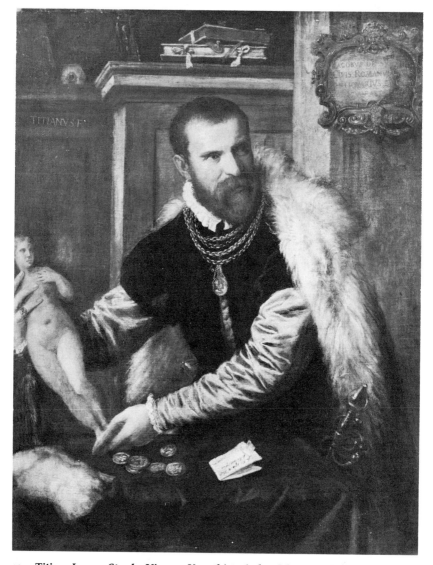

12. Titian, *Jacopo Strada,* Vienna, Kunsthistorisches Museum. Oil. 1567–68.

Jacopo Strada was a goldsmith, painter, art dealer, architect, and antiquarian. A noted writer and expert on Roman emperors, he is representative of the scholar, writer, courtier-artist of the sixteenth century. Titian's portrait of him clutching a statue is not overly sympathetic. Surrounded by coins and dressed in furs and heavy golden chains, Strada looks more like a grasping, sly dealer than a learned, detached antiquarian.

13. Santa Croce, Florence.
The vast size of the church of Santa Croce is apparent in this view. Begun in the late thirteenth century, the church was built to hold the crowds drawn by the famous Franciscan preachers who visited Florence. The huge transept with its private chapels and the tall choir are also visible here.

the members of their family were buried in the chapel, either in the floor under decorated tomb slabs or in tombs set into the walls.

On the stone altar table would stand an altarpiece. In front of the altar table was often another painting, usually of a decorative nature, called the *paliotto* or altar frontal. Over the altar table an altarcloth of beautifully woven and decorated material was draped on which, during the Mass, the vessels holding the wine and wafers would be placed. Often the liturgical objects would be stored in a carved stone tabernacle closed by a small door.

Frequently, the walls of the chapel were decorated with frescoes. These varied in size and subject matter, although they most often depicted the life of Christ or one of the saints. The paintings often covered the entire wall surface, from the vaults, usually painted with saints and decorative motifs, to the lowest levels, sometimes embellished with fictive painted marble.

In some Quattrocento churches, especially those designed by the Florentine architect Brunelleschi and his followers, there are very few

frescoes. In part, this is because in these structures the chapels are quite small. But the principal reason for the suppression of wall painting is found elsewhere: the remarkable contrast of dark stone and stark white plaster, so characteristic of these buildings, would have been disturbed by large colored frescoes, which would have created various bright spots along the aisles and destroyed the meticulous balance of the churches. Throughout the Renaissance, however, there was always a demand to modernize chapels in older churches, and painters were continually commissioned to paint new frescoes over older ones.

If the chapel had windows, they were often filled with colored glass. Churches in the Italian peninsula do not have the large expanses of glass found in the cathedrals of northern Europe; the amount of glazing is limited to rather narrow, tall windows in the chapels and along the aisles and, occasionally, to round lights set into the facade. Often the iconography of the chapel windows was a continuation or amplification of the stories told in the altarpiece or in fresco around the walls.

Family chapels were closed off from the rest of the church by gates. Many of these gates were made of wood and have not survived, but others wrought of iron are still in place.[32] The large, expensive gates, the work of remarkable talent and inspiration, are fine examples of the melding of function and decoration in Renaissance objects. Not only do they close the chapel to strangers; they also complete it with a splendid, transparent facade.

14. **Florentine, Altar Frontal (Paliotto), Florence, Santo Spirito. Tempera. c. 1500.**

This is one of the several surviving altar frontals in Florence. Painted on wood and placed directly in front of the stone altar table, it represents a standing St. Lawrence fronted by two kneeling figures. To the sides, angels draw back a brocaded curtain covering the rest of the panel. This painted material is a reference to the expensive fabric that previously covered the fronts of altars.

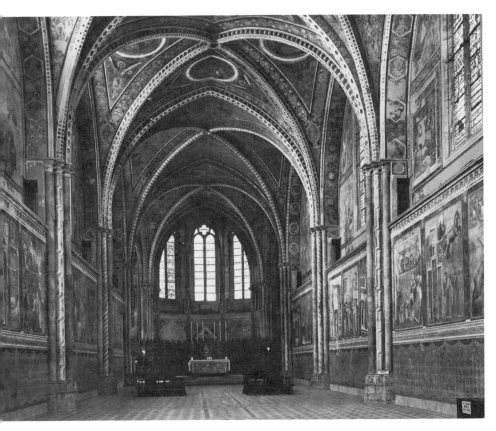

15. Upper Church of San Francesco, Assisi.

San Francesco at Assisi is the mother church of the Franciscan order and the tomb of St. Francis. During the late thirteenth and early fourteenth centuries, its walls were decorated by some of the most important painters working in the Italian peninsula. A complex, carefully devised program was drawn up for the upper church. This provided for decoration of the vaults, the areas between the windows, and the lower parts of the walls. The result is a splendid, colorful overall decoration.

When the chapels were new, and whole, they must have looked very different. Furnished with altarpieces, altar frontals, altarcloths, colored glass, frescoes, and gates, they were a blaze of color and decoration. Planned as a unit in which the various parts enhanced and amplified each other, they were replete with a meaning, symbolism, and beauty we can only dimly discern.

The now bare aisle walls of many churches were also decorated. Sometimes an extensive fresco cycle covered them with form and color. Often, however, the decoration was not the result of an overall plan: frescoes of many subjects, sizes, and shapes were gradually added to the walls.

Until about the middle of the sixteenth century when they were destroyed (the victims of modernization), structures called monks' choirs stood squarely in the center of many of the larger churches. These were big, complicated stone constructions, with thick, high walls that probably rose above the head of even the tallest worshipper. Here the monks celebrated the Mass away from the eyes of the laity.

The monks' choir must have blocked the view down the nave of many churches, and the gates between the choir and the side aisles may have impeded access to the church beyond the monks' choir. In some churches, this probably meant that a great deal of the building was not accessible to everyone.

A pulpit, often placed in front of the monks' choir toward the church's entrance, was a necessary piece of church equipment. Large enough to hold at least one person, it was raised above the floor either by its own columns or by attachment to one of the church's piers. Occasionally these pulpits were of wood, but the grander ones were elaborate, expensive objects of marble or bronze. Decorated with stories in relief from the life of Christ, among other themes, these structures are some of the most joyful of all Renaissance sculpture. Singing galleries *(cantorie)*, in form much like extended pulpits, also make their appearance during the Renaissance. Sometimes finely carved, these held the members of the choirs who furnished song for the religious ceremonies.

Renaissance artists were also called upon to decorate other parts of the church. Facades, especially those of the city's major churches, were often embellished with sculpture. Sometimes these facades were quite elaborate, with dozens of figures and reliefs attached to them. Other sculptures, and sometimes mosaics, were found over the doorways and occasionally on the free-standing belltowers *(campanili)* of churches. Costly doors, both of wood and bronze, were also executed by sculptors.

The great churches were staffed by scores of people and visited by thousands more for whom it was necessary to provide a comfortable and fitting environment. Many of the larger churches were surrounded by a whole complex of service buildings; these libraries, dormitories for monks and visitors, kitchens, refectories, and other necessary structures were also decorated by artists.

Refectory painting, that form of ancillary building decoration which has most frequently survived, was often of considerable size and importance. The end wall of the eating hall, where the head table was placed, was often painted with a scene of the Last Supper or another story with reference to dining. These paintings must have been highly

16. Ground Plan of the Church of Santa Croce, Florence. Begun c. 1290.

This plan shows the numerous private chapels running around the transept. The area roughly from no. 11 back to the transept was included in the now destroyed monks' choir. The pulpit is at no. 3. So large is the church, begun c. 1290, that the congregation could usually be accommodated in the first three bays. To the right of the church are the numerous ancillary cloisters and buildings, including the refectory (now a museum) at no. 7.

prized, for their execution was often entrusted to the most popular and well-known artists of the times: Leonardo's famous example comes immediately to mind.

These same artists were also often paid to work in the communal buildings of the Renaissance cities.[33] The most decorated of these was

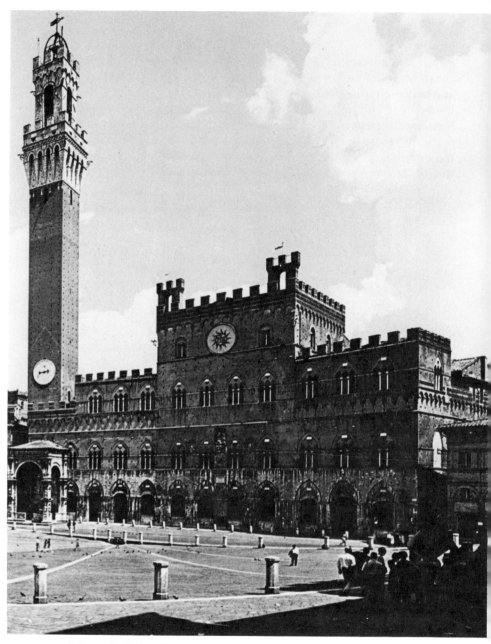

17. Palazzo Pubblico, Siena.

Begun in the thirteenth century, the Palazzo Pubblico was the major governmental center of Siena. Like many others of its period, the palace still retains numerous fortress like architectural features. The tall belltower was both a source of civic pride and a necessary observation post. The interior of the palace is notable for its rich fresco decoration.

usually the town hall—the seat of communal government and the physical manifestation of the city's power, wealth, and authority. The construction of such buildings was a matter of considerable concern and expense to the urban population, as well as a source of civic pride. Usually one of the largest buildings, the city hall often resembled a fortress: its crenellated battlements, small windows, and vigorously rusticated facade were all borrowed from military architecture during the early years of the commune, when city government had to subdue the violent elements on both sides of its walls both physically and psychologically.

Commissions for town hall decoration were given to many types of artists. Painters executed altarpieces for the numerous altars found within these buildings.

Numerous frescoes were also found throughout the town halls. Often these depicted subjects specific to the city: an important battle, a conquered town, a military or political hero. Sometimes they were large allegorical paintings, which served as examples of the importance of good government or illustrated some other communal theme or goal. Most often, however, the paintings were of the central figures of Christianity: Christ, the Virgin, and the saints. Even among these traditional images, the inclusion of some of the city's patron saints helped to give the paintings a civic meaning. Every city had a pantheon of patron saints. These special protectors were found everywhere, from street corner tabernacles to the coins that citizens exchanged.

Within the town halls there were often chapels, sometimes of considerable size. The larger ones were really like small churches, furnished with an altar, altarpiece, choir stalls, and gates, their walls often covered with frescoes. Painted on the same walls and, in fact, nearly everywhere in the town hall were the coats of arms of the city, its most famous symbol and the heraldric embodiment of its personality and history.

The coat of arms, one of the most important and common types of image found in the Renaissance, was the emblem of family as well as commune. A family's genealogy, power, and status were symbolized by its coat of arms, which hung in its chapel, decorated its armor, graced its maiolica ware, and was emblazoned on another symbol of its power—its home.

The dwellings of the Renaissance family ranged from the humble to the grand.[34] The smaller, poorer homes were probably visually austere, furnished perhaps with just a single devotional image of rather crude quality. Our total knowledge of what must have been an extensive form of popular painting is gleaned from the several surviving examples of this type.[35]

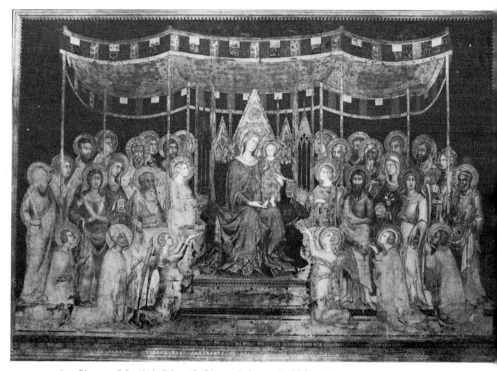

18. Simone Martini, *Maestà,* Siena, Palazzo Pubblico. Fresco. 1315–21.

Simone's large painting is in the major council chamber of the town hall of Siena, the room where the rulers of the city often met. Under an ample canopy decorated with the coat of arms of Siena, the Madonna and Christ sit flanked by rows of saints and angels. In the front rank kneel four of the principal patron saints of the city. A long inscription exhorts the governors of Siena to please the Madonna, for whom the city had a special devotion, with their wise rule. The entire fresco is a remarkable unity of religious and civic iconography.

The larger and more sumptuous dwellings would have contained numerous works of art, many of a highly practical nature. Renaissance furniture, for example—beautifully made, exquisitely inlaid, and superly finished—is the product of superior designers who were also remarkable craftsmen.

The *cassone,* or chest, was often the creation of the combined skills of the furniture maker and the painter.[36] In Renaissance houses (which were without closets), many household and personal items were kept in chests, which varied in size from the dimensions of a cigar box to those of a huge steamer trunk. Carved, inlaid, and painted, these handsome, utilitarian objects have survived in considerable numbers because they became treasured possessions of the families who owned

them. Especially interesting are the wedding chests, often decorated with vivid and exciting narratives.

At the Renaissance table, small bronzes, gold and silver ware, fine glass, and painted maiolica were placed on splendid embroidered linen tablecloths. Stone and terracotta sculpture and reliefs, costly mirrors, combs of ivory, board games, and other luxury items were scattered through the house.

Many of the rooms were extensively painted: imaginary landscapes, heroes of antiquity, geometric patterns, busts of Christ, large images of St. Christopher (which provided protection from sudden death if looked at daily), and scores of coats of arms decorated the walls. Few of these wall paintings have survived, but their type must have been found in hundreds of homes up and down the Italian peninsula. Other paintings—small portable triptychs and larger works, sometimes allegorical or mythological in nature—were also found in various parts of the house. The Renaissance room was alive with ornament and color.

From the second half of the fifteenth century, some of the great palaces had chapels. These were most often for the private worship of the family (and probably the servants as well). Domestic chapels were furnished in the same manner as their counterparts in churches and town halls. Frescoes of various sizes were also found in these chapels; their subjects, as is to be expected, sometimes were of a more personal and private nature than those of the frescoes found in the family chapels in churches.

Commissions for work in private houses were just one of a number of forms of Renaissance artistic patronage. There were at least four major classes of patronage: private, communal, corporate, and ecclesiastical. But in many cases there was really no clear division between the four.

The wealthy private patron commissioned artists for scores of items ranging from frescoes for the church to *cassoni* for the bedroom. The splendor and richness of his house and chapel enhanced his prestige and power. If he were a prince or a duke, then his patronage and his image were of importance far beyond his city: what one commissioned was a fair indication of what one was.

The individual also commissioned works of art for his chapel burial place. He paid for the altarpiece and the fresco cycle that were integral parts of the miraculous religious rites which offered the promise of salvation and eternal life. The wills of many Renaissance patrons explicitly provided for the erection, decoration, and maintenance of the burial chapel and its tombs. If the will was made *in camera* (that is,

on the sickbed), there was often a sense of real urgency about these crucial matters.

In order to be saved and join the ranks of the blessed, the patron had to be free of sin. This excluded hundreds of wealthy merchants and bankers who built and commissioned many of the major chapels. These men were tainted with the sin of usury; from lending money they had made a profit that the Church deemed excessive and, therefore, they had committed a dreadful sin. In reality, it was rather easy to become a usurer because the theological strictures on the subject were so broad and complicated. Nonetheless, hundreds of patrons lived in fear of damnation. Good works—the restitution of money gained usuriously by benefaction to the poor and the endowment and decoration of religious institutions—would, the patrons believed, vastly improve their moral condition. In this view, they were encouraged by the Church.

Altarpieces, frescoes, and other works of art were commissioned, we now see, for many reasons other than aesthetic ones: they added to the prestige of the patron and his family; they were part of the great ritual that was an inextricable part of his spiritual life; and they could, it was hoped, help him escape the damnation awaiting all sinners. Isolated today on museum walls, these paintings and sculptures were once, in fact, laden with a heavy cargo of the individual patron's hopes, fears, and aspirations.

The reflection of the collective desires of citizens, from the most powerful and influential individuals in the city to the poorest members of a minor confraternity, civic patronage was often granted by committees. We tend to believe that art and committees do not mix, that the making and buying of art are highly individual activities, which do not readily lend themselves to group action. Of course, the Renaissance did not believe this. Occasionally, the committee decided only after an artistic competition had been held. Committees, like the individuals who formed them, tended to be pragmatic and tough-minded: they wanted their money's worth. Economy of materials, workmanship, and finish were all important factors in their decision. The period saw the commissioning of scores of important works by committee action.

Works of art that were civic in nature were commissioned not only by government officials but also by the guilds and other powerful organizations. Civic patronage was, of course, most visible in the town hall, the center of government; but it extended much farther afield. Other governmental buildings, the city's gates, walls, and fountains, and some of the major churches were also entirely or partially financed

by the commune. Religious institutions were often dependent on the continuing support of the commune, and committees in charge of both the building and decoration of a number of important churches had a high percentage of laymen among their members. The mingling of the sacred and the secular in Renaissance life is nowhere better seen than in the communal sponsorship of religious buildings.[37]

The committee system of patronage was not just limited to communal commissions—it was also used by many of the multifarious corporate bodies that thrived in the Renaissance. Confraternities, guilds, religious orders, and other organizations needed the skills of the painter, sculptor, and metalsmith. A confraternity might want a processional banner, a guild a statue or an altarpiece, a charitable organization a fresco, and so on. The artists and the works the committees chose are fine indexes of what was both acceptable and in fashionable good taste. The fact that committees were usually composed of senior members often ensured a conservative, traditional slant. The words "conservative" and "traditional" should not be interpreted pejoratively, however, for these committees commissioned works of supreme importance and beauty.

Ecclesiastical patronage was also, by its very nature, often highly traditional. The mechanism of such patronage tended to be quite complex: works of art for a church could be given by individuals, by families, by corporate organizations such as confraternities, by the commune, or by members of religious orders. In all cases, the authorities in charge of the church certainly had to approve what was commissioned and give permission for its installation. They probably also had a say in the choice of subject.

There are a number of cases of what might be called "indigenous" religious commissions: the payment for a work of art by a cleric for a location in his or her church, convent, or monastery. Such patronage was, however, in nature often much like that of the individual commission, an act of religious piety, a good work.

All Renaissance patronage was based on a system very different from our own. There were no art galleries where the patron could simply choose an already finished work of art. Some artists did have a few small paintings for sale in their shops, and sometimes these were bought by merchants with an eye toward resale; but the vast majority of important works were made to order.[38] The system was based on the presupposition that the patron would, to a great degree, tell the artist what to paint or carve or build. Furthermore, he would often decide on the price, tell the artist what materials to use, how big the work should be, and when it should be delivered.

Commissions for art were similar to commissions for other Renaissance objects. Whether they were as large as buildings or as small as portable diptychs, items were contracted for, made to specification and, it was hoped, finished on time. Once the altarpieces and statues were placed in the churches they became something else: sacred objects associated with the mysteries of the religious rites. But while the artist and patron haggled over their price, they were considered goods, commodities. During the later part of the period, certain great artists —Michelangelo and Titian among them—who had begun to break away from the workshop system were allowed (or perhaps created) a degree of flexibility. For most of the Renaissance, however, painters and sculptors were rather rigidly controlled by the artistic legal contract.

Not all works were done on a contractual basis, but most of the larger and more expensive ones were the result of a legal agreement.[39] The nature and extent of many of these contracts can be gauged from one drawn up in 1478 between the Sienese painter Matteo di Giovanni and the bakers' guild of Siena.[40]

Anno Domini 1478, November 30. Antonio da Spezia and Peter Paul of Germany, bakers, inhabitants of the city of Siena, in the street of the Maidens, administrators, as they affirm, elected and deputed for the purpose mentioned below by the Society of St. Barbara which meets in the church of San Domenico in Siena, for the purpose of renting the meeting room and for the work on the painting, in their own personal names ordered and commissioned Matteo di Giovanni, painter of Siena, here present, to make and paint with his own hand an altarpiece for the chapel of St. Barbara already mentioned, situated in the church of San Domenico, with such figures, height and width, and agreements, manners, and arrangements and length of time noted below, and described in the common language.

First, the said panel is to be as rich and as big, and as large in each dimension, as the panel that Jacopo di Mariano Borghesi had made, at the altar of the third of the new chapels on the right in San Domenico aforesaid, as one goes toward the high altar. With this addition, that the lunette above the said altarpiece must be at least one-quarter higher than the one the said Jacopo had made. Item, in the middle of the aforementioned panel the figure of St. Barbara is to be painted, sitting in a golden chair and dressed in a robe of crimson brocade. Item, in the said panel shall be painted two angels flying, showing that they are holding the crown over the head of St. Barbara. Item, on one side of St. Barbara, that is on the right, should be painted the figure of St. Catherine the German and on the left the figure of St. Mary Magdalene. Item, in the lunette of the said panel there should be and is to be represented the story of the

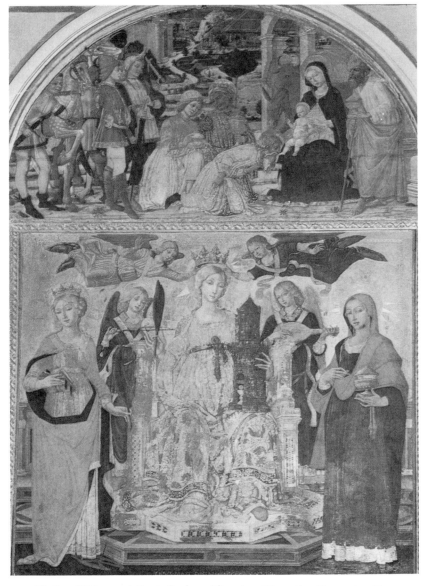

19. Matteo di Giovanni, *Santa Barbara Altarpiece,* Siena, San Domenico. Tempera. c. 1477.

The contract for this picture (see pages 52–54) describes in detail what Matteo had to paint, the materials he was to use, and the amount of his pay. Even within these rather strict demands, quite common in the Renaissance, Matteo has created an original and highly personal interpretation. A good example of guild patronage, the altarpiece was ordered by the bakers of Siena.

three Magi, who come from three different roads, and at the end of the three roads these Magi meet together, and go to offer at the Nativity, with the understanding that the Nativity is to be represented with the Virgin Mary, and her Son, Joseph, the ox and the ass, the way it is customary to do this Nativity. Item, that in the columns of the said panel are to be painted four saints per column, who will be named to the said master Matteo. Item, that in the middle of the predella is to be painted a crucified Christ with the figure of our Lady on one side and St. John on the other, and on either side of this Crucified are to be painted two stories of St. Barbara, and at the foot of the columns of the predella two coats of arms, one on each column, as will be explained to master Matteo. Item, that the said master Matteo has to have this panel of wood made to the measurements mentioned, at his own expense, and have it painted and adorned with fine gold, and with all the colors, richly, according to the judgment of every good master, like the one of Jacopo Borghesi, and have it set on the altar at his own expense, in eight months from now, without any variance.

And all these things for the price of ninety florins, at four pounds the florin, in Sienese money, to be paid to the said master Matteo in this way and at these times, to wit, 25 florins at the present time, another 25 florins at Easter next, 20 florins on the feast of the Holy Ghost next, and the balance, to wit another 20 florins, at the end of the time, and when the said master has completed the painting in every degree of finish, and placed it on the said altar. Done at Siena, in the hall of the notaries' guild, in the presence of bakers of Germany, inhabitants of Siena, witnesses. After which, in the same place, Master John son of the late Frederick, of Germany, at present cook of our lords the Lords of Siena, and Master John son of the late George of Germany, embroiderer, and inhabitant of Siena, promised the said master Matteo to guarantee that the said clients paid the said sums.

From this rather lengthy, detailed, and dry document we can see that Antonio da Spezia and Peter Paul were acting as representatives for the bakers, who had already, probably in a committee meeting, decided on Matteo di Giovanni as their artist. The altarpiece was to be placed in the guild's chapel in the huge brick church of San Domenico in Siena, a location it still occupies.

A good deal of attention is paid to the size of the panel: the guild members were anxious that it be at least as large and rich as an altarpiece already in place in the church. Indeed, the addition of a lunette was included to make certain that the bakers' picture would be at least one quarter taller than its rival.

A detailed set of instructions about the picture's subject follows the sections on size. The altarpiece's iconography had probably been worked out long before; Matteo was here simply to follow instruc-

tions. This was not as constricting as it might seem, for within the framework of standard images and set iconographic types considerable variation was possible. Proportion, narrative construction, the relation of figures to space, much of the color, mood, and many other key aspects of painting were left up to the artist. In fact, a comparison of works of the same subject by several painters or even by a single painter reveals the great variety of Renaissance style and narrative interpretation.

The patron and contract often furnished rather specific instructions on type, size, subject, and the number and identity of saints; but, with only several exceptions, the artist could not be told, nor was he told, how to carve or paint.

The very notion that an artist had to accede to so many of the patron's orders opposes our romantic ideas about art as a cathartic personal expression. These beliefs were, of course, alien to the Renaissance artist. Nor did the artist think, as we do today, that any restrictions would be damaging to the spirit and form of his art. And in truth they were not.

The complicated payment arrangements in Matteo's contract are common. After an advance to the artist, the money was to be given in three payments, the last to be allotted when the picture was finished and installed on the altar. Sometimes the final price was left unsettled until the work was completed and evaluated by the artist's colleagues. As one can imagine, the system created much apprehension and considerable conflict.

The contract for the Renaissance painting was a legal instrument. Artistic creation was shaped by numerous legal, social, professional, and traditional aspects that are now extraneous to our art. Yet out of the contractual agreement arose hundreds of works of splendor and invention, not the least of which is Matteo di Giovanni's wonderful altarpiece for the Sienese bakers. Far from being stultified by these outside dictates, Renaissance artists thrived on them; originality and variation within the boundaries of tradition are among the most striking characteristics of Renaissance art.

It was also common, and traditional, for the patron to worry about the materials artists used. Matteo was instructed to have the panel made and to purchase and use good materials. This insistence on fine materials—the most expensive blues and golds, for example—is found in scores of contracts. The patrons wanted value for their money; they were extremely concerned with the physical, material aspects of the commission. The idea that the artist was a businessman who made a product is quite apparent in these negotiations over material. Patrons

were prepared, indeed eager, to pay a good deal of money; few were spendthrifts.

Materials, like nearly everything else about Renaissance painting, were used traditionally. From the first days in the shop, the apprentice artist learned to handle a limited but nearly perfected range of materials. These, as the contract between Matteo and the bakers demonstrates, were of key importance to the artist and his patron. Moreover, the genesis of a painting or sculpture, the most basic ideas about form, texture, and finish, were conditioned by what the artist held in his hand. It is to this crucial and fascinating part of Renaissance artistic practice that we turn next.

❧II❧
THE MATERIALS OF RENAISSANCE ART

The materials of art have their own logic. When an artist of talent makes a painting or a sculpture, he is always aware of the potentials and limitations of his materials; the better the artist, the more likely he is to know just what he can and cannot do with them. The entire creative process, from first idea to last touch, is conditioned by the physical properties of material.

The Renaissance artist was a master craftsman with a refined understanding of the materials of his art. The need to learn about materials was one of the reasons for the lengthy apprenticeship of the fledgling artist. Each artist had to master a finite range of substances used in his particular specialty. He dealt with simple materials used in combination, but because of a lack of knowledge of their chemistry, a good deal of his work was empirical in nature. Much guesswork and many mistakes were part of even the most sublime Renaissance paintings and sculptures, just as they are in the best modern works.

The Renaissance artist's practical, clear understanding of the nature of his materials was complemented by his marvelous sense of their potential. From their earliest training, artists were taught to think of form and material as being totally fused, parts of a single whole. The great frescoes, panel paintings, and sculptures of the Renaissance are as much about material as they are about form or subject.

When he designed a fresco or a free-standing statue, the artist understood, from long years of experience, that its various forms had to be made a certain way to realize the potential of the chosen material. He knew, for instance, that he could extend a marble arm just so far; he knew that groups of figures in a fresco had to be arranged to allow them to be painted on a series of fresh plaster patches; and he knew all the characteristics of a certain blue pigment he wanted. The very genesis of a work, the strategy for its preparation, and the artist's vision of it as a finished object were strongly dependent on his com-

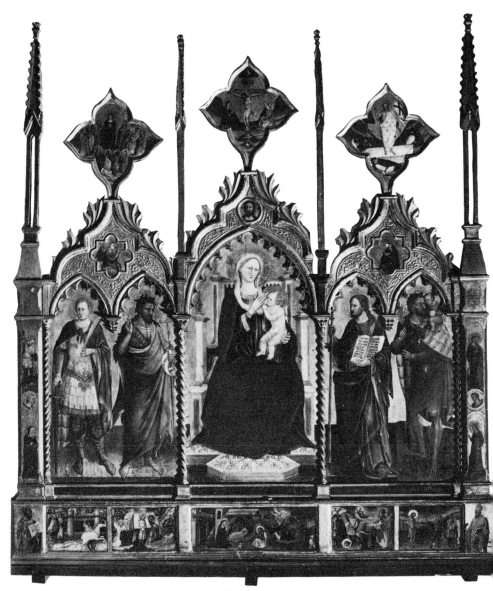

20. Bicci di Lorenzo, Altarpiece, Bibbiena, Santi Ippolito e Donato. Tempera. 1435.

This large, complex altarpiece, complete with pinnacles and predella, is of a type popular in the early decades of the fifteenth century. Each of the saints flanking the Madonna —Hippolytus, John the Baptist, James the Major, and Christopher—is recognizable through physical type, dress, and attribute. Christopher, patron of travelers, for example, fords a stream with the Christ Child on his shoulder, while John the Baptist wears a hairshirt and holds a cross. Christ appears three times: in the central section on the Virgin's arm, in the predella *Nativity,* and crucified in the central pinnacle. Each predella panel illustrates a story from the legend of the saint who stands above it. Note the painted side pilasters.

prehension of the materials used. Each substance—stone, metal, paint, wood—had its own special physical properties, which demanded special approaches.

Renaissance tempera paintings on wooden panels have survived in great numbers.[1] These incredibly sturdy objects are the end result of a demanding, time-consuming process that illuminates many aspects of the cooperative workshop structure.

After the artist was commissioned, either by contract or verbal agreement, he arranged for the manufacture of the panel itself, although in some cases he may have used an already built panel. Generally, the artist does not seem to have had a hand in the actual carpentry; instead, this was left to a carpenter who had the necessary experience, skill, materials, and tools. The panel and its frame were highly prized and costly. It is not surprising to discover that sometimes the carpenter's fee exceeded that of the painter and his shop.

Except for the smallest works, most panels were composed of seasoned boards (poplar was most common) nailed and glued together to form a painting surface. Simple glues of cheese, lime, or animal skin were easy to make and extremely strong. After gluing, the panel was often braced with a series of wooden strips running horizontally across its back.

21. **Vecchietta, Altarpiece (detail of back), Pienza, Museo della Cattedrale. Tempera. c. 1465.**

This illustration shows the construction characteristic of fourteenth- and fifteenth-century wooden panels. Note how the wide planks are joined with glue and then braced.

The carpenter also was responsible for the frame and any wooden ornamentation. During the Renaissance, changing fashion caused a number of modifications in the shape and size of panels; but, as a general rule, the more expensive works were large and heavily decorated, with elaborate frames and other peripheral embellishment.[2]

When the framed panel was delivered to the artist's shop, it was ready for the long process necessary to prepare it for painting. Much of this work, which was of extreme importance, was done by apprentices and helpers under the careful, constant supervision of the head of the shop.

Every surface to be painted had to be clean, dry, and smooth. Consequently, the wood was sanded with the greatest of care and inspected for knot holes and other irregularities; if these were found, they were filled with a mixture of sawdust and glue, and sanded smooth. If nail heads protruded, they were covered with pieces of beaten tin so that no rust would spoil the painted surface.

The next step was to coat the area to be painted with liquid size made from sheep parchment or some other common material. (Some irreplaceable miniatures were destroyed when old, illustrated parchment manuscripts were boiled down to make size.) A thin coat of size was first applied with a large bristle brush and allowed to dry. This was subsequently covered by at least two more coats of a thicker, stronger size. The purpose of these layers was to seal the wood and make a smooth, stable surface for further layers.

Often strips of linen, sometimes worn-out tablecloths of beautiful quality, were torn up and glued to the panel. These formed yet another layer between the wood and the final paint surface. It was important to do all this layering because wood is porous, unstable; it contracts and expands with ease as the temperature and humidity change. A paint film applied directly to wood will, in time, crack and flake with the movement of the panel. Size and linen protect the paint from the wood's expansion and contraction; they also act as a barrier, preventing the wood's moisture from seeping into the paint.

The final preparatory layers were of gesso, a thick, water-based paint made with chalk and size, resembling plaster of Paris. Several coats of liquid *gesso grosso* (thick gesso) were first applied to make the surface even. These were allowed to dry for several days, then scraped and sanded smooth.

Next came one of the most arduous tasks: the application of coats of *gesso sottile,* an extremely fine, slick, thin gesso. The first layer was rubbed on by hand, then each of the successive coats was brushed on before the previous one had dried. After eight or so coats, the panel was taken out to dry thoroughly in the sun.

22. Parmigianino, *A Painter's Assistant Grinding Pigments,* London, Victoria and Albert Museum. Red chalk drawing. c. 1535.

Here Parmigianino (1503–1540) depicts a young assistant, probably his own, grinding pigment smooth. The apron-like clothes seem to have been worn by both master and apprentice.

23. Pesellino, *Mystic Marriage of St. Catherine of Alexandria,* **Florence, Uffizi. Pricked cartoon. Pen and bistre wash. c. 1450.**

This delicate pen drawing was probably used to put in the underdrawing of a small altarpiece. Around the principal lines of the sheet are hundreds of little pinpricks through which charcoal was pounced onto the painting's ground. Such drawings were kept in the shops for study, and sometimes reused.

To make the gesso an even, absorbent surface that would readily take the paint, it was necessary to smooth it. A spatula and tools called *raffietti* (little hooks) were used to scrape the gesso until it was wonderfully sleek. This was a task of great importance—it was up to the apprentices to get the surface so burnished that it looked like ivory.

All this panel preparation was time-consuming and hard; by performing most of these tasks, apprentices both aided the master and learned their trade, so to speak, from the ground up. There was no better way to gain a first-hand knowledge of the materials of their craft.

Once the gesso was dry, the artist was ready to start the complicated process of painting. The first step was to put in the underdrawing. In most cases, this was done by the master himself. He was the one who had been commissioned and it was his responsibility to provide the design. In fact, the similarities in design between works that allow us to identify individual artists derive from these underdrawings. The design of a work—the relationship between its parts—is, in a real sense, the artist's signature.

With charcoal made in his shop, the artist began the design by outlining the forms he wished to paint. When these were delineated, he started to work up tones by putting in the halftones and darks, creating the modeling for whatever he was composing. A feather was used to erase a mistaken or unsatisfactory line. The genesis, planning, adjustment, and clarification of the drawing unfolded as the artist put on more and more charcoal. The whole process was fluid and experimental.

Artists of the first part of the Renaissance—roughly until 1450— seem not to have made many preparatory paper drawings; design work began on the panel itself. This method of design appears to have been largely abandoned during the second half of the fifteenth century. The increasingly complicated narrative, intricate perspective constructions, sharply foreshortened figures, and detailed landscapes of later paintings did not lend themselves to this direct approach. Series of preliminary paper drawings were employed with greater frequency to help the artist. Some of these designs were transferred by cartoons—a sort of stencil—to the gesso. The hundreds of drawings still existing in almost every stage from first idea to completed figure document fully artists' struggles with design. The painter no longer planned his design in full size on the actual panel, but, instead, on a smaller scale on paper.

When it was finished to the artist's satisfaction, the charcoal drawing on the panel (used by all artists regardless of the preparatory methods they practiced) was brushed off until it was hardly visible.

This was necessary because the charcoal would have marred and discolored the paint to be applied over the gesso. Then, with a small, sharp miniver bristle brush and a watery ink, every outline was reinforced. The remaining charcoal was swept away with a feather and the entire drawing worked over with ink washes.

At this stage, the panel was ready to be gilded. Many of the tempera panels of the Renaissance employed at least some gold, either in the haloes or for decoration of the costumes; often, especially in the earlier panels, gold was used as a background to the figures. The Renaissance painting was frequently an early form of conspicuous consumption: patrons wanted the best blues and the most expensive gold, sometimes

24. Florentine, *Madonna del Giglio,* Florence, San Giuseppe. Tempera. Early 16th century.

This detail of the Virgin and Child shows the *back* of the paint film after the removal of the wooden support and ground. Now visible are the painter's careful strokes delineating the forms covered by paint. Such skillful, sure drawing is the result of years of apprenticeship.

quite a lot of both. The religious image was precious in both the spiritual and the physical senses.

Gilding was done by a craftsman who specialized in working with beaten gold. In the artist's shop, he began by outlining the figures and other objects not to be gilded with an incised line. These incisions, which can still be seen on many tempera panels, helped separate color from gold.

Next, the area to be gilded was covered with bole—a variety of easily pulverized reddish clay mixed with size. Often the gesso under the parts to be gilded was roughened slightly to allow the gold to reflect more light and, consequently, appear richer. The bole was not put on in a single application, but spread slowly layer by layer—up to eight layers were not uncommon. It was then allowed to dry before being polished with a cloth. The reddish cast of the bole imparted a depth to the thin, almost translucent leaves of gold placed upon it by the gilder.

Many sheets of gold could be beaten out of a single gold coin, 100 leaves out of just one ducat. These leaves seemed to have averaged about 8.5 centimeters square and weighed about half a troy grain.

Each leaf was overlapped by its neighbors along the edges and all were pressed into the wetted bole with a piece of cotton. When the gold was almost dry, it was burnished. This was done with great skill and care, for the final polishing of the gold gave it a lustrous quality. Often the gilder burnished a certain way for gold that would receive light from a source above, and another way for a gilded surface destined to be lit from the side. When burnished, gold has a richness and depth that enlivens the entire picture.

The gold was frequently decorated by scored or punched patterns. Artists' shops were equipped with a number of simple punches that when combined would make patterns, sometimes of considerable complexity. Great originality is found in these punched decorations, which were done with amazing skill.

Gold appears often in tempera panels in the details of costumes, on architecture, in haloes, and in many other areas. When seen by flickering candlelight in a dark church, the gilded tempera panels gleamed and glimmered in a way that is now hard to imagine. Of course, artists knew this, and they planned their compositions and the areas to be gilded accordingly.

With the completion of the gilding, the artist was ready to paint. The exact chemical composition of many Renaissance pigments is not known, but it is safe to say that until the late Quattrocento, most of the panel paintings were done mainly in tempera. In tempera painting,

25. Sassetta, *St. Francis Before the Cross,* Cleveland, Cleveland Museum of Art. Tempera. 1444.

The background gold of this panel, originally part of a large altarpiece in Sansepolcro, has almost all fallen away. The shape and size of each of the beaten gold sheets is now marked by traces of gold where the sheets overlapped, forming a double thickness that has remained on the panel.

the vehicle—the substance that carries the pigment and adheres it to the support (gesso, in the case of tempera)—is egg. Egg has many good properties: it is cheap, readily available, dries fast, and is easy to store and keep clean. It is also extremely durable, as anyone who has tried to clean dried egg off a plate has discovered. Moreover, tempera does not fade: if they have been cared for, panels painted over 600 years ago remain nearly as lustrous and brilliant as the day they left the workshop.

Egg yolks, and occasionally the whites as well, were mixed with water and ground pigment. Depending on the amount of water, the viscosity of the mixture varied from thick to extremely thin. Sometimes a little vinegar was added to preserve the yolk and reduce its natural greasiness.

Pigments had to be ground to a paste before they could be added to the egg-water mixture. They were difficult to apply, so artists needed to be well versed in their preparation and handling. Each color had its own characteristics and properties; only the knowledgeable painter could apply it with enough skill to utilize its potential. During their apprenticeship, artists spent many hours learning to identify, grind, and blend the scores of common colors. Moreover, as they assisted the artist in the actual painting, they learned how to apply color.

Colors came principally from mineral and vegetable extracts and manufactured salts. Minerals, berries and flowers, insects, metal oxides, copper acetate (formed by placing copper over vinegar), and scores of other materials were used for pigments. Painters did not process most of the raw materials that went into the making of color, but, instead, bought them from the *speziali* (druggists) who used them in preparing some of the hundreds of Renaissance drugs and salves.

When the artist decided on his colors, he would grind and mix the required pigments. These were suspended in the egg vehicle, then applied with brushes made out of either miniver, hog, or other animal fur or bristles (of varying size and shape). There was a considerable brush lore—each artist had his own preferred material, shape, and size for any given task. There must have been a brisk fur trade just to keep the painters in brushes.

The actual application of tempera was a difficult task. Because of the gesso's absorbency, the medium's viscosity, and its quick drying properties, broad, speedy brushstrokes were impossible. Instead, the artist worked with small brushes, putting in one limited area after another, carefully controlling his strokes and the amount of pigment on his brush.

Tempera painting, by its very nature, does not encourage the artist to think in terms of massive, broadly painted forms. Instead, it fosters the painstaking construction of clearly delineated shapes and the inclusion of considerable minute detail. Most artists working in tempera have painted this way—Giotto and Masaccio are two remarkable exceptions. Tight control and meticulous execution are almost always the trademarks of tempera painting. The feel of the material, how the brush holds and releases the paint and the way the paint sets and dries, all encourage a specific way of thinking.

When well preserved, the surface of a panel painting done with tempera is hard, extremely smooth, and luminous. There is a dense brilliance about the colors, which are often built up by glazing—the application of translucent layers of paint one upon the other over the white gesso.

Often layers of different colors were used to produce a single hue. A surface red, for instance, might overlay coats of different reds, yellows, and other colors; sometimes, gold and silver were used as underlayers. By glazing in this complicated fashion, the artist could achieve effects of great variety and subtlety. Light reflecting from the white gesso ground outward makes the various layers take on a special quality that gives certain passages a glowing richness unlike any other type of painting.

Delicate highlights of white lead pigment and a network of tiny finishing brushstrokes were applied to the surface of the tempera painting. Then the work was allowed to dry thoroughly—a year was considered desirable, if not always practicable—before varnish was applied.

Today, it is unusual to find Renaissance tempera paintings perfectly preserved.[3] This is unfortunate, because damage distorts the artist's original intention. Of course, this holds true for all works of art, but it is especially regrettable in a tempera painting that originally possessed a surface of great refinement and colors of exceeding brilliance.

Throughout the centuries, overzealous varnishing has distorted hundreds of tempera panels. Any sort of varnish, including the original Renaissance type, tends to dampen color; but too much varnish, or varnish allowed to penetrate the paint and become dirty, can change a color completely. The blue of hundreds of Madonnas' robes, for instance, is azurite, which, when penetrated by varnish, changes to black; this transformation has occurred in the majority of cases. Other colors are also susceptible to similar mutations.

Equally damaging is over-cleaning. Panels were often placed upon altars that held burning candles. In just decades, the dirty, discoloring

26. Florentine, *The Virgin Adoring the Christ Child with the Young St. John*
(detail), Bloomington, Indiana University Art Museum. Tempera. c. 1475.

This close-up of a well-preserved tempera panel shows the smooth, enamel-like surface
of the medium. Painstakingly painted in many coats, with a small brush, the tempera
dried quickly to form a hard, impervious surface. Tempera is a demanding, difficult,
delicate substance, best suited to rendering fine details.

27. Pigment Cross Section.

This drawing of a cross section of pigment sample from a Sienese painting of the fifteenth century, studied with an electron microprobe, reveals that many thin layers were used to build up the yellow color of a saint's robe. Red ocher (b), gold leaf (c), yellow (e) and white lead (d) underlie the final surface; there is also an alternation of tempera layers with oil. Such a complicated, painstaking process demonstrates that the artist was well aware of the translucency of his paint.

smoke dulled and distorted their surface. Unfortunately, until very recent times the candle soot was removed by rubbing the panels with harsh abrasives. This destroyed the finely painted upper layers—the intricate network of delicate line and the subtle modeling that added vitality to the surface.

In many cases, years of rubbing have taken off several layers of paint. This is seen most clearly in the faces, where green underpaint had been utilized to build flesh tones. After harsh cleaning, the upper layers of flesh color have been removed, exposing the green tone; many times the entire appearance of the face is altered.

Much damage also has been done by incompetent restoration. Until the twentieth century, restoration almost always meant repainting. Pictures and statues were made to look new. Wherever there was damage or wear, regardless of the extent, new paint was applied. When

a picture or statue left the restorer's studio, it literally looked brand new—the authentic original appearance of the work was simply not taken into account. Thousands of works, from all periods, were treated in this fashion. The more famous and important a work, the more likely it was to receive this kind of misguided attention.

Nearly all Renaissance tempera panels have areas of repaint. Old restorations and the attempts of modern picture dealers to improve their wares have taken their toll. Other unretouched damage incurred in the half millennium since their completion is also apparent on most Renaissance paintings. Consequently, the observer must try to discover what is original and what is not, a task of some difficulty but considerable visual rewards.

Another hindrance to the experience of the work's original appearance may be detachment from its original setting. The churches for which many of the panels were destined were dark. Thus the necessarily bright colors of well-preserved panels and their considerable areas of shining gold appear washed out under museum lighting. In the few instances where altarpieces remain in their original site and are still lit by candles, we are struck by how brilliant, glittering, and ethereal they look in the light of the small, bright flames the Renaissance artist thought would always help illuminate his picture.

From an early date, many artists used oil as a vehicle in small parts of their tempera paintings, but both the development of the oil medium and its early history are mysterious. Oil glazes over tempera were probably common during even the earliest stages of development of Italian panel painting. They must have imparted unique, highly desirable surface and color characteristics, but, until around 1500, oil was seldom used as the primary medium. From the beginning of the sixteenth century, however, oil rapidly replaced tempera as the most common medium for paintings other than frescoes.[4]

Old histories of art theorize that oil painting was an invention of Jan van Eyck of Bruges and that it was introduced into Italy by the enigmatic Antonello da Messina (c. 1430–1479), who may have learned it from Netherlandish paintings in Naples. Today, this idea seems too simple: there is now evidence, both textual and chemical, that oil was used in tempera painting and well known to artists of earlier centuries. Nor do artists utilize mediums or techniques simply because they are newly invented. Frank Lloyd Wright did not use reinforced concrete to make certain forms solely because he wanted to experiment with the material nor Jan van Eyck oil just because it was at hand. Rather, artists seek, select, and use the materials that will allow them to express their visual ideas most fully. The relation between materials and artistic

intent is powerful indeed; the more talented an artist, the stronger the connection usually is.

Oil became increasingly popular because it allowed a freedom of form and technique alien to tempera. Beginning in the late fifteenth century, a style of painting emerged that was extremely volumetric, spontaneous, fluid, and monumental. Some artists working in tempera tried, without great success, to accommodate their technique to the new style, but tempera lacks the breadth and boldness possessed by oil—it is a more demanding, less flexible medium. It also dries so fast that mistakes are hard to correct and, more importantly, changes are not easily accomplished. Conversely, oil is one of the most malleable painting materials.

In oil painting, as in tempera, pigments are ground to a paste, but they are then mixed with oil instead of egg. This oil, usually linseed or walnut, has a number of important characteristics: it dries slowly (consequently one fluid layer can be worked into another); it allows the utilization of a larger, more loaded brush, which can be broadly and swiftly deployed; and it imparts, through glazing, a particular color and surface quite different from tempera. It also permitted a greater range and depth of color, especially in the darks, and a better control of overall tonality.

The earliest examples of the use of oil are found on panels painted primarily in tempera. As oil emerged as a more or less independent medium, it was still used on a gessoed panel, just as tempera had been. The first artists who experimented with oil were trained as tempera painters and they all must have been strongly influenced by the tempera technique. But as oil became increasingly popular in the early sixteenth century, the gessoed panel gave way to a cloth support, usually canvas. Canvas was lighter, and, since it could be rolled up, was easy to store. Because canvas is less affected by changes in temperature and humidity than wood, it is a sturdier, longer-lasting support. Wood often moves so much and so quickly that it separates from the gesso and paint layers, while canvas is much more stable. Canvas also has a "tooth" or roughness formed by the weaving. This holds the oil well and imparts a surface texture that can enliven the painting. The tooth, which is very different from the smooth surface of tempera painting, can be varied by the choice of material, weaving, and priming.

Painting on canvas requires far less preparation than tempera—the construction and the layer-by-layer buildup of panel painting was enormously time-consuming and laborious. The ease of painting with oil on canvas was certainly one of the secondary reasons that attracted artists to the medium.

28. Andrea del Sarto, *Holy Family with the Infant St. John,* New York, Metropolitan Museum of Art. Oil. c. 1530.

Painted in oil on wood, this picture was probably commissioned by the Florentine noble Giovanni Borgherini. Visible throughout the work are sweeping passages of a brush heavily loaded with oil. Layers of colors worked into each other impart a light and liquidity impossible with the older, less flexible tempera medium.

29. Palma Giovane, *St. John the Baptist Preaching* (detail), Bloomington, Indiana University Art Museum. Oil. c. 1595.

This detail shows clearly the texture or "tooth" of the canvas. In some areas—for example, around the man's right eyebrow—the priming is left uncovered to form shadow. Note also how a loaded brush has rapidly put in the sleeve in the upper right corner. The extensive and complex workings of the artist's hands are everywhere apparent.

Canvas was too rough and porous to receive pigment directly; it had to be first sized and then primed. The priming, often made with oil, lead white, and glue, but sometimes colored by other pigments, was an important step because it furnished an undertone upon which the artist painted. No longer restricted to just the white of the prepared gesso, he could choose a much wider range of colors. Often a dark priming would make the colors appear brighter than they would seem over the white gesso. The priming, or ground, could also form a sort of middle tone between dark shadows and highlights. There was, in other words, a new approach to the construction of the picture.

Building on a design put in with charcoal, or occasionally doing away with the underdrawing altogether, the painter began modeling his figures and landscapes by laying down darker and lighter tones on the prepared ground. Transitions from highlights to shadows were achieved by blending the tones at their borders. Everywhere there was glazing and blending, until no surface was truly unmodulated. The touch of the hand is always apparent, conveyed by the brush, the palette knife, or the fingers. In the hands of a knowledgeable and talented artist, oil painting was capable of an amazing coloristic brilliance and fluency. Its colors, complicated, subtle, and glowing, held a wondrous, deep light.

Oil painting is not tempera painting in another medium; the very basis of its structural language is different. It is an art of large forms, modeled with delicate halftones. There is a quickness about its execution and planning that is extrinsic to tempera. Some of the greatest tempera artists—Giotto and Masaccio, for example—were masters of the broad, monumental image, but they saw beyond the inherent limitations of their medium, and perhaps helped create the stylistic climate that led to the development of oil painting.

Oil is a malleable substance that encourages the artist to be spontaneous. He can blend and glaze with a freedom and thoroughness impossible with tempera. The work can be left for days and then resumed with ease. Oil gives the artist the freedom to make mistakes, to change his mind a hundred times, and to realize his artistic vision quickly.

Moreover, oil lets the artist create a new type of surface. Many painters, but especially those of the Venetian school, no longer tried to mask their brushstrokes. The evidence of the brush—the mark of the artist's hand—remains to show the dynamic process of painting. In a very real sense, the onlooker was now able to see not only the finished painting but the many steps leading to its completion. From the ground to the last fluid brushstroke, the hand and mind of the

artist at work were now visible. This new attitude toward revealed creation is, of course, a concomitant of the rise of the artist as a distinct and special individual, a divinely inspired creator.

The third great painting medium of the Renaissance was fresco.[5] Like oil and tempera, it was known well before the Renaissance, being practiced in Greece and Rome and other parts of the ancient world. Because of its usefulness for quickly and economically decorating the large, unbroken wall surfaces so characteristic of Italian buildings, fresco found special favor in the peninsula. There, starting around 1300, it underwent an unparalleled development into the sixteenth century.

Apprentices were essential for the making of frescoes. In tempera and oil painting, they helped to prepare the support, and in many cases took part in the actual painting, working from the master's designs and under his supervision.[6] In an artistic world where there existed no individuality in our sense of the word, this was only natural and right. But even the largest panels and canvases are small compared to most frescoes. For these the entire shop was mobilized, especially when a chapel or other big project was under way. Such large-scale paintings demanded much equipment and considerable skill, learned only through years of study in the workshop; the fresco is the quintessential product of the collaborative system that is Renaissance art.

Because Renaissance frescoes were done on walls, these surfaces had to be prepared thoroughly before painting could begin. The first task was to erect scaffolds, wooden frameworks holding platforms of planks on which the painters stood. Working on a large wall, it was necessary to shift the scaffolds and platforms around so the artist would have access to the entire area to be painted. The platform also had to be large enough to accommodate the apprentices and all the equipment needed for the job—brushes, paintpots, buckets, and odds and ends. Although they must have supervised their construction, making sure they were the right height and were in the correct places, the artists did not actually erect the scaffolds. This job was usually given to outside workmen. Many times the holes in the walls originally used to hold the scaffolds of the masons were reutilized for painters' scaffolds. After the painting was finished, it was difficult to close these holes, and we can often see today exactly where the scaffolds were placed.

Most of the stone or brick walls were highly irregular. Before any painting could begin, it was necessary to make the wall surface relatively smooth and to ensure that it was protected from moisture, the great enemy of fresco. Sometimes waterproofing was accomplished by

30. Girolamo del Pacchia, *Mystic Marriage of St. Catherine of Alexandria* (detail), Siena, Pinacoteca Nazionale. Oil (unfinished). c. 1520.

This work by a minor Sienese artist, active in the early sixteenth century, was for some reason never finished. In many places—the Madonna's cloak, the lower parts of Christ's garments—the priming and the underdrawings are still visible. In several passages, one can see how the artist began to work one layer of paint into another as he built toward the completion he never achieved.

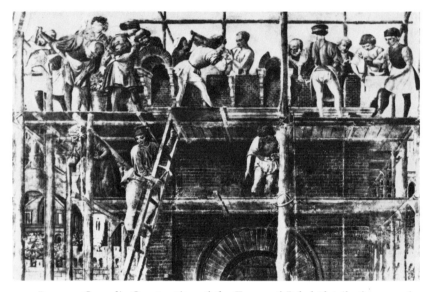

31. Benozzo Gozzoli, *Construction of the Tower of Babel* (detail of a now destroyed painting), formerly Pisa, Camposanto. Fresco. 1467–84.

In this detail from a large fresco, the artist has depicted a type of scaffolding very similar to that used by painters. The masons work on planks carried by timbers placed into the wall itself. The entire framework of the scaffolding is braced by large logs lashed to the platforms. A vivid picture of Renaissance fresco painters at work can be had if one imagines them, instead of the masons, on these scaffolds.

attaching a series of thin, woven reed mats to the walls. These, it was hoped, would provide a barrier between the damp wall and the layers of plaster covering it.

A thick, rough coat of plaster was then applied either over the vapor barrier of reed mats or directly onto the wall surface itself. The plaster covered the rough stones and bricks of the wall, filling in the cracks between them. Called the *arriccio,* this first coat was needed to smooth the wall and make it suitable for painting.

Although there exist records of the work being executed by men from outside the shop, artists must often have done their own plastering. Cennino Cennini gives rather complete instructions about plastering, including how to make and apply it, so we can be certain that the apprentice learned how to handle a trowel. He must have known how to mix plaster, how much to put on, and when to work it, for the drying of plaster was a key factor in fresco painting. But whoever did the work, it had to be skillful. The consistency of the *arriccio* plaster had to be controlled carefully and the plastered wall surface made

smooth, but not so smooth that it lacked tooth, the roughness that would hold yet another layer of plaster.

Working on the dried *arriccio* with the aid of plumb lines, a compass, and a level, the artist determined the center of his composition and found true horizontal and vertical. It was, of course, necessary to ascertain these crucial bearings before any composing could begin. As with tempera panels, composing was at first done on the actual surface to be painted. The genesis of most frescoes painted before about 1450 occurred as the painter stood before the dry, freshly plastered wall. During the second half of the fifteenth century, such *in situ* composing became rarer as cartoons and drawings were increasingly utilized. But for a great part of the Renaissance, the artist's first pictorial thoughts were recorded on the wall itself. Certainly, there must have been some limited use of paper for notation, even though few early drawings can now be connected with frescoes. The patron might have wanted some idea of how the finished fresco was to look, and the clergy may have wished to check the artist's interpretation of holy figures and scenes, but they were probably shown only sketchy drawings that gave just an approximation of the finished work.

The earliest marks on the *arriccio* were made with charcoal, the same material used for the underdrawings on tempera panels. Because it was first necessary to block in the composition and to determine the size and relation of the objects to be represented, the early drawings on the plaster were extremely sketchy. In the case of an unusually talented, experienced artist, the charcoal drawing often did not proceed beyond this initial mapping-out stage. For the most part, however, further drawing was in order. The positions of objects in space, the details of figures and architecture, and the overall tonality were often indicated, all important guideposts for the next stages of the painting.

When the composition was worked out to the artist's satisfaction, he began to go over the charcoal drawing with a brush loaded with a red ocher dissolved in water; the resulting brush drawing is termed a "sinopia." After the sinopia had dried, the charcoal was brushed off, leaving only the network of red line, a process analogous to the removal of the charcoal in the underdrawing of a tempera painting.

Sinopias are of many types. Many are extremely free, sketches dashed off rapidly, indicating only the barest outlines and positions of the objects to be painted. A number of these are masterpieces that appeal especially to the twentieth-century taste for the spontaneous act of creation. These impulsive works are probably based on equally impulsive charcoal underdrawings.

At the other end of the scale is the meticulously finished sinopia,

32. Masolino, *Saint* (detail), Empoli, Sant' Agostino. Sinopia. 1424.

The rough, grainy character of the *arriccio,* the first layer of plaster, is seen here. Also visible is the high quality of Masolino's preparatory drawing. The figure's body, head, facial features, and hair are put in with an economy, clarity, and rapidity that are astounding. Masolino's fresco no longer survives.

complete in the smallest detail; occasionally, one even finds the names
of the planned colors entered on the drawing. Many of these under-
drawings are really completely finished works, even including the
tonality of the fresco to be painted.

Such sinopias were probably made for the apprentices, who would
need rather complete drawings to follow as they helped with the actual
painting. These drawings were like a map used by them to find their
way about the fresco. The less detailed, freer sinopias were probably
guides for the master himself, who had a good deal of experience with
fresco painting and a well-focused idea of what the final painting
should look like. In any case, he could probably improvise much better
than the less experienced students under his direction.

Between the extremes of the loose sketch and the highly finished
drawing exist hundreds of sinopias with varying degrees of detail.
Even the sinopias of a single artist vary in execution. Each commission
presented slightly different problems to be resolved in the sinopia: on
occasion, a painter had to spend considerable time working out an
unfamiliar pose; sometimes, a composition demanding a close study of
light and shade made the artist labor over sinopia washes. The artist's
working method itself changed as he gained experience in wall paint-
ing.

Fresco painters practiced on the wall. While standing on the scaf-
folding, they made practice drawings with charcoal and sinopia on the
plaster. Some of these have been uncovered and proved totally un-
related to the fresco that covered them. Almost all reveal a casual,
empirical working out of problems, indicating that their authors were
gaining experience and improving technique as they drew. Many of
the drawings have a remarkable freshness, charm, and occasionally
humor. Together, they are a precious record of the formation of style
and pictorial ideas, allowing us an intimate glimpse into an almost
completely hidden aspect of Renaissance creativity.

Perhaps because early Renaissance artists drew on the walls for
practice, and developed an acute sense of scale, their works have a
marvelous relation with the surrounding paintings, as well as with the
architecture of the buildings they grace. There is a finely wrought scale
and proportional alliance, both between the objects in the individual
frescoes and between the various paintings of a fresco cycle. Each
fresco stands in harmonious relationship to the size and shape of the
wall it occupies. Seldom in the history of art has there been such a
happy marriage of decoration and surrounding space.

Toward the middle of the fifteenth century, the increased complex-
ity of pictorial space resulting from the more frequent use of compli-

33. Bicci di Lorenzo, *Madonna with Four Saints,* Ponte a Greve. Fresco and sinopia. c. 1430.

The rather carefully worked-out sinopia of this tabernacle (note the modeling with sinopia wash to work out the tonality) was heavily modified in the fresco. The angles

were suppressed, the Madonna's gesture modified, and the saints completely changed. Such major variations between sinopia and fresco are quite common.

34. Veronese, Sinopia Studies, Verona, Arco di Aventino Fracastoro. c. 1400.
These precious sinopia sketches have nothing to do with the fresco that covered them.
They were probably made by apprentices as a form of drawing exercise. Especially
interesting are the studies of hands, recording the artist grappling with a difficult visual
problem. Such studies executed right on the wall must have been common.

cated one-point perspective constructions, the desire for a more de-
tailed, crowded, complex narrative, and the increasingly sophisticated
foreshortening, all compelled fresco painters to plan their works on
paper. Many types of drawings were used: quick notations for the
overall composition; figure studies; landscapes; detailed sketches for
parts of individual objects. Once the artist had worked out all the parts
to his satisfaction, finished drawings of the whole or parts of the
composition were made. Toward the end of our period, this was done
on squared-up paper. The grid allowed the artist to transfer and pro-
portionally enlarge the drawings to full-size cartoons that had also
been squared up. These cartoons, sometimes pricked around the out-
lines of forms, were placed against the wall. Charcoal was pounced
through the small pricked holes in the cartoons, or the plaster was
scored with a stylus through the outlines. When the cartoon was
removed, an accurate record of the drawing remained on the wall.

The entire process is analogous to the use of drawings and cartoons
for panel and canvas, with one major difference—the panel, the sur-
face to be painted, was in the workshop where the artist could con-

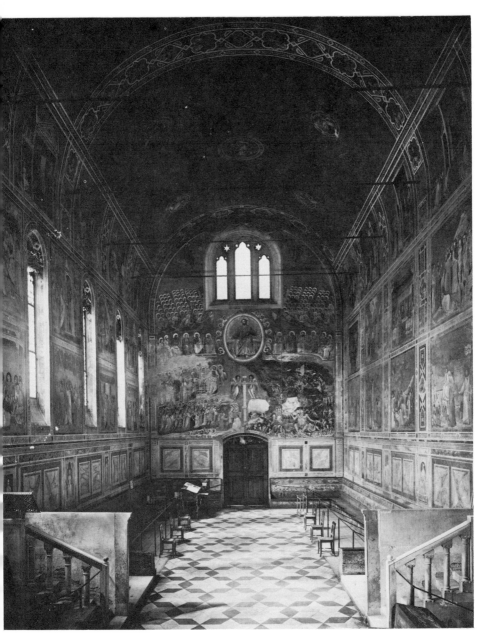

35. Giotto, Arena Chapel, Padua. c. 1305.

When Giotto first stepped into the Arena Chapel in Padua, its walls were blank. The entire painted interior of the chapel—its articulation, color, and form—is his creation. Like all great fresco painters, he kept the overall unity of the large room foremost in mind. The result is one of the most harmonious and beautiful interiors ever painted.

86

37. Andrea del Castagno, *The Resurrection,* Florence, Sant'Apollonia. Sinopia. c. 1450.

The angels in this celebrated sinopia have been traced from cartoons probably made from drawings using standing apprentices as models. The resulting cartoons were then turned horizontally and applied to the wall. Consequently, the sinopia angels appear applied and have only a tenuous spatial relation with the figures below.

36. Jacopo Pontormo, *Angel of the Annunciation,* Florence, Uffizi. Black and red chalk drawing. c. 1528.

Pontormo's squared drawing was used to transfer the angel to a cartoon for a fresco in the Florentine Church of Santa Felicita. Using the squaring-up method, artists could enlarge or reduce images with ease in their own shops. A long series of preparatory drawings often lay behind the final drawing used for the squaring up.

tinually refer to it. By using the fresco cartoon, it was not necessary to conceive and work up a composition *in situ* on a distant, cumbersome wall.

This change in working procedure created a subtle shift in the fresco's relation to its environment: from the middle 1400s on, frescoes are more independent of their surroundings. Because they are designed in the shop, they do not harmonize as well as earlier frescoes did with nearby paintings, nor with the walls on which they are painted. They are more like a series of isolated easel pictures. Such modification does not signify a loss of quality but, rather, represents a basic change in the ideation of the fresco. Remarkable frescoes, of course, were produced after the middle of the century; one has only to think of Michelangelo's Sistine ceiling paintings. Yet, in many ways, that earlier period when inspiration and genius crackled as the artist stood facing the blank wall was the golden age of the fresco.

Whatever way the sinopia was worked up, it was necessary to cover it with one more layer of plaster. The fresco technique (known as *buon* or true fresco) could only be done on wet plaster. When the pigment suspended in lime water was put on wet plaster, a permanent chemical bond between color and plaster occurred. Without this crucial bond, the pigment would not adhere properly, and in time would flake off the wall.

Patches of new plaster (the *intonaco*) of varying size were put over the *arriccio,* masking parts of the sinopia. The patches were applied and painted from top to bottom, so that drips and runs would fall on the unpainted wall below. Because it was necessary to cover no more than could be done in a single painting session, each patch *(giornata)* was a different size. If, for instance, an important, highly detailed face was being painted, a small patch would be put in; but if the work centered on a mountain or some other equally undetailed object, then a much larger area could be plastered, because the painters could work more quickly. An examination of the painted surface under raking light reveals that almost every fresco is a crazy quilt of *giornate,* some tiny, others quite large.

38. Piero della Francesca, *Dream of Constantine,* Arezzo, San Francesco. Fresco. c. 1455.

The white lines mark the boundaries of the individual plaster patches of the fresco's *intonaco.* Working from the top down, Piero painted the picture in patches of varying sizes. Patches 3, 9, and 4 are large because they contain, for the most part, little detail. Others (6 and 8, for example) are considerably smaller because Piero had to paint important heads on them. Patches 4 and 9 roughly follow the outline of the tent flaps so that the structure's color could be contained within them.

But the patches could not just be painted at any time. The degree of wetness of the plaster affected the final tone of many pigments. To understand this key problem constantly confronting the fresco painter, let us take a hypothetical case. A brown pigment when applied to a patch ten minutes old will dry to a certain value. But if the same pigment is put on another patch that is, say, half an hour old, it will dry to quite a different value than on the fresher patch.

If a particular color runs across two or more patches, it is imperative for the artist to paint both at the same stage of wetness—a difficult task because of changes in atmospheric humidity and temperature from hour to hour and day to day. If the artist miscalculates, the color will change from patch to patch and the fresco will be marred. Once a mistake is made, it can be corrected only by chipping out the plaster and replastering. If the artist paints over his error once the wall has dried, the unbonded overpaint will eventually fall off the wall.

The essentials of good fresco painting—skillful plastering, a complete understanding of the drying process of plaster, and a full knowledge of pigments—make it one of the most dramatic and demanding mediums in the history of art. The artist must work with speed and coordination. Often standing high above the ground, he and his assistants had to get the patches laid in and painted before the plaster dried. It was always a race against time. One can imagine the bustle and noise as the shop workers stood on the scaffold amid trowels, buckets of plaster and water, dishes of paint and brushes. Falls were common, and legend recounts the death of at least one painter in this way.

As the *intonaco* was put on, the artist roughly retraced on it the sinopias that had just been covered by the patches. The remaining areas of uncovered sinopia on the *arriccio* and the parts of the already painted fresco served as guides, both to scale and proportion, for the new drawing on the fresh plaster. If he was using the cartoon method, the painter put the appropriate paper drawing against the wet *intonaco* and pricked or incised its outlines on the plaster. This easier method eliminated completely the more spontaneous sinopia on the *arriccio*.

Occasionally, the new drawings on the *intonaco* were used also to further determine the tonality of the fresco. These tonal drawings are bold washes of red pigment, which modified the colors laid over them. Fresco, like tempera and oil, can be glazed to impart a delicate freshness and transparency to the surface. This surface is, moreover, always over the bright whiteness of the plaster which, like gesso, modifies the colors placed upon it.

After the drawings were in place on the *intonaco* patch (and while the plaster was still wet), the artist used a large brush to apply the pigment

39. Central Italian, *Rea Silvia Buried Alive,* Foligno, Palazzo Trinci. Fresco. c. 1430.
Much of the *intonaco* of this fresco has fallen away, leaving the underlining sinopia exposed. This fresco now demonstrates vividly the relation between the preparatory drawings and the final plaster layer *(intonaco)*. Here sinopia and painted image correspond to an unusual degree. Often the sinopia served only as a loose guide.

dissolved in lime water. With big, sweeping brushstrokes he rapidly covered large areas of the hard, absorbent, grainy wall with the fluid pigment mixture.

Everything about fresco painting—the rapidity, the scale, the brushes, the nature of the vehicle—encouraged a quick, monumental, free treatment of both composition and surface. Wall painting is as much decoration as narration, and in even the most complex cycles filled with many stories and figures, the decorative breadth, boldness, and visual excitement of fresco are always present.

Almost all buon fresco paintings contain some tempera. Many of the extremely fine details could not be applied on the fluid, wet plaster

and, consequently, had to be put on after it had dried. Many details of costume, face, landscape, and architecture originally were done with tempera. This paint is not as permanent as buon fresco and flakes with age, robbing the frescoes of their enlivening detail. Blue, a color often used, was not completely soluble and could not be applied to the fresh plaster. Mixed with size rather than egg (which turned it green), blue was painted on after the plaster dried. Consequently, most of the surviving frescoes are bereft of large areas of blue sky, revealing patches of the red underpaint used as ground.

Not all frescoes were done mainly in buon fresco; many were painted upon the dry wall. This method, called *fresco secco* or dry wall painting, was less permanent, but probably cheaper and faster. The wall was prepared with a coat of plaster like the *intonaco* of buon fresco, although somewhat grainier. On sizable frescoes the large, horizontal patches of plaster so characteristic of fresco secco are still visible.

Fresco secco was much less difficult, because it freed the painter from the worrying time pressure of buon fresco. The pigment was applied with an egg vehicle (sometimes the white was used) or with an adhesive made with lime. Secco was, in many respects, similar to tempera painting. The artist built his composition slowly and with care. Fresco secco must have encouraged him to think in terms more appropriate to tempera painting than to buon fresco. More detailed, fragmented composing is often found in fresco secco pictures; many lack the sweep of the artist's unceasing struggle against the drying plaster.

Most of our knowledge about frescoes is of recent origin. Ironically, the destruction caused by World War II and, two decades later, by the flood in Florence of 1966, increased our knowledge of the technical and artistic aspects of wall painting one hundredfold. The need to preserve and restore the scores of damaged frescoes led to the invention and utilization of new methods of conservation. These in turn dramatically revealed much about the nature of fresco.

In many cases it was necessary to detach the fresco from the wall —something the Renaissance artist would have thought impossible. To do this, an ingenious method was developed: an incision is made

40. Giotto, *Scenes from the Life of St. John the Evangelist*, Peruzzi Chapel, Florence, Santa Croce. Fresco. c. 1330.

In these three frescoes, the horizontal white lines are drawn to show the large divisions of plaster (called *pontate*) characteristic of fresco secco. A comparison with fig. 38 demonstrates the differences in the plastering of true (buon) fresco and fresco secco. Each of the rough squares below the white horizontal lines traces the locations of the beams set into the walls to hold the scaffolding platform on which the artists stood (see fig. 31).

around the fresco to separate it from the surrounding wall. If the fresco is large, several cuts are necessary so that it can be lifted off in a number of manageable pieces. Then canvas or similar material is glued to the painting with a water-soluble adhesive. Once the glue dries, it is possible to pull the painting, both *arriccio* and *intonaco*, or the paint film alone, from the wall. When the fresco is removed, it may be rolled up, rather like a carpet, and stored for eventual cleaning and preservation.

To remount the fresco, it is necessary to attach it to a new support, usually metallic. This operation flattens the fresco's structure, destroying the gently undulating surface that even the smoothest *intonaco* possesses. The change robs the fresco of a certain irregularity that the

41. Removal of a Fresco from the Wall.

Here two men detach a fresco by glueing canvas to its surface and peeling off the paint film. When the operation is complete, the paint will be remounted on a new support and put back on the wall. Other attempts, usually less successful, to remove frescoes have been made for centuries.

painter used to hold and reflect light and to impart a depth of color and illumination. Consequently, remounted frescoes often appear unduly flat, their surfaces lifeless and dull. For this reason, it is wise to detach a fresco only if it is in immediate danger.

A startling new world of Renaissance creativity was revealed by the uncovering of hundreds of sinopias. The informal, direct style of these drawings shows a hitherto unglimpsed aspect of Renaissance wall painting. In fact, modern eyes are so drawn to the sinopias that they have often been studied and discussed in isolation, but this is a distortion of their true nature and function. The sinopia, like any preparatory drawing, has to be seen in relation to the finished work. Only by studying sinopia and fresco together can the relationship between preliminary designs and finished works of art be fully understood. The sinopia was, after all, private, meant to be seen only by the artists and, perhaps, the patrons. Never in their wildest dreams did the painters imagine that one day it would be possible to peel back the thin *intonaco* skin and uncover the underdrawings recording their private visual thoughts and studies. Renaissance artists considered the sinopia a temporary tool, not something for prolonged scrutiny. It was a rough, casual vehicle for working out pictorial problems, a means rather than an end. They simply would not have understood our fascination with the sinopia. The formal, finished, polished fresco was their pride.

The earliest Renaissance drawings, on parchment or rag paper, are fundamentally like sinopias: not finished works of art in themselves, they are part of the creative process ending when the last brushstroke was laid on the fresco, panel or canvas.[7] The number of surviving drawings from before the middle of the fifteenth century is modest, but this scarcity is probably due more to artistic practice than loss over time. Most designing for painting in fresco and tempera was done on the actual support in the early Renaissance. From the first concept to the completed work, the artist's ideas were recorded *in situ;* the progressive maturation of a work through paper drawings does not appear to have been the common practice it would later become.

Artists drew for many purposes: to give patrons some idea of what a finished work would look like; to make detailed studies of objects; to construct cartoons; to record other works of art they had seen and wished to remember (a frequent occurrence); and to set down certain facts about the natural world to be incorporated later into their work.

Whatever his purpose, the artist had a wide variety of materials at hand. For studies or exercises in which he learned by drawing an object numerous times from different angles, ink was often the favored medium. Put on with a sharpened quill, it could be applied to delineate

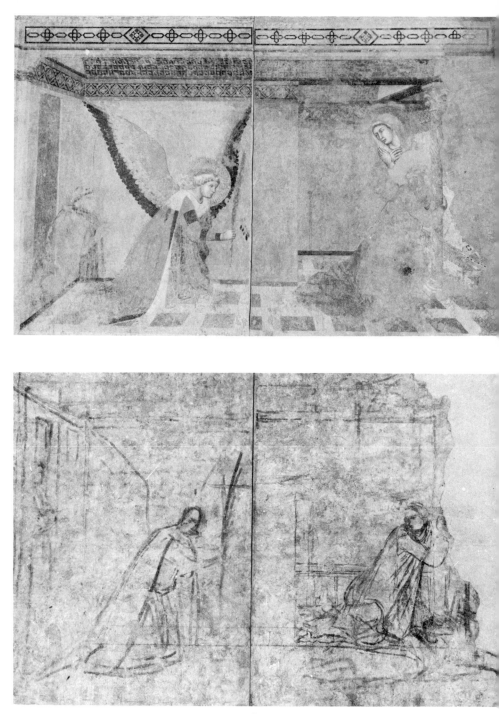

43. Tuscan, *Figures and Decorative Motifs*, New York, Pierpont Morgan Library. Ink drawing. c. 1350.

This sheet, drawn, to save paper, on the back of a deed of sale dated 1321, was used to record motifs and figures the artist found of value. A number of these motifs, such as the little walled city and the rider, probably were copied from other paintings or drawings. It is interesting to observe that the artist takes not whole compositions, but details; the men throwing stones are the only figures from a *Stoning of St. Stephen* that interested him.

42. Ambrogio Lorenzetti, *Annunciation*, Montesiepi, Oratory of San Galgano. Fresco and sinopia. c. 1340.

When the damaged fresco was removed, the dazzling sinopia revealed that it had been altered dramatically. The daring, swooning Virgin was replaced by an obedient, less human figure, who passively accepts the angel's startling news. These modifications, aimed at making the painting more conventional, were carried out on the fresco only a decade or so after it was finished. The monk responsible for this mutilation had his portrait painted at the left of the fresco, but because it was put on secco it has almost fallen from the wall—a fine touch of poetic justice.

44. Pisanello, *Studies of Hung Men,* New York, Frick Collection. Pen and ink. c. 1440.

In this dispassionate but moving drawing, Pisanello carefully studies the gruesome bodies of two hung men. Larger sketches at the bottom of the sheet examine the legs of the victims. The pen allows the artist a clarity and detail admirably suited to his task. These studies were used for a fresco in Verona painted by Pisanello around 1440.

contours precisely and create clear detail. Many of the most remarkable drawings of the Renaissance are extremely simple, highly refined, economical studies made only with ink, a substance that also could be diluted to create washes, areas of tonality helpful for the study of shadow and light.

More atmospheric, volumetric effects could be achieved by employing charcoal. We have already seen that this material was used for working up sinopias and for preliminary drawings on panel. On paper, the crumbly charcoal provided an irregular, broken line that took full advantage of the tooth or roughness of the handmade paper. Charcoal was especially favored for the construction of volumetric form, and thousands of figure studies were made with it. Used together with white highlighting, it could build, almost miraculously, drapery and other volumetric material. Chalk in many colors (red and black were popular) was also used for similar purposes. Soft, easily workable charcoal and chalk both permitted the responsive, rapid, effortless drawing so necessary for quickly setting down thoughts and impressions.

Silverpoint—the most delicate and retiring Renaissance drawing medium—was used on a tinted paper prepared by calcining bones (usually table scraps) and mixing the ashes with pigment and liquid size. A thin, pointed silver rod was then used to draw on this rough surface. As the point was applied, particles of silver were dislodged and embedded in the paper's grainy surface. With time, the silver tarnished and the lines became darker. Silverpoint drawings need to be seen close up as their reticent lines do not tell from a distance. Small-scale, intimate subjects were marvelously rendered in this costly material, which must have made these drawings themselves precious.

Often, especially in the later part of the period, it was common to execute drawings in a number of mediums, for example, superb drawings in ink and charcoal on tinted paper (paper made by coating it with a size-pigment mixture) highlighted with white. Generally speaking, as drawings became increasingly valued, more time and attention were devoted to their making.

The evolution of drawing was rapid. From something intended only to appear on the painting support and then be erased or covered, drawing developed into one of the most prized forms of Renaissance art. In the fourteenth and fifteenth centuries, paper and parchment drawings were used and studied until they were worn out. Sketchbooks that artists kept for themselves and their students were also destroyed by use. But by the sixteenth century even the most casual working out of an idea, a scrap of creative inspiration by an important

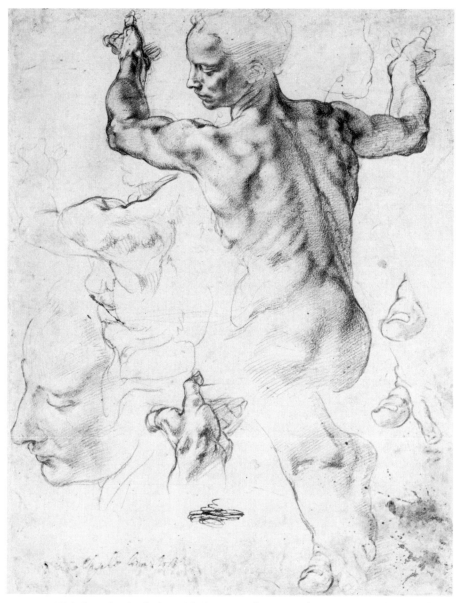

45. Michelangelo, *Study for a Sibyl,* New York, Metropolitan Museum of Art. Red chalk drawing. c. 1510.

This masterful sheet shows Michelangelo grappling with the torso, hands, face, and feet of the twisting figure intended for the Sistine Ceiling. To the Renaissance artist, the representation of the figure was a key problem solved only by the constant experimentation of drawing. The human body was drawn until the proper proportions, foreshortening, and detail were achieved. Of course, not all artists were such consummate draftsmen as Michelangelo, nor did they all experiment with such diversified and challenging poses.

46. School of Filippino Lippi, *Seated Youth,* Boston, Museum of Fine Arts. Silver-point, bistre, and white. c. 1500.

Drawn on prepared yellow-brown paper, this lively study demonstrates the delicate modeling possible with silverpoint. The seated, gesturing youth is very likely an apprentice who, for the moment, has turned model. Apprentices were often used to model for many figure types, both male and female.

47. Michelangelo, *Andrea Quaratesi,* London, British Museum. Black chalk drawing. c. 1530.

The Florentine Andrea Quaratesi was a good friend of Michelangelo; this haunting drawing in black chalk must have been made as a gift for him. Such presentation portrait drawings, which became popular in the early sixteenth century, demonstrate how drawing itself had emerged as an independent art form rather than existing simply as an aid to the composition of paintings or sculpture.

artist, was preserved and treasured. This development would have surprised and amused the earlier artists, who thought of drawings only as a means to an end.

Illumination, a medium with ties to both drawing and painting, was principally used for manuscripts of all sizes and types, ranging from miniature prayer books to gigantic hymnals.[8] Most of these manuscripts were made of parchment manufactured from animal skins, usually those of cows and sheep. Fresh skins were scraped, cured, and then stretched to dry. The preparation of these skins was probably not done by the artists, but entrusted to special parchment makers. There must have been a close interconnection between these craftsmen and the butchers and other suppliers of animals who furnished the skins.

When the parchment was purchased by the painter, its surface was rubbed with pumice or chalk to make it less oily and to decrease its natural absorbency. It was then coated with thin layers of liquid size. Often the parchment was colored by mixing pigment with the size: green, gray, buff, and pink were among the most popular colors for parchment and tinted paper as well. These colored parchment pages set off the bright color and abundant gold of their illuminations magnificently, transforming the pages into leaves of remarkable splendor. Occasionally, the parchment was dyed to achieve an equally sumptuous effect.

There were two principal vehicles for illuminations. The first was "glair," a substance obtained from egg whites whipped into a froth and allowed to settle. The result was a runny, free-flowing liquid that was then mixed with pigment. Although a simple process, the preparation of glair was not easy; it required a relatively clean environment, something not easily found in artists' shops of the Renaissance (or, for that matter, today). The making of glair, like the construction of so much Renaissance artistic material, called for manipulating simple materials with considerable skill and technique, learned during the all-important apprentice days.

Glair is an ideal vehicle for small-scale painting, but it does not allow colors to attain their maximum saturation. Sometimes, the dried glair-pigment mixture was varnished with honey to make the colors seem fuller and richer.

After the fourteenth century, because of its disadvantages, glair was used less frequently. In its place the illuminator employed gum arabic which, in all likelihood, had become simply a generic name for the gums of a number of domestic trees. Gum arabic could be applied more thinly than glair and it allowed pigments to develop a greater transparency, saturation, and brilliance.

Perhaps the medium closest to illumination, whether with glair or with gum arabic, is tempera painting. Both are suited to a careful, considered, and precise formal language; both are constructed with small brushes and numerous layers. Glair and gum arabic, however, are not as viscous as egg-based tempera. The need for a free-flowing vehicle that could be easily controlled was paramount for the small scale of most illuminations painted with tiny brushes. These brushes and the great detail of most illuminations required a highly responsive vehicle.

Glair and gum arabic, sometimes used together or along with several other vehicles, including egg yolk, sugar, and ear wax, all served the illuminators, who were really draftsmen and painters in miniature. Sometimes illuminators were also artists who painted full-scale tempera panels and frescoes, but for the most part they were specialized craftsmen who did only illuminations. Because of the need for thousands of illustrated religious texts, monks, working in scriptoria, were often responsible for the pictures in these manuscripts. There remain many unsolved questions about the illuminator's workshop, but it appears that the text of the manuscript was designed and written by a scribe. When the painter received the manuscript, the text was complete, but there were blank spaces for the illuminations. These were designed on the prepared parchment itself with a lead point. This was then reinforced with ink. Then the designed area was sized, the gold applied, and the pigments placed.

Illuminations, and the gold leaf that graced them, were the crowning glory of the Renaissance manuscript. They not only served as illustrations to the text but were also highly decorative. Painted with great care, sumptuously colored and gilded, they made the manuscript (already a luxury item) even more valued and costly. So prized were they that when the first printed books appeared in the late fifteenth century, they were often designed to look like manuscripts and frequently had painted illustrations and decorations. Connoisseurs of splendid manuscripts were reluctant to place printed books, which they considered mechanical and rather crude, on their library shelves. Nevertheless, the printed book rapidly became extremely popular and soon developed its own form of decoration and illustration which, like the book itself, was reproduced mechanically.

The earliest of these printed illustrations were woodcuts.[9] In this relief-printing technique, which first appeared in the fourteenth century and may have derived from textile decoration, the images are made by a carved close-grained block of hardwood. The artist cuts into the wood with chisels, knives, and other sharp tools, removing those

48. Niccolò da Bologna, Leaf from the 1383 *Statues* of the Goldsmiths Guild of Bologna, Washington, D.C., National Gallery of Art. Miniature. c. 1383.

This headpiece from the Bolognese goldsmiths' guild *Statues* depicts the Madonna and Child enthroned and flanked by two saints: to the left, St. Petronius, patron of Bologna, and to the right, St. Eligius, the goldsmith's patron.

**49. Florentine, *Blessing Christ in a Mandorla Supported by Angels and Cherubs.*
Woodcut. 1491.**

This woodcut of 1491 is from the book entitled *Monte Santo di Dio,* published in Florence.
The broad, undulating lines characteristic of the woodcut are seen everywhere. Also
typical of the medium is the strong, clear alternation of the dark of the inked areas and
the white of the paper. This handsome sheet is one of the earliest Florentine woodcuts
used to illustrate a book.

to optatiſſime carne ſentendo, nelle quale lalma ſua uigendo, ſe nutri -
ua ſe euigiloe ſuſpirulante, & reaperte le occluſe palpebre. Et io repente
auidiſſima anhellando alla ſua inſperata reiteratione riceuute le debilita-
te & abandonate bracce, piamente, & cum dulciſſime & amoroſe lachry-
mule cum ſingultato pertractantilo, & manuagendulo, & ſouente baſian
tilo, præſentandogli, gli monſtraua il mio, Imino ſuo albente & pomige-
ro pecto paleſemente, cum humaniſſimo aſpecto, & cum illici ochii eſſo
ſecia uario di hora, riuéne nelle mie caſte & delicate bracce, Quale ſi læſio
ne patito non haueſſe, & alquantulo reaſſumete il contaminato uigore,
Como alhora ello ualeua, cum tremula uoce, & ſuſpiritti, manſuetamen
te diſſe, Polia Signora mia dolce, perche cuſi atorto me fai? Di ſubito, O
me Nymphe celeberrime, me ſentiui quaſi de dolcecia amoroſa, & pieto-
ſa, & exceſſiua alacritate il core p medio piu molto dilacerare, per che quel
ſangue che per dolore, & nimia formidine in ſe era conſtricto p troppo &
inuſitata læticia, laxare le uene il ſentiua exhauſto, & tuta abſorta, & attoni
ta ignoraua che me dire, Si non che io agli ancora pallidati labri, cum ſo-
luta audacia, gli offerſi blandicula uno laſciuo & muſtulento baſio, Am-
bi dui ſerati, & conſtrecti in amoroſi amplexi, Quali nel Hermetico Ca-
duceo gli intrichatamente conuoluti ſerpi, & quale il baculo inuoluto
del diuino Medico.

50. Venetian, *Polifilo and Polia* from Francesco Colonna's *Hypnerotomachia Poliphili,* Venice. Woodcut. 1499.

This page from the splendid *Hypnerotomachia Poliphili* shows the fine integration between print and illustration found in the first books illustrated with woodcuts. Even though it depicts a considerable amount of space, the woodcut, because of its linear nature, does not disturb the inherent flatness of the type and white paper on which it is printed. Both text and image are equally clear and equally easy to read.

areas he does not wish to receive the ink. The block is then inked and pressed onto paper. The inked areas print black, while the cut-away sections do not print at all, their shapes appearing as white or whatever other color the paper happens to be.

The earliest woodcuts were crude devotional images, probably circulated in considerable numbers. Some were hand-colored and pasted to wood or other firm supports to act as a sort of inexpensive, popular domestic icon. Equally rough block books with simple woodcuts were known to the fifteenth century, but it was not until around 1500 that woodcuts of higher artistic quality were produced in any quantity.

Because of their linear, flat character, woodcuts were the ideal illustrations for books. Painted illuminations had always been influenced by the increasingly illusionistic tendency of art in the Italian peninsula during the fourteenth and fifteenth centuries. By the late 1400s, in fact, a serious conflict had developed between the inherent flatness of the manuscript's words and blank parchment, and the deep space and convincing volume of the illuminations, which punched fictive holes in the pages. This nearly crippling tension was resolved by the introduction and utilization of the woodcut, either black and white or hand-colored. The best woodcutters, occasionally well-known artists in other mediums, were always sensitive to this problem and took full advantage of the characteristic flatness of their medium.

Woodcuts were soon joined by engravings as a popular form of illustration. In fact, by the sixteenth century the engraving was becoming increasingly popular for book illustrations.

The origins of the engraving are not entirely clear, although it appears a roughly similar technique developed in the metalworker's shop. Goldsmiths, silversmiths, and other workers in metal produced objects, usually of a small, delicate type in the niello technique: jewelry, boxes, candelabra, and armor were often decorated in this way. An extremely ancient method of working metal, the technique consists of coating an engraved or incised metal surface with a black substance made of copper, sulfur, silver, lead, and borax.[10] The metal is heated until the mixture becomes soft and fills the incised lines. When the object cools, it is scraped, exposing the uncut areas, which are then burnished. The contrast between the gleaming metal and shiny black linear network is strong and pleasing.

Niello—the word can refer to either the technique or the object—is close to the practice of engraving. In fact, paper impressions of niello objects such as paxes (figurative tablets the worshippers kiss during the Mass) were made by the metalsmiths to check the progress of the work and to make a record of the piece once it was finished. Casts were

also made from niello objects; these could be rubbed to produce a printlike image. Exactly when and where the first niello prints were made is a mystery, but evidence points to Florence around the middle of the fifteenth century.

Near this date, actual engravings made from incised copper plates, inked and then printed in a press, were being produced in number.[11] Because many prints could be made from the durable plate, it was possible to replicate a single image many times.

Engravings served many purposes. Like woodcuts, they could be distributed widely. These prints were saved, pasted to a backing, and placed in the home or workplace, much as small images of saints on cards are displayed in Italy today. Playing cards were made from engravings, and a number of beautiful Tarot cards, among the most

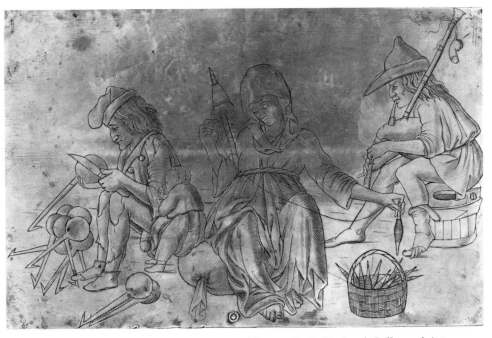

51. North Italian, *Sexual Allegory*, Washington, D.C., National Gallery of Art. Copper engraving plate. c. 1475.

Engraved copper plates are rare. This one, by an artist working in the northern part of the Italian peninsula during the last quarter of the fifteenth century, is interesting because it is filled with allusions to human sexual organs: kitchen spoons, bagpipes (complete with a phallus), and spindles. Exactly what the purpose of the engravings pulled from this plate would have been is unclear. There were, however, many examples of erotic art in the Renaissance, both in prints and other mediums.

·E· **RE·VIII·** ·8·

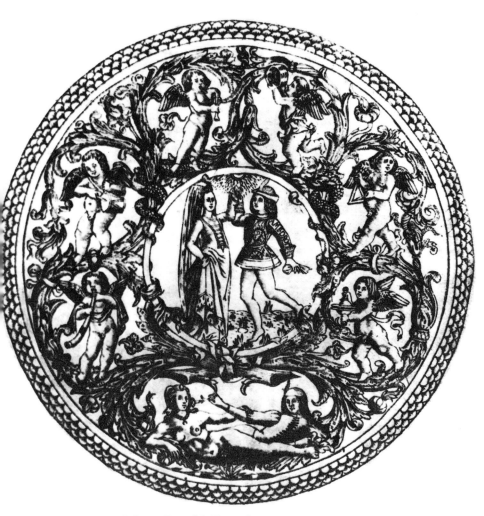

53. Florentine, Gift Box Roundel. Engraving. c. 1475.

Fancy boxes, perhaps made for weddings or for a suitor to give his beloved, often contained engravings like this. Filled with candy or other delicacies, these boxes made attractive gifts. The music-making cupids, dancing couple, and lovers, all entwined in a garland, surely provided a most appropriate visual accompaniment for the occasion.

52. School of Ferrara, *King* from a Deck of Cards, Washington, D.C., National Gallery of Art. Engraving. c. 1465.

Tarot and other forms of cards were popular in the Renaissance. Like modern playing cards, it was necessary for them to be easily readable. Their illustration had to be bold, clear, and simple. Space, moreover, had to be held in check because the illusion of depth is disturbing and out of place on any type of card.

fascinating of all the early prints, still survive. Engravings were also used to grace the inside of gift boxes and for other decorations.

By the early sixteenth century, the engraving had been used to make records of paintings. Naturally, the idea of copying was nothing new; artists had been doing it for several centuries. But the earlier copies had been unique. Set down in an artist's sketchbook or on a single sheet of paper, these were solely for the use of the artist, who would study them, make drawings after them, and pass them on to pupils until the paper was worn to bits. With the advent of engraving, scores of copies of famous paintings could be circulated to a wide audience of artists and, in the sixteenth century, collectors. A whole branch of engraving concerned exclusively with reproducing painting and other works of art developed in the Renaissance. It remained of utmost importance to the world of art until its replacement by the photograph in the nineteenth century. Engraving helped to spread the fame of artists and brought about a wider awareness of their works.

The Renaissance was a seminal period in the history of the print. It saw the early development of both the woodcut and the engraving, the first artistic mediums to replicate images on an extensive scale. It also witnessed the evolution of these two mediums from simple reproductive and decorative functions to sophisticated art forms; by the sixteenth century, engravers and woodcutters were producing prints that were major works of art. These graphic mediums achieved an independence and vitality they have maintained ever since.

There was an equally distinguished flowering of sculpture during the Renaissance.[12] From Niccolò and Giovanni Pisano to Michelangelo, the Italian peninsula was home to a long line of remarkable sculptors working in a variety of materials.

One of the most difficult of these was stone, a substance found in overabundance in the peninsula.[13] Because of its durability, cutting properties, and finished appearance, marble was the stone most preferred. But the procuring and working of marble, or indeed of any other stone, presented a multitude of problems.

Unlike a panel, which could be purchased locally from a carpenter and transported to the artist's shop with relative ease and low expense, the stone had to be quarried, often from mountainous regions far from where the sculptor was working, and then brought to the artist. On occasion, the sculptor went to the quarry to look at the stone and pick out the block he thought most suitable for his project. An experienced sculptor could tell much about how the block would cut and polish by examining its size, color, and grain. But there was (and still is) no

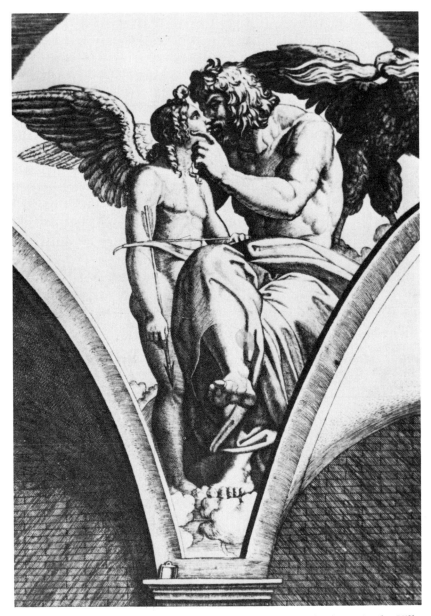

54. Marcantonio Raimondi, *Jupiter and Eros* (after Raphael's fresco in the Villa Farnesina). Engraving. c. 1518.

This engraving, after a spandrel fresco in the Villa Farnesina, helped make Raphael's painting known to a wide audience. Sold through printsellers, for centuries such reproductive engravings performed a task now relgated to the illustrative photograph.

55. Michelangelo, *Working Drawings for a Statue,* London, British Museum. Ink drawing. c. 1525.

This remarkable drawing, perhaps intended for the quarrymen, shows the dimensions of a nude figure, probably a river god. The dimensions are measured in Florentine *braccia.* Certainly a rough and rapid sketch, the drawing is nevertheless a fine example of the power of Michelangelo's drawing skill and a good demonstration of his concern for the important early stages of his sculpture.

certain way to determine if the block contained internal faults or weaknesses or discolorations, so even the most knowledgeable artist could never be certain about his selection until he actually began carving. Many blocks had to be abandoned when cutting revealed they contained major flaws.

Our knowledge about the transportation of stone during the Renaissance is incomplete, but delivery of the weighty material must have created countless problems for architect and sculptor alike. Water transportation was used whenever possible, but stone often had to be carried or dragged overland. The logistical problems of building and carving the huge cathedrals of the many hill towns must have been enormous. That these buildings exist is a tribute to the engineering skill and perseverance of the Renaissance craftsman.

Once the stone arrived in the city, it was delivered to the sculptor. The smaller blocks were carved in his own workshop, but the larger pieces, moved only with the greatest difficulty, were carved on site. Like the masons to whose guild they sometimes belonged, the sculp-

tors often worked in sheds erected near the buildings for which they were carving. On occasion, they would set up inside an already finished building. For instance, when statues were being carved in the Florentine Duomo during the early Quattrocento, the makeshift studios were closed to public view and at least one, Donatello's, was locked.

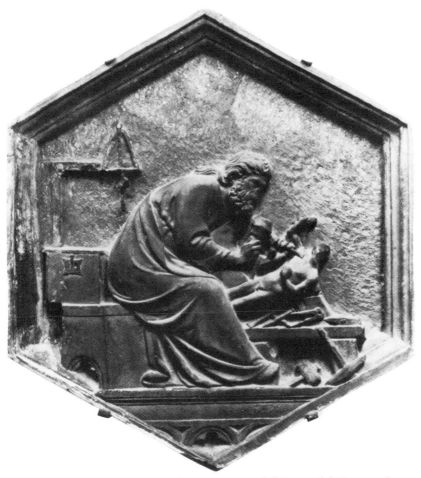

56. Andrea Pisano, *Sculpture,* Florence, Museo dell'Opera del Duomo. Stone. c. 1330.

Andrea's relief, which formed part of the decoration of the belltower of Florence cathedral, affords a fascinating view into a sculptor's workshop. Intently bent over his task, the artist shapes the figure with a flat chisel and mallet. Around the unfinished statue lie calipers, punches, other chisels, and hammers. On the wall hangs a bow drill.

No matter where he worked or under what conditions, the sculptor had to be part engineer just to turn and position the block to get it ready for carving. Often, the design was furnished by a painter, a rather common practice during the early part of the Renaissance.[14] All of these designs have vanished, so that we know almost nothing about their size and type. Sculptors themselves probably worked out ideas and various views in their own paper sketches.

But until the middle of the fifteenth century, most of the creation seems to have been done on the stone itself: the sculptor drew the design directly on the block. Then he began to rough the figure out with a pointed punch and flat chisel. By making oblique strokes with the chisel driven by a mallet, the skilled sculptor could reveal the basic shape of his figure with relative ease; and the long, oblique strikes of the tool allowed him to make considerable speed.[15]

After the several faces of the stone had been worked to rough out the form to the sculptor's satisfaction, further definition and clarification were carried out with toothed or clawed chisels of different sizes and types. These helped the sculptor to model the block and smooth its surface. A bow drill (an extremely taxing tool) was also sometimes employed to model passages, to form hair curls, to cut decorative patterns, and to assist the sculptor in making relief lines. Throughout the entire process, files and abrasives (sometimes emery, pumice, and straw) were used to smooth planes and to work the surface to the degree of finish desired.

When Renaissance stone statues or reliefs are examined closely, many reveal the number of stages through which they have passed. The good sculptor utilized his tools to create different degrees of finish and illusion. A figure's skin may show the careful use of abrasive, but its hair or drapery may still carry the undisguised marks of the claw chisel. Not only the creation of the object's volumetric structure but also the modeling and texture of that structure are created by the skillful, varying employment of the sculptor's few simple tools. The use of these tools is an extremely personal process. Each sculpture is created by its author's unique way of handling his tools; the particular choice and mastery of these is his stylistic autograph.

The sculptor, however, was usually not the only artist to work on his statue or relief. In the early Renaissance, sculpture, as we have seen, was often designed by a painter who furnished the sculptor with a drawing. Painters were also employed to paint the work after it had been finished by the sculptor; we know from documents paying painters for this task that it was quite common. Little of the original color, however, remains on Renaissance sculpture. We are so accustomed to

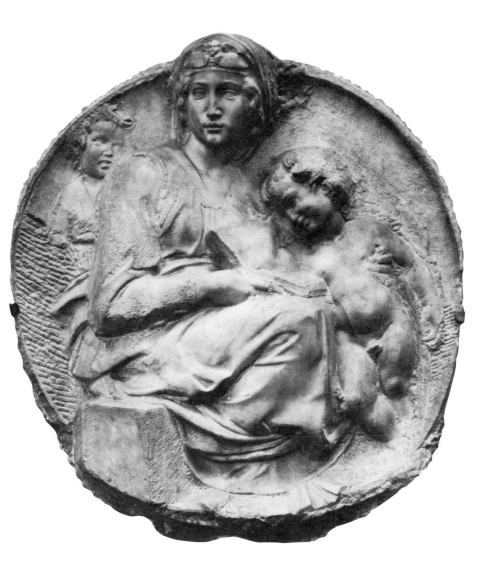

57. Michelangelo, *Pitti Tondo,* Florence, Bargello. Stone. c. 1505.

Many of Michelangelo's pieces demonstrate clearly how the marble was worked from the roughest cutting to the smoothest polishing. In the *Pitti Tondo,* one sees a great variety of tool marks ranging from the rough punch cutting on the bottom of the stone circle to the fine claw chisel stippling covering the body of the Christ Child. Michelangelo might have never intended to finish this piece in the conventional polished sense. Instead, he may have wanted the onlooker to see the stages by which the figures gradually emerged from the block—the steps of creativity.

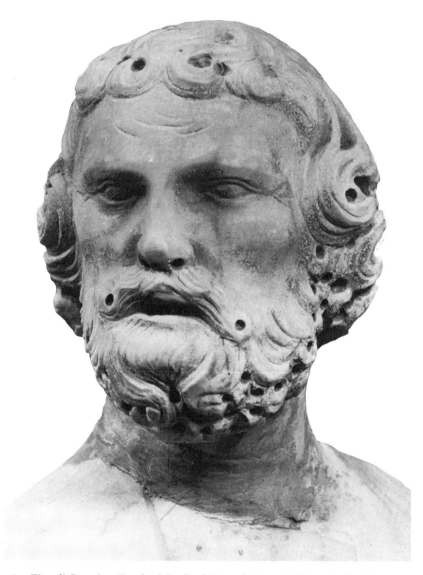

58. Tino di Camaino, Tomb of Cardinal Riccardo Petroni, Siena, Cathedral. Stone. c. 1320.

This detail of an unfinished head of St. Peter shows extensive use of the bow drill. The hair, ends of the mustache, and especially the beard are deeply drilled. Using a chisel, the sculptor would enlarge and, sometimes, connect these holes to patterns of hair.

the now bare stone that it is difficult for us to imagine what these painted statues and reliefs must have looked like.

Wooden and terracotta sculptures were often entirely colored. Painters also extensively colored the hundreds of inexpensive stucco copies of marble and terracotta Madonnas made during the Renaissance. Stone statues and reliefs were usually only highlighted with color: eyes, mouth, hair, hems, and background seem to have been painted, but the rest of the stone was left unpigmented. Occasionally, as in the pulpits by Niccolò and Giovanni Pisano, and Donatello, a glass mosaic was introduced into the background of the reliefs.

The actual carving of stone was an intensely collective process.[16] This is not surprising when we consider that almost every other craft of the Renaissance was also a joint effort. In fact, the working methods of painters and sculptors were quite similar. Sculptors, like painters, were associated in workshops under the direction of a master who trained apprentices. It was this master who obtained the commissions, and who planned and supervised the actual execution of the work— the bigger the commission, the more help he needed. Sculpture in stone is a physically taxing task involving a considerable amount of danger, both from the sheer weight of the material and from the tools used to carve it. Careful planning to protect the members of the workshop was the master's responsibility.

Carving on the block was done to the master's designs. When there was a lot to do, or when he was absent, the apprentices and helpers did much rough carving with punch and flat chisel. On large-scale commissions—the facade of a church, for instance—there were specialists entrusted to do certain parts of figures or other objects. Unfinished sculpture proves that many figures were not executed all at one time by one hand, but, rather, were done by several hands at different times during the workshop's carving campaign: one sculptor might rough out the body, another might carve the hair, yet a third might put in the drapery. This process would then be repeated, with some variation, throughout the entire job. As all this was done to a design furnished by the head of the shop, there was no artistic individuality in our sense of the world: each figure was, in fact, a cooperative effort. On smaller pieces the master might do most of the work, including the final polishing. Even on larger commissions, he probably put many of the final touches to statues prepared mainly by his assistants. This situation finds a close analogue in the working method of both fresco and tempera, where many hands would work over a single surface.

A change in working methods seems to have occurred during the first half of the fifteenth century. In these decades, sculptors relied less

59. **Verrocchio, Sketch-Model for the Monument of Cardinal Niccolò Forteguerri, London, Victoria and Albert Museum. Terracotta. c. 1476.**

In 1476, Verrocchio was commissioned to erect a monument to Cardinal Niccolò Forteguerri for the cathedral of Pistoia. This is an early model for that monument; in fact, it may be the one on which the commission was awarded. Such models allowed both patron and artist to see, in a reduced size, how the project would appear when finished.

on the design put directly on the stone. Instead of using only the drawing on the block, they began to employ models, or *bozzetti.* Using wax or clay, the sculptor could experiment with the form of his figure on a small scale with malleable material. After making a series of studies or sketches in clay or wax, he could build a rather exact reduced-size prototype of the figure he was about to carve. By employing a model, the basic problems of form, position, solid and void, and movement could all be solved before the artist attacked the block. Formal ideas could now be worked out in three dimensions. Sketches, not only on paper but also in wax or clay, could be used to study and perfect the sculpture. As an important intermediary step between first idea and finished painting or sculpture, the model in several materials (or paper drawing) grew in popularity as the Quattrocento progressed.

In the Renaissance, as in other periods, free-standing sculpture was not always conceived as a fully three-dimensional object, nor, indeed, was it constructed with more than a single viewpoint in mind. But by tactually and visually demonstrating form in real space, the use of models seems to have encouraged sculptors to plan their figures from several viewpoints. Fully three-dimensional sculpture constructed with an infinite number of changing viewpoints was a much rarer thing, however, achieved only by several artists of great talent.

The model allowed the sculptor to transfer his plastic design mechanically to the larger block of stone. A series of points or measurements was made on the model. These points were then transferred to the stone by a simple mechanical process called pointing. In this way, the exact proportions of the model could be duplicated in the block, rather as a small drawing could be transferred to a large cartoon by the grid system.

The models—tangible indications of what the finished product was to look like—were also shown to the patron for approval. He could, at this early stage, give his blessing or suggest changes before the work was translated into some more permanent material.

Wax and clay were also used to make sketches for relief carving in stone, a technique extremely popular during the Renaissance. In the relief technique, the sculpture projects from a background to which it is still attached. Relief was often utilized for narrative scenes requiring considerable fictive space and detail. It was also frequently employed as purely decorative carving for architecture.

The depth of the carving, which varies greatly, depended on what effects the artist wished to achieve. If the relief had to be seen from some distance, then a high-relief technique was employed. The sculptor cut away a great deal of stone, nearly detaching the figures and

60. Giovanni Bologna, Sketch-Model of a River God, London, Victoria and Albert Museum. Clay. c. 1580.

For an as yet unidentified statue, this sketch-model of a river god would have helped its artist plan his figure in full round. The quick, inspired additive process of modeling in soft clay is readily apparent in the sketchy, suggestive quality of the river god. Such evocative models, most of them now lost, must lie behind many bronze and stone sculptures. The very fact that such models survive, albeit in small numbers, demonstrates that these informal sketches were, like paper drawing studies for paintings, now valued in their own right.

other objects from the background. In some cases, it is almost as though three-dimensional objects were actually applied to the block instead of being carved from it. The strong effects of light and shadow common to free-standing sculpture play an important role in high relief.

At the opposite end of the relief scale was *rilievo schiacciato,* a technique much favored by Renaissance sculptors.[17] This was an extremely shallow relief in which forms, often standing only millimeters above the background, seem barely to emerge from the stone. On occasion, the sculptor incised rather than carved; the careful use of incision could provide delicate, highly atmospheric effects suitable for close-up viewing.

The strongly atmospheric, often incised surface of the *rilievo schiacciato* technique is related to painting. A perspective of line can be constructed in *rilievo schiacciato,* imparting a fictive depth and recession unobtainable in higher-relief carving. Clouds, wind-blown trees, subtle areas of light and shadow, and atmospheric perspective can be conveyed most effectively with the low-relief technique. Not surprisingly, the first widespread use of *rilievo schiacciato*—in early fifteenth-century Florence—had a major influence on painters.

Highly illusionistic narratives could also be made of bronze. Bronze working has an ancient history, but after the collapse of the Roman Empire, the Renaissance was the first period to make extensive use of it for many art forms.[18] An expensive material (an alloy of copper and tin), bronze was often used in the making of objects of conspicuous consumption, such as statues of famous men or the great doors to an important public building. It was also a hard substance to work, and this added to the value of the finished piece. Like the making of ceramic ware or cast iron, the creation of bronzes called for the use of high temperatures and rather difficult techniques. Although sophis-

61. Nanni di Banco, Base of the *Four Crowned Saints* (detail), Florence, Or San Michele. Stone. c. 1415.

The Florentine Guild of Stone and Woodworkers commissioned Nanni di Banco to fill their niche on the Church of Or San Michele with the Four Crowned Saints, early Christian sculptors who were martyred for refusing to make pagan idols. In this detail, a sculptor works on a capital, while another completes a small figure that seems to come to life under his tools. The stools, working clothes, and equipment are all accurately depicted.

62. Donatello, *St. George Killing the Dragon,* Florence, Bargello. Marble. c. 1415.
The predella from Donatello's famous *St. George* is done in the *rilievo schiacciato* technique.
The figures in the foreground are carved away from the block, while the landscape is
sketched suggestively by exploiting the grainy texture of the marble through incisions.
Deep, atmospheric perspective, resembling that found in painting, is thus achieved.

ticated, there was still a considerable amount of guesswork in the
process; a high percentage of objects were ruined in their making, an
expensive waste of time and material. Moreover, the good sculptor had
to know how to design his work to conserve the costly bronze. Some
knowledge of engineering was also necessary because the pieces often
had to be done in sections.

Bronze sculpture was made in an additive manner, as opposed to the
reductive technique of stone carving. The genesis of bronze takes place
when the sculptor constructs, out of wax or clay, a figure or object used
to make a cast. The artist can spend a considerable amount of time
working through his various ideas for the piece, shaping the malleable
wax or clay with tools and with his hands until it is nearly the form
and finish he wishes to reproduce in bronze.

Then follows a rather complicated procedure: the model is coated
with plaster, applied on larger objects in sections or cut into sections
after it has hardened. After the plaster dries, the sections are removed.
The inner faces of the plaster, which were next to the model, are then
covered with a thick wax layer.

These wax shells are removed from the plaster molds and affixed to
a core of clay by wires. The wax is coated with a mixture of ash and
water and covered with more clay. Thus, the wax is now sandwiched

between the interior clay core and the new exterior mold of clay. All the layers are pinned together by the iron framework.

If the piece is small enough, the entire sandwich can be placed in the furnace; or, if too large, the various sections are fired individually. When the furnace is heated, the wax liquefies and escapes through various vent pipes introduced into it by the sculptor during the construction of the last layer of clay.

A space is created between the clay core and the outer layer of clay, the area formerly occupied by the wax itself. Into this void the molten bronze is poured through pipes. When the bronze cools and hardens, the core and the outer layer of clay are removed, revealing the hollow bronze object or the thin pieces cast from the separate sections, which are then connected.

This method of bronze casting, known as the lost-wax process, was the most economical. By using a clay core, it was possible to make the statue hollow, thus saving a considerable amount of expensive bronze. Also, the hollow, relatively lightweight sculpture was easier to transport and set up. With the lost-wax method there was no limitation on size: objects from the smallest medals to life-sized horses could be made using the process.

This type of bronze casting was also artistically responsive. Clay or wax, the first materials the bronze sculptor used, are extremely malleable; sensitive to the artist's tools and hands, they easily register the impression of both. Unlike marble or other types of stone, they allow for mistakes and changes in plan.

Sculptors could finish the surfaces of bronze objects in many ways. When the metal was cast, it seldom, if ever, had the degree of finish the artist wished. Indeed, it was often very rough and unfinished. Consequently, the sculptor and his assistants had to chase the material with chisels, other tools, and abrasives to remove casting marks and to give the forms their finished surface. After considerable chasing, the surface was burnished to remove further imperfections, and to bring the metal to the degree of smoothness demanded by the sculptor. The bronze was then patinated to achieve a desired color. Patination, an important part of bronze making, could be achieved with oil, acids, colored lacquer, or a number of other substances. The color of the finished bronze, depending on the chemical composition of the metal as well, varies widely: a deep, bluish black, a brownish red, and a greenish brown are just three possible hues. The smooth, hard surface of the bronze is marvelously complemented by these lustrous colors. Often bronzes were gilded or silvered.

Renaissance sculptors had widely varying ideas about how finished

**64. Il Riccio, *Antaeus* (detail), New Haven, Yale University Art Gallery. Bronze.
c. 1500.**

For some unknown reason, the sculptor never finished this lively statue. The roughness
of its surface indicates that it remains unchased, lacking those marks of the chisel, file,
and abrasives necessary for final definition. The figure shows how much work was still
needed after the statue was cast, even when the casting was done by an expert sculptor
or founder. Many small bronzes such as this were cast as solid rather than hollow.

**63. Donatello, *St. Louis of Toulouse,* Florence, Santa Croce Museum. Gilt bronze.
c. 1425.**

The rear view of Dontello's large *St. Louis,* intended for a niche on Or San Michele,
Florence, reveals that the statue is made up of thin membranes of bronze. The *St. Louis*
was not cast in one piece but is composed of several parts bolted together.

65. North Italian, *Hercules and Antaeus,* Baltimore, Walters Art Gallery. Bronze. c. 1500.

This small bronze group, perhaps meant to be displayed on a desk or table, is a distinguished example of how an antique theme was chosen to give the Renaissance sculptor a chance to display his virtuoso handling of both bronze and figures in action. The hardness and sensuousness of the cast, chased, and polished bronze are wonderfully revealed in the twisting, interlocked bodies of the muscular nudes. The glistening finish is imparted by a coat of dark patina.

their bronzes should be. Indeed, even in the work of a single sculptor (Donatello is the best example) different bronzes demanded different degrees of surface refinement. Nudes, for example, were often given a polished, lustrous surface that reflected light and conveyed a sense of the hardness and sensuousness of the metal. Other surfaces revealed to a much greater degree the processes of their creation, preserving the record of the sculptor's hands working the original wax or clay, yet evoking the material and structure they were designed to portray. As in oil painting, bronze sculpture allowed the artist to create a delicate harmony between process and image. In the works of the talented painters and sculptors, there exists a magical balance between the material and that which is represented: one moment curls are seen as real hair, the next as bronze ridges. This duality creates an enlivening tension characteristic of many major works of Renaissance art.

Terracotta sculpture, which first became popular around the middle of the fifteenth century, is related to the making of bronze in its use of clay. Clay sculptors must have had many ties with potters as well. The shaping and firing of clay pottery was an important industry during the Renaissance. Scores of potters living in every city provided the immense variety of cooking and tableware needed for families and institutions.

The techniques of making and firing clay were highly developed, and from the fourteenth century Renaissance potters in many centers produced objects of the highest quality. Although mirror holders, ink stands, and other decorative objects were turned out, the vast majority of the potter's labor was directed toward pots, dishes, and vessels. Most of these were humble, unglazed objects used for cooking, but a number were shaped and painted with extraordinary skill and taste. The fifteenth and sixteenth centuries were, in fact, the golden age of pottery in the Italian peninsula.[19]

With some modifications, the technology and techniques of the pottery were adopted by the sculptor working in terracotta.[20] *Terracotta* is Italian for "baked earth," and both pottery and terracotta sculpture are made of clay fired in kilns. When the objects were removed from the heat, they were various shades of brown, red, or buff and rough to the touch. Sculpture, both figurative and decorative, was often completed by simply coloring it with pigments. Many high-quality reliefs and free-standing statues, often built around an armature, were modeled by a sculptor and then turned over to a painter.

Another method of pigmentation of terracotta was also used. In this technique, which probably derives from maiolica pottery, fired pieces were dipped in a *bianco*—a glaze of lead and tin oxides, and a silicate

of potash derived from wine lees mixed with sand. This furnished the statue or relief with an extremely porous matte white coating which, when dry, was the perfect, stable surface to receive and hold color without blurring it. Both the potter and the sculptor were restricted to a rather limited number of hues. These yellows, greens, blues, purples, oranges, and their combinations, were applied to the baked clay with a brush. Here potter and sculptor alike became painters.

Painting on the *bianco* was much like working on the *intonaco* of a fresco. The pigment was absorbed at once, so mistakes could not be erased or covered easily. A direct, simple, economical approach was called for. Combined with the strong hues used by the sculptor, such an approach encouraged the creation of sculpture that was beautifully and brightly colored and simply conceived.

After the pigments were applied to the *bianco,* the sculpture was fired again. When it emerged from the kiln, the lustrous colors (many of which changed hue and saturation after heat had been applied) were fused to the clay's surface. Unlike so many Renaissance panels and frescoes that have faded due to various causes, the color of the glazed terracotta remains, in most cases, as fresh as the day it was removed from the kiln. It takes time to adjust to the sculpture's brilliance, but patience reveals that these pieces are marvels of decorative color and economical shape. The blaze of color and the sparing use made of it create a series of smiling images that are one of the high points of Renaissance art.

It has been suggested that glazed terracotta sculpture became popular in the mid-fifteenth century because it was a cheap substitute for marble carving. This idea seems erroneous, for not only was the visual appearance of glazed terracotta quite different from marble but it was also meant to serve a different aesthetic. Moreover, unlike the hardest marble, it could withstand even the most severe climatic changes and was, consequently, more suitable for outside locations. Hundreds of roadside shrines and street corner tabernacles still testify to the longevity of this humble material.

Wood, another unpretentious material, was also used for sculpture during the Renaissance.[21] Like fresco painting or bronze casting, the

66. After Benedetto da Maiano, *Virgin and Child with St. John the Baptist and Two Cherubs,* London, Victoria and Albert Museum. Painted terracotta. c. 1490.

Painted terracotta reliefs of this type were popular during the fifteenth century. Probably relatively cheap, they could be bought for placement both in churches and in the home. Many, like this example, were extensively pigmented, sometimes by a painter called in by the sculptor. To modern eyes, the painted colors of the reliefs often tend to be rather strident.

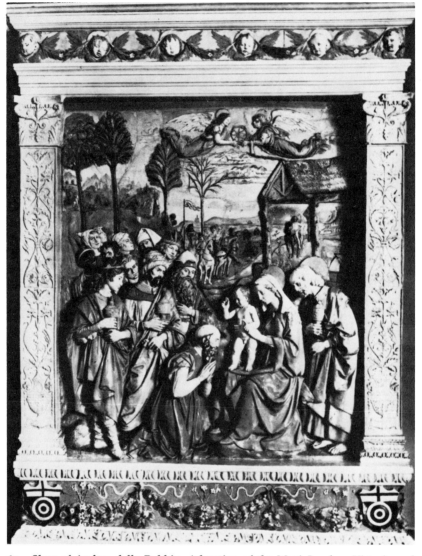

67. Shop of Andrea della Robbia, *Adoration of the Magi,* **London, Victoria and Albert Museum. Glazed terracotta. c. 1500.**

This large altarpiece, over two meters high, of glazed terracotta is a good example of the more colorful, elaborate work of the della Robbia family around 1500. Its blue, brown, yellow, white, and green colors, while variegated and lively, are more gaudy and numerous than the simpler hues of the glazed terracottas of Luca della Robbia, the founder of the family's flourishing business. In the altarpiece there is a conscious imitation of a particular painting, something not often found in the more self-sufficient works of Luca.

technique is an old one, and a number of remarkable large wooden statues—often Madonnas or figures from Crucifixion groups—survive from the several centuries immediately before our period. These demonstrate clearly that an extremely high level of skill had already been attained. During the Renaissance there existed a taste for wooden sculpture, but it does not seem to have been as great as that for stone, bronze, or terracotta. However, the fragility of wood and its poor survival rate make any statement about its popularity risky. The fact that wood is an extremely difficult material to work may have also limited its use.

From Roman times, wood was relatively scarce in Italy. The material needed for large figures and groups of figures must have been difficult to obtain and quite costly. Until quite recently we have considered wood a common, cheap substance, far more available than marble, but this was probably not the case in the Renaissance, when a number of important artists worked in the material.

Once the sculptor obtained a piece of wood of sufficient size, he had to dry it or have it dried. Green wood, in most cases, is unsuitable for carving because as it dries it has a tendency to split and crack. Yet once the artist began carving even a correctly seasoned piece of wood, it might be revealed to have knots and flaws, much as a seemingly perfect marble block could turn out to be unusable. Woods vary from hard to quite soft, and each has a slightly different cutting characteristic. Before he could begin to carve, the wood sculptor had to know much about his material—a knowledge obtainable only through the long apprenticeship common to all Renaissance artists.

The block of wood was roughed out with a saw and adze, an axlike tool with a long, flat iron blade. Wood sculpture is closely related to the craft of carpentry (in Florence the sculptors were in the same guild as the carpenters), and many of the techniques and tools of carpentry are also those of the wood sculptor.

After the figure or other object was roughed out, the sculptor began to work with chisels of many sizes and shapes to refine the form. These chisels, which were driven by wooden mallets, had to be razor-sharp to shape the wood in the desired fashion. Much experience was required to use the chisel correctly, for the angle at which it was held and the force of the mallet blow had to be varied to achieve different types of cuts. Whether the sculptor was cutting a figure or a relief, the material demanded the utmost subtlety and skill in the use of tools; consequently, there is often a marvelous restraint and delicacy about wood sculpture.

Wood is, of course, softer than stone and far less brittle. It lends

itself to fine, sharp carving. It is also far more forgiving than stone—mistakes can be removed, new blocks of wood attached and then recarved. Like other artists of the Renaissance, the talented wood sculptor utilized his material to the utmost. The best pieces, no matter how realistic or decorative, still have the look and feel of wood below the surface. The particular, undefinable mark of the sculptor's chisel in the wood—and often the overall shape of the statue—remind the onlooker of the nature and feel of the tree.

A number of surviving wooden statues appear unfinished. These figures—often of the crucified Christ or the Virgin and the Angel of the Annunciation—were carried in religious processions. Wood was chosen because of its lightness, an important consideration for those who had to carry the figures, often over considerable distances. Many of the figures were dressed with clothes before the procession began. The Virgin, for instance, might wear a dress of linen and the Angel a brocaded robe. With this in mind, the sculptor carved only the simplest indications of drapery on the figures, so that the statues look incomplete without the real clothes they once wore. Sometimes wooden statues were equipped with movable limbs, which could be adjusted into different positions. A single figure of Christ, for instance, could be carried in a procession as either the crucified Christ or the Christ of the Lamentation, depending on the religious occasion.

Wooden sculpture was frequently painted. As in panel painting, it was necessary to provide a support over the unstable wood. Layers of size, linen, and then coats of gesso were applied to the surface. When the gesso dried, tempera was used to paint the sculpture, often in a forceful, simple style resembling that of glazed terracotta.

The remarkable familiarity with materials possessed by all Renaissance artists, and their consummate technical skill—something seldom matched in the history of Western art—remain monuments to the highly developed workshop structure, a structure that was also geared to the production of a wealth of types in painting and sculpture.

68. Jacopo della Quercia, *Virgin,* San Gimignano, Collegiata. Polychromed wood. c. 1420.

Quercia's elongated, graceful painted wooden statue is paired with an equally masterful Angel of the Annunciation. Still reflecting the log from which it was carved, the statue is dressed in red drapery of stark simplicity. Because such figures were often clad in real clothes and carried in parades, it was unnecessary to carve them elaborately below the neck. Such Annunciation groups usually flanked the high altar of the church.

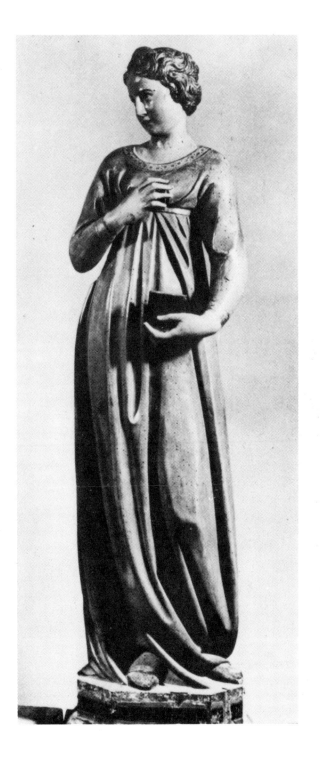

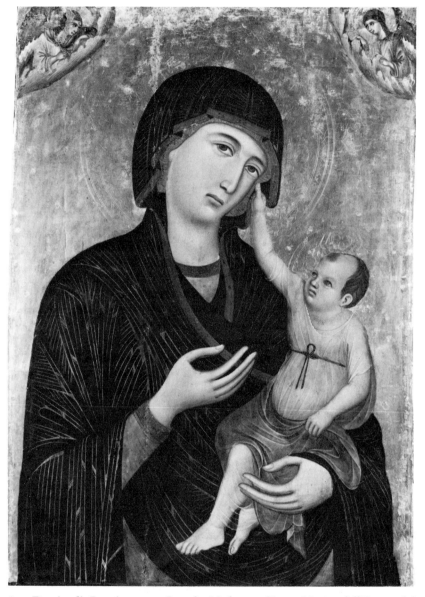

69. Duccio di Buoninsegna, *Crevole Madonna,* **Siena, Museo dell'Opera del Duomo. Tempera. c. 1280.**

This early painting by Duccio may have been commissioned for a monastery. An image for contemplation in which the Virgin shows her son to the worshipper, it is a moving example of the devotional panel, where all attention centers on the holy figures of Madonna and Child.

❦III❧
THE TYPES OF
RENAISSANCE ART

The work of Renaissance shops can be classified into various types. Tradition, both within society and within artistic education, demanded the repetition of types: for example, altarpieces fall into groups defined by shape or size or subject.

As needs changed, new types appeared, which would then be added to the repertoire. Consequently, it is often possible to date works by their subjects and their format: large gabled altarpieces most frequently date from the late thirteenth and early fourteenth centuries; small portable triptychs make their appearance around 1300; and so on.

The mentality of the Renaissance artist and his patron was conservative. A standard set of types had been established and the apprentice artist learned them by rote. Each type was well known to the patron, who commissioned it for some specific purpose and function. Today, when there are no standard types and artists strive for uniqueness and novelty, there are few visible mileposts. Contemporary painting and sculpture, consequently, often defy classification. But in the Renaissance the standardization of types was seen as a blessing, not a burden, for it added to the stability and confidence that so characterized Renaissance art. Of course, innovative and talented artists occasionally heavily modified or even changed some traditional types, but this was rare. For the most part, artists treated the types they inherited with respect; they were to be utilized and then passed on to the next generation of painters and sculptors. It is only in our century that traditional types have been regarded as stultifying and repressive.

The type of Renaissance painting that survives in greatest numbers is the altarpiece. These paintings, which are preserved in the thousands in museums and churches all over the world, for most of our period were made of wood, although around 1500 the use of canvas became popular. The variety of altarpiece types is great, ranging from the

extremely humble to the grandiose and gigantic.[1] The simplest and earliest of these altarpieces were single panels. Their subjects were manifold, but usually, like the panel itself, simple, straightforward, and uncomplicated.

Images of the Madonna and Child are among the most frequently encountered on the single panel. Half-length and full-length versions of the subject abound, in a number of readily discernible types. Like the panels themselves, the images of mother and child fall into certain broad categories; a number of these were utilized by artists working throughout the Italian peninsula, but many are specific to certain regions. The painters of Siena, for example, developed several Madonna types not seen elsewhere during that period. The particular localisms so characteristic of Renaissance art also appear in iconographic matters.

The central image of many single panels was frequently a full-length saint, either seated or standing. These powerful images, often frontal and iconic, were extremely popular during the early Renaissance, but as the fourteenth century progressed they became rarer, until, by the beginning of the 1400s, they almost entirely disappeared.

Often the saint, who appeared in single panels of a number of different sizes and shapes, was surrounded by scenes from his or her life and legend. These were narrated in a series of ancillary pictures flanking the figure; sometimes as many as twenty of these little scenes accompany the saint, serving as visual annotations on his or her image.

Many of these altarpieces were worshipped for particular reasons. For instance, the earliest depictions of St. Francis emphasize his miraculous healing power: of the small panels narrating his legend, a high proportion are devoted to his cures of the infirm or his powers of exorcism. In a society where the ability to heal physical ailments was limited, the wondrous cures of the saints and their relics held out considerable hope. During the Renaissance, pilgrims traveled long distances—as they still do—to pray to an image which, they hoped, would perform a miracle. The famous saint, his or her legend, and the iconic power of the painting or sculpture, all fused to create a potent object considered capable of performing miracles.

Many altarpieces from the Renaissance are made up of several independent panels attached either by hinges or some sort of screws or bolts. The simplest of these is the diptych, a type with origins in antiquity.[2] Diptychs, found in rectangular or gabled form, are usually quite small, sometimes not exceeding 30 centimeters. Because the diptych could fold in half, the painted part of its wings could be protected if it was moved. The diptych folded into a neat, small pack-

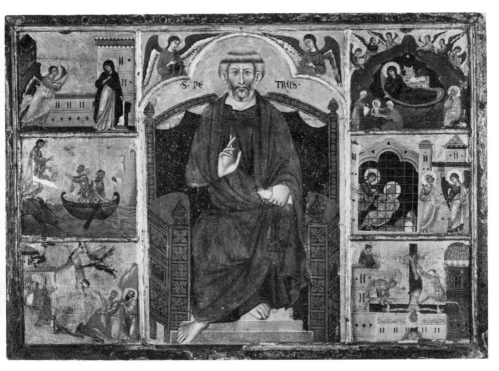

70. **Master of the St. Peter Dossal,** *St. Peter and Six Scenes,* Siena, Pinacoteca Nazionale. c. 1285.

Rectangular panels like this are among the earliest types of altarpieces. Combining both a hieratic image and smaller narratives to the side, the panel presented the central saint to the worshipper and offered examples of his or her life and miracles. The type went out of fashion around 1300.

age, which allowed it to fit into the pocket or traveling case of the pilgrim, monk, or merchant. At night it could be unpacked, opened, and set up. Although they now survive in only scattered examples, small diptychs must have been part of the luggage of thousands of Renaissance travelers.

Portable diptychs were painted with a number of subjects, but the most common seems to have been the Madonna and Child on one wing flanked on the other wing by the crucified Christ. Because, when closed, the backs of the portable diptychs were visible, they were often painted to simulate marble. Occasionally, they were decorated with the owner's coat of arms or other heraldic devices.

Decoration with fictive marble is also found on a number of triptychs, the other popular type of folding panel from the Renaissance.

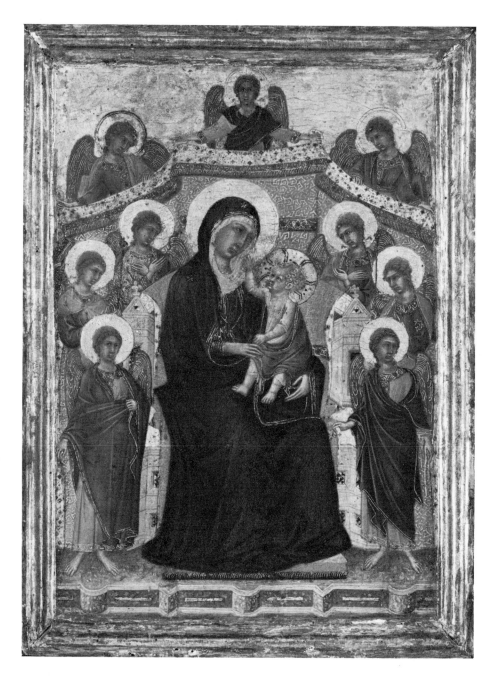

71. Duccio's Shop, Diptych, New York, Metropolitan Museum of Art, Lehman Collection. Tempera. c. 1310.

This small diptych composed of the Madonna and Child enthroned with angels and the

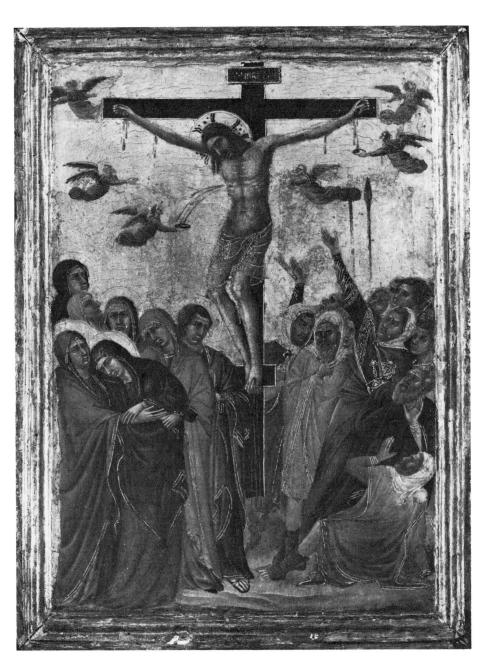

Crucifixion is a type popular during the late thirteenth and early fourteenth centuries. Often the backs of the panels were painted with decoration or coats of arms, or both, which were visible when the diptych was closed. As these objects were carried on voyages and set up at night, they had to be small and light.

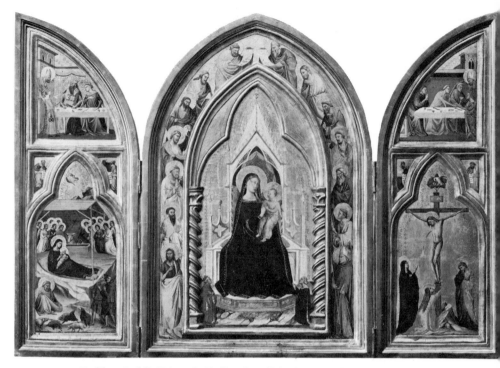

72. Taddeo Gaddi, Triptych, Berlin, Staatliche Museen. Tempera. 1334.
This elegant triptych is of a type popular around the 1330s. Set up on small altars in the home or in the headquarters of religious confraternities, it could be closed by folding the wings over the central painting. Because two miracles of St. Nicholas seen at the top of the wings occur at the dining table, it is possible that this altarpiece was meant to be placed in a room used for eating.

The first of the folding triptychs (altarpieces composed of three panels) date from around the late thirteenth century and are Tuscan in origin. Like the diptychs, these seem to have been made for the traveler. Furnished with small latches, and attached to bases so they would stand by themselves, the portable triptychs soon developed into an important painting type.

Like the diptychs, they were often commissioned from first-rate painters who made them into remarkable works of art. Usually larger than the diptychs, they could be more or less permanently set up in houses, as well as carried by travelers. A small domestic altar used by the extended family would not require a full-scale altarpiece. The smallish triptych, light enough to be moved into the sickroom or, if necessary, placed in the saddlebag, was the perfect size and weight.

The triptych type is also common to large, non-folding altarpieces.

A number of other folding panels existed for various purposes. One of the most interesting, and rarest, is the custodial: a winged set of panels that originally flanked a statue of the Virgin or other holy figure.[3] The custodials often were painted with numerous scenes from the life of Christ—so many, in fact, that with their tiny animated figures, they resemble comic books. Other folding panels were undoubtedly used to cover relics and protect valuable religious treasures.

The polyptych, an altarpiece of five or more interconnected panels, became popular around 1300. The type remained in fashion for several centuries throughout the Italian peninsula. In Florence and other centers, however, it became rarer after the first decades of the Quattrocento when it was slowly replaced by several varieties of large, unified paintings.

In the majority of cases the central, or main, panel of the polyptych was painted with images of the Virgin and Child, often surrounded by angels. The cult of the Virgin was omnipresent throughout the Renaissance, and her image, along with Christ's, is repeated in thousands of examples of every type of painting. Often, the figures of mother, child, and angels are accompanied by saints, who flank the throne on which the Virgin sits. Although the Virgin is occasionally depicted standing, this image never achieved the great popularity of the seated type.

As a rule, the polyptych's side wings are filled with saints. The main body of the polyptych with the Virgin and Child, and the saints in the side wings, thus resembled a horizontal rank of holy figures, all enclosed in the spatial niches of their own panels. As the worshipper looked up toward the altar, this array of holy beings, often depicted full-length, was an impressive sight indeed.

In the Renaissance, saints were important and their role in painting well defined.[4] Each had a specific legend. There existed a pantheon of saints venerated throughout the peninsula; these included, besides the Virgin, the four evangelists (Matthew, Mark, Luke, and John) and a number of early Christian saints (Peter, Paul, John the Baptist, Jerome, and many others). During the Middle Ages, more saints had been added to the rolls of those highly venerated figures of the early Church. Certain famous saints from more recent times were also the object of substantial cults: St. Francis of Assisi, and St. Dominic and St. Catherine of Siena, are examples of nearly contemporary holy people. Often, as in the case of St. Francis, canonization took place within a very short time of demise and newly sanctified figures were added to the familiar stock of images.

There were also hundreds of local saints, each with his or her own

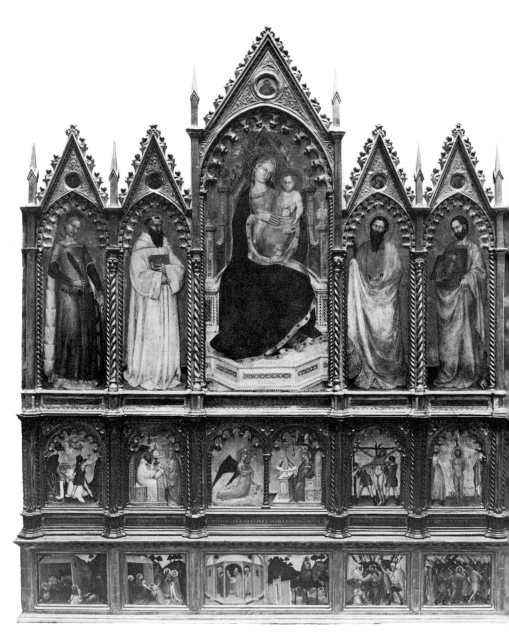

73. Giovanni da Milano, Polyptych, Prato, Galleria Comunale. Tempera. c. 1355.

This elaborate multi-leveled polyptych is one of the most splendid of its type. From left to right the wing saints are: Catherine of Alexandria, Bernard, Bartholomew, and Barnabas. Each stands over an episode from his or her legend. The Virgin is placed over the Annunciation. The lowest predella narrates five stories from the life of Christ from the Nativity to the Way to Calvary. It is rare to find two rows of predella panels.

legend. Every city, guild, confraternity, and profession had its special patron or patrons. Moreover, everyone had a personal saint, that holy person after whom he or she was named. Saints and their legends played a crucial part in almost every activity: someone afflicted with a toothache would pray to St. Apollonia; eye trouble was the specialty of St. Lucy; while on a journey, one prayed to St. Christopher. Other saints protected the poor, the criminal, the soldier, the seafarer—people in all walks of life.

In the polyptych, and in every other image, each saint had certain special characteristics that demonstrated exactly who and what sort of saint he or she was. Age and facial types were among the most distinguishing of all characteristics: Peter, for example, is always portrayed as old, gray-bearded and bald; St. Francis is gaunt and tonsured; and John the Baptist appears as young, hirsute, dark-complexioned. For each famous holy figure a set of conventions developed that usually allowed the worshipper to identify the saint by physical type alone.

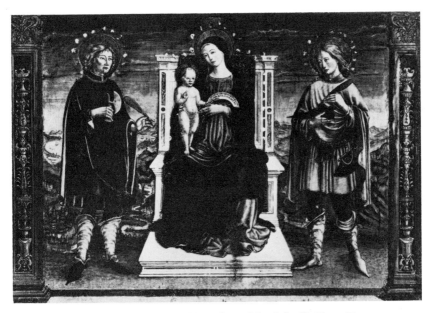

74. Andrea di Niccolò, Altarpiece, Siena, Santa Mustiola alla Rosa. Tempera. 1510.
Commissioned by the guild of Sienese shoemakers, this altarpiece depicts the patron saints of cobblers, Crispin and Crispinianus. They hold a leather cutting knife and a shoe. The saints wear especially beautiful soft leather boots, something sure to be appreciated by the shoemakers who paid for the painting. The rare motif of the roses in the saints' haloes occurs because the church is dedicated to Santa Mustiola alla Rosa.

Clothing also played a major role. Early Christian saints were identifiable by their toga-like robes; those recently canonized wore, for the most part, contemporary clothing—hose and short tunics, for example. Soldiers were recognizable by their military dress. Saints belonging to the religious orders were clad in the well-known habits of their orders: a black and white habit indicated a Dominican, a brown one a Franciscan, and so on.

To help with identification, many of the saints held or stood next to their attributes. These attributes were often related to their martyrdoms: the wheel of St. Catherine, Lawrence's gridiron, the flaying knife of Bartholomew, and scores of other objects added their testimony to the martyr's palm held by many of the saints. Hundreds of other saints were accompanied by a multitude of things related to their lives and miracles.

When a Renaissance worshipper looked at a polyptych with a number of saints painted on it, he was able to identify the figures and then place them within the context of his own life, occupation, health, and so on. The large body of common knowledge about the saints' particular miracles, and their protection of certain groups, made their images on the polyptych or, indeed, any Renaissance work of art, much more immediate and compelling than today. We see saints as historical, or symbolic; but the Renaissance perceived them as active forces who—like Christ—often moved from the pictures into the daily life of the city. Every Renaissance citizen had his special sets of saints to whom he prayed, and he knew that there were literally hundreds of others who could be called upon for special intervention and protection. Renaissance life was permeated by these saints and their stories to a degree we find hard to imagine.

Below the range of saints, angels, and the Virgin and Child on the main body of the altarpiece, there were often placed a series of smaller rectangular panels collectively called the predella.[5] *Predella* is the Italian word for step or foot board; in fact, the predella panels do serve as a sort of step or base for the larger panels above.

In most cases, the predellas contain scenes from the life and legends of the saints illustrated in the panels above. A *Nativity* or *Adoration of the Magi* was often placed in the predella panel beneath the Virgin and Child. The *Crucifixion of St. Peter* or *St. John the Baptist in the Desert* frequently were found under the representations of those two saints. The predella furnished a narrative comment on the figure or figures pictured above it. It illustrated, in many instances, the most famous episode of the saint's life, or one of his or her miracles, or perhaps a scene of martyrdom.

Many artists modified their styles slightly in the predellas. Although it is, for the most part, untrue that they adopted an entirely different style (as is sometimes claimed), they do seem to have worked in a freer, slightly broader way in the smaller panels. Perhaps this was simply an adoption of working methods to the smaller size of the predella, or perhaps it was due to the assignment of the predella panels to assistants.

Above the main panels were other smaller pictures. These pinnacle paintings are of widely varying shape and size. They, like the predella, have reference to the main panels. The most common subjects for the pinnacles are the *Annunciation, Christ Blessing,* and the *Crucifixion.* Usually the Angel and the Virgin of the Annunciation are each placed over one of the side wings, while the figure of Christ, either crucified or blessing, is set over the main panel. Consequently, the center panel, which frequently depicts the Virgin and Child, is bound below by the *Nativity* and above by the *Crucifixion.* This configuration is a synthesis of Christ's life, and depicts not only his image as a child but the events of his holy birth and his sacrifice for mankind. The concepts of birth and death embodied in these scenes would be understood by all those who participated in the Mass said before these images.

The polyptych was further decorated with a number of smaller panels attached to the pilasters on its sides. These often contained standing saints.

The number of polyptychs that still survives undamaged is small. When the fashion for Renaissance painting began in the nineteenth century, thousands of polyptychs were broken up: instead of selling just one work, unscrupulous dealers could sell six, eight, or ten panels from the dismantled polyptych. In a sense we should be grateful for this interest and market in Renaissance paintings.[6] It was much preferable to the older practice of burning them for the gold retrieved from their ashes, or using their wood to build furniture; yet the nineteenth- and twentieth-century dismantling of multi-paneled altarpieces and the sale of their panels separately resulted in the dispersal of hundreds of works that were integral just a century or so ago.

As the fifteenth century progressed, the polyptych increasingly gave way to large altarpieces painted on a single field. The demand for compositions united through the use of a single-point perspective, in most cases, made the multi-panel polyptych form outmoded. The newer altarpieces, usually either square or rectangular, could accommodate the unified construction and deep fictive space so sought after by Quattrocento artists.

Many of the features from the polyptych type survived in the new

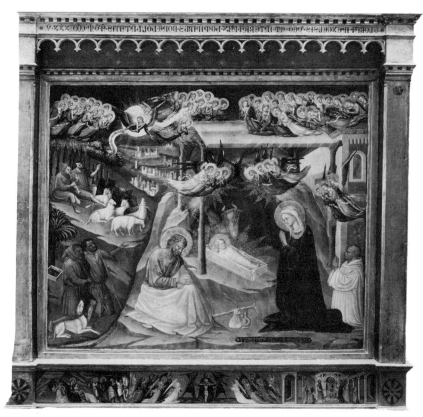

75. Bicci di Lorenzo, *Nativity,* Florence, San Giovannino dei Cavalieri. Tempera. 1435.

Bicci's altarpiece, dated 1435, is one of the first to be painted on a single, unified panel. The predella, side pilasters, and elaborately carved lintel are all original. Note also the wheel-like coats of arms of the church, San Giovannino dei Cavalieri. The unified altarpiece became increasingly popular during the fifteenth century.

form of altarpiece. The predella, for instance, is often found in the single-field works, although the grafting of the separate little panels produced a pictorial base not as unified with the upper level of the altarpiece as it had been in the polyptych, where each predella scene made a comment on the images above. Often small pilasters complete with panels were utilized for the single-field altarpieces. The pinnacles found over the polyptychs did not, however, survive the transition to the single panel. Instead, the new shape was frequently decorated with a wooden canopy, often painted with stars on a blue field or some other geometric decoration. These canopies, which strike the modern eye as slightly garish, survive in just a few examples; in the Renaissance, some were equipped with painted curtains used to cover the panel.

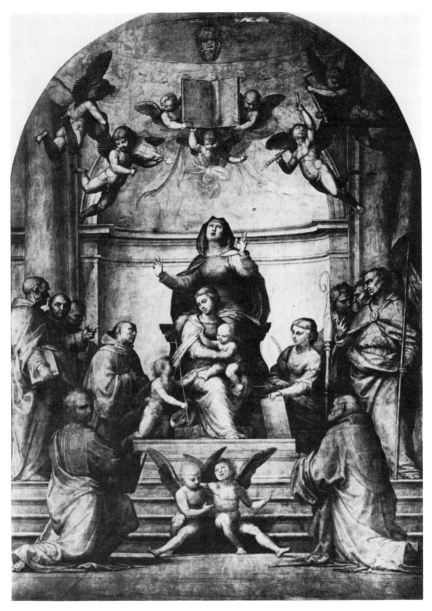

76. Fra Bartolomeo, Altarpiece, Florence, Museo di San Marco. Oil. 1510.

This large, single-field altarpiece is typical of a type popular in the early years of the sixteenth century. Grandiose in size and subject, such altarpieces are often tours de force of a highly rhetorical style. Great parts of Fra Bartolomeo's altarpiece are left unfinished, exposing the ground and extensive underdrawing; this is especially apparent in the saints to the right.

Around the beginning of the sixteenth century extremely large single altarpieces, sometimes using the light, flexible canvas support that had recently become popular, were painted in increasing numbers. These altarpieces often dispensed with the predella, which was now too small in comparison to the main field, and with the pilaster panels. With this development the altarpiece entered a new age very far from the smaller, single-panel altarpieces and triptychs of the Trecento. The way for the development of the giant late Renaissance canvas was now open.

The evolution of the altarpiece was not a Darwinian one. Certainly, one can trace general trends and fashions in the medium, shape, and size of the altarpiece, but there are many exceptions; the route was often circuitous. In provincial centers, for instance, old types gave way slowly or not at all. Sometimes patrons commissioned artists to anachronize, to make copies of older altarpieces in the hope of capturing some of their venerable, holy quality—the urge for old-time religion was always strong during the Renaissance.[7] In certain sections of the Italian peninsula (Venice, for example), altarpiece design seems until the sixteenth century to have been extremely conservative.

A clearer case of evolution can be traced in the painted cross.[8] These works, known as early as the eleventh century, hung high in the apses of many churches. The image of the crucified Christ was central to Christian dogma and, consequently, survives in thousands of examples. Almost every church was furnished with at least one cross and some of the largest had several.

The first crosses were complex: often life-size, they consisted of a central figure of the crucified Christ surrounded by scenes from his life and legend.

The cross with painted stories, occasionally equipped with a carved wooden figure of Christ at its center, was a compact, extremely developed type. Yet during the last quarter of the Duecento, it was gradually replaced by a new type with decorative pattern in the apron—the rectangular field around Christ—instead of stories. The cross was now almost exclusively focused on the figure of Christ, who became increasing human and pathetic.[9] The body gradually overtook more and more of the apron, effectively blocking the space and making narrative painting in this section impossible. The need to focus on Christ's humanity, and the desire to depict him in isolation, modified the older type—and forced the artist to work in a more naturalistic style.

By the early fifteenth century, few large crosses were produced. A new, smaller type in which the cross and Christ were cut out in silhouette found a limited popularity in Florence during the first part

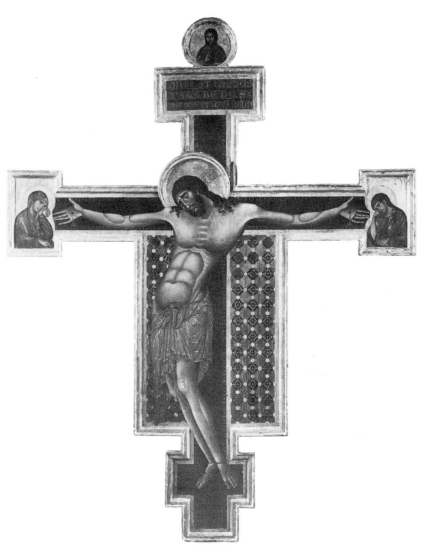

77. Cimabue, *Crucifix,* Arezzo, San Domenico. Tempera. c. 1280.

Cimabue's large painting, done around 1280, is one of the last in a long line of crosses
made to hang high in the choirs of churches. The monumental style and scale are in
perfect accord with the painting's size—336 × 267 centimeters.

of the Quattrocento. Because of their lightness and rather small size,
some of these crosses may have been carried in religious processions,
which would have been difficult if not impossible with the older, larger
crosses weighing hundreds of pounds.

The bases of some of the cut-out crosses depict kneeling members

78. Antonio Veneziano, *Flagellation of Christ,* Palermo, San Niccolò Reale. Tempera. 1388.

Below the scene of Christ's flagellation are inscribed the many names of the members of the flagellant confraternity that paid for the painting. The flagellant societies, like many other confraternities, commissioned numerous altarpieces, banners, and other types of painting, but little of this art survives.

of flagellant societies. The flagellants and scores of other confraternities and lay organizations were active commissioners of Renaissance panels. They purchased them for their altars in major and minor churches and for their meeting houses. But aside from the traditional altarpieces and crosses, the confraternities ordered types specific to their own varied needs. Few of these types have survived. As a result, we know almost nothing about their history or popularity, but the remaining examples afford a fascinating, if limited, glimpse into this lost world.

Gabled panels with the members' names inscribed on them must have been owned by many confraternities. One example of this type depicts the Flagellation in the gable and, underneath, lists the members of the flagellant society. Other types of painted registers must also have been quite common.

Processional paintings—used on the frequent religious feastdays—were also a necessity for many confraternities. We have just seen that crosses were often carried, but they were only one of many types held above the marching, robed members of the lay organizations of the Renaissance. Numerous standards—each painted with a very specific image—were also widely used. Many of the surviving standards are painted on durable, light linen. This material, stretched on rectangular frames held on long poles, could be carried for considerable distances with little strain. Because the standards were seen by the crowd both from the front, as the procession approached, and from the back, after the members had passed, they were usually painted on both sides.

These fascinating objects were found in every town in the Italian peninsula from the earliest times. They survive in the greatest numbers in Umbria, a region in central Italy, where they seemed to have been especially popular. Their strange, hieratic images of the Virgin and saints evoked to save the confraternities and commune from the plague, war, or other disasters are riveting. There is a static iconic quality about these standards, which derives both from a long, unchanging iconographic tradition and from the need for the artist to make images whose supernatural qualities could be powerfully and quickly understood as they were carried along. Modern standards, still strangely hieratic, are often carried in religious processions throughout Italy.

Many of the confraternities played an active role in caring for the poor, sick, and old. They were also often responsible for burying the dead and this, like hundreds of other activities of the Renaissance, involved functional art. There still exists a limited number of arched panels that made up the head and feet of biers. These, like the stan-

79. Niccolò da Foligno, Plague Standard, Kevelaer, Presbytery. Tempera (?). c. 1470.

This fascinating standard, meant to be carried in procession, depicts the Virgin and SS. Sebastian, Clare, Francis, Ruphinus, Victorinus, and Roch, imploring mercy from a wrathful Christ flanked by angels holding spears, to spare Assisi from plague. Below the saints is an accurate depiction of the city. SS. Sebastian and Roch were the saints most often invoked against the plague.

80. Sodoma (?), Bierhead, Siena, Pinacoteca Nazionale. Oil. c. 1500.

In Siena and other Tuscan towns, biers were often decorated with paintings. This example, originally set at the head or foot of the bier, depicts two members of a religious confraternity. The images on these biers are always direct and somber, and often, as here, eerie.

dards, must have been numerous and again were objects carried in procession.

The bierheads are painted with figures of the Virgin, Christ, the saints, and, occasionally, members of the confraternity. Often there is only one half-length figure to each panel, except in the case of Christ's *Pietà,* a suitable subject for a bierhead. In many cases, the figures are pushed to the foremost limits of the pictorial space; in this way, they achieve a closeness to the deceased that is most fitting for their purpose. Some of these panels are by remarkable artists, who have taken full advantage of their function to produce works of considerable power. The association of painting with death, of course, is integral to Renaissance art. The function and iconography of hundreds of chapels and thousands of altarpieces, as we have seen, revolved around the Mass and its promise of judgment, resurrection, and salvation for those buried in the church and for the worshipper.

Banners, drapes, and many other items made of cloth painted by professional painters were also commonly used by the confraternities and other organizations. Carried in procession, draped over biers, placed on altarpieces, hanging in the group's chapel or meeting house, these painted cloths were a vital part of organizational ritual. Similar objects were also ordered by the commune for the town hall and for the many civic processions held during the Renaissance. These processions—which celebrated local and religious festivals, the entry of rulers and prelates, and other special occasions—often furnished employment to numerous artists, who helped design the processional cars, arches, and other decorations that were a necessary part of the day.

Confraternities and Church authorities also employed artists to design and furnish stage sets for the religious pageants and spectacles held both inside the churches and in the piazzas before them.[10] These were sometimes quite elaborate affairs, in which actors would impersonate the holy figures. Children disguised as angels would announce the birth of Christ to a young woman dressed as the Virgin, while a painted cardboard dove of the holy spirit descended fom the church vaults on a wire. All this ephemeral art is, of course, lost, but documents and descriptions from the Renaissance testify to its widespread popularity.

Another type of Renaissance panel, the altar frontal or *paliotto,* was nearly omnipresent. Placed in front of the altar table, it was often composed of a field of pattern decoration in which was a central medallion, filled by a sacred figure. These altar frontals were probably done by special artists who, to judge by their often rather crude compositions, turned them out quickly and cheaply. Wear and changing

fashions have destroyed all but a few. The Church of Santo Spirito in Florence is one of several places where they remain in their original location in any number; in fact, the west transept of the church is one of the few parts of a Renaissance church to come down the centuries relatively untouched. It still retains, besides its decorative altar frontals, the altar tables and original altarpieces, all in their original positions.

Those many paintings commissioned by private citizens for their homes have also survived in small numbers only. This class of painting, like the altarpiece or altar frontal, was made with a well-defined function in mind. Unlike the altarpiece, however, many of the domestic painted objects were used physically: they carried or held things, and were in constant service, a fact responsible for their destruction through wear. Kept by succeeding generations of the same family, they were built to take years of handling. Most of the surviving works are in poor condition, some nearly destroyed by decades of use.

One of the most common painted objects found in the Renaissance home was the *cassone,* or chest. Renaissance buildings were made of stone and brick, materials that do not allow the easy construction of closets or other storage areas. Consequently, the *cassoni* were a necessary and common part of most Renaissance households.[11]

Chests, which came in standard sizes, were built by specialized workshops of carpenters under strict guild control. Because they were meant to last a lifetime, or more, the making of *cassoni,* and other furniture, was strictly regulated for quality—the same type of wood, for instance, had to be used throughout the construction of any single chest.

Many of the simple *cassoni* destined for the kitchen or storage rooms were just given a coat of paint by the carpenter and sent directly to the customer's home. But those chests (often furnished with moldings) that were to be decorated were delivered to the shops of artists, who made their living by painting them.

The unpainted *cassone* was first readied by a process similar to the preparation of a panel for tempera. The wood was sanded, filled, sized, then coated with gesso on both the inside and the outside. When the gesso was dry, it was gilded by a specialist, who covered the chest's moldings and pilasters with gold leaf.

Painting was done on the sides of the chest, on the front, on the inside and outside of the lid, and on the back. Wherever the chest stood (originally they all seem to have had feet), part of its decoration would have been visible. Painted chests were prized, expensive pieces of furniture.

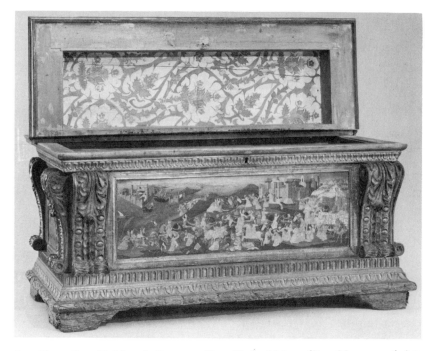

81. Florentine, Trebizond *Cassone,* New York, Metropolitan Museum of Art. Tempera. c. 1475.

Representing the conquest of Trebizond on the front, this chest is the only fully preserved *cassone* from the fifteenth century. Elaborately carved and gilded, it stands on four sturdy feet. The raised top reveals the stencil pattern common to many *cassoni* of the period. Such large, highly decorated chests must have been treasured possessions, passed down from generation to generation.

The inside of the finished chest was covered with linen or silk to protect its contents. The inside of the lid was often painted with a textile pattern applied with a stencil; on occasion, this same pattern appears on the lid's exterior.

Full-length female nudes and young men in various states of dress also appear alone on the inside of the lids. Exactly why these attractive figures are there is unknown. Certainly the nudes must have been considered slightly risqué; perhaps their function was similar to that of the contemporary pin-up.

Although chests were made for many occasions, those surviving in the greatest numbers were for marriages. They were bought by the bridegroom or given as gifts, and sometimes carried in the wedding procession. Wedding chests were usually made in pairs; consequently, their paintings often were connected closely. The earliest *cassoni* have

front panels divided into compartments, but by around 1430, this area was given over to a single field.

Ancient history, the Old Testament, and contemporary writers (Boccaccio especially) were the favored sources for *cassoni* paintings. Scenes were picked that had either direct or allegorical reference to both marriage and the roles of the newlyweds, particularly the woman. Modesty, fidelity, courage, bravery, submission, and other virtues

82. Fucecchio Master, *Cassone* Panel (detail), Waltham, Mass., Rose Art Museum. Tempera. c. 1470.

In this detail from a *cassone* panel, a wedding procession moves through a handsome piazza to enter a palace. To the right, a servant carries a *cassone,* undoubtedly made for the use of the newlyweds. The horse and fine saddle must also be gifts.

83. Shop of Apollonio di Giovanni, *Story of Esther, Cassone* Front, New York, Metropolitan Museum of Art. Tempera. c. 1460.

This animated *cassone* front depicts Esther's banquet held in a Renaissance loggia. The massive, rusticated palace and large church with its great dome make a splendid background for the lively procession and elaborately costumed guests. Such a scene must have been the ideal of Renaissance refinement, emulated by many contemporary wedding feasts.

were encouraged by the selected stories, which were meant to instruct as well as delight. These pictures were not only good examples for the couple; later, they served as important early lessons for their small children, who met them, so to speak, eye to eye. The Triumphs of Love and Chastity, the Meeting of Solomon and Sheba, numerous scenes from the *Odyssey,* the story of Esther are just a few examples from among many which, often quite subtly and obliquely, made important points about the conduct of married life.

Battle scenes from antiquity were also extremely popular. The movement and number of soldiers (many wearing golden armor) in landscapes provided a decorative texture ideally suited for painted furniture. However, in the last years of the Quattrocento, the fashion for painted chests faded. In their stead, elaborately carved *cassoni* were installed in the Renaissance home. Unpainted, these large, heavy chests were exclusively the product of the woodworkers.

Cassoni painters were also responsible for the decoration of other pieces of furniture. Beds with the head and footboards painted with religious or profane subjects were particularly popular in the Renaissance.

85. Florentine, Birth Tray *(Desco da Parto),* Berlin, Staatliche Museen. Tempera. c. 1430.

This birth salver depicts the *Birth of the Virgin* taking place in the sprightly architecture of the early fifteenth century. A train of women, some of them nuns, makes its way toward the birth chamber. To the extreme left, a man carries a round birth salver. Used to carry delicacies to the new mother, these objects were treasured.

84. Beccafumi, Part of a Painted Bed (?), Birmingham, Art Gallery. Oil. c. 1540.

It is likely that this comely figure (Venus ?) in a landscape painted by the Sienese artist Domenico Beccafumi once formed part of a bed. Although none of these painted beds has survived intact, records reveal that they were elaborate objects. The goddess of love and fertility, Venus, would of course be a most appropriate choice for the decoration of a bed.

86. Bartolomeo di Fruosino (?), Birth Tray *(Desco da Parto),* New York, Metropolitan Museum of Art. Tempera. 1428.

Seated on a rock and holding a pinwheel, the chubby infant on the back of this birth tray is a good-luck charm meant to ensure easy birth. The curious, and now unfathomable, inscription reads: "May God grant health to every woman who gives birth and to the father . . . may [the child] be born without fatigue or peril. I am an infant who lives on a [rock?] and pees silver and gold."

Aside from chests and other decorated furniture, the *cassone* workshops, along with the shops of panel painters, produced several types of painted wooden trays.[12] These were usually quite large, sometimes nearly a meter in diameter. Most of the surviving ones are *deschi da parto,* or birth trays. These seem to have been the most common type, although other trays were also commissioned for important events.

Both faces of the birth tray were often painted with scenes, symbols, or decorative patterns. Up to the first decades of the Quattrocento, the trays were twelve-sided, but this rapidly gave way to a circular shape. Often framed with a molding that also served as a rim, the trays were

used to carry fruit, sweets, and other presents to the new mother. Sometimes by a major artist, these handsome objects made attractive, long-lasting gifts.

Naturally, the subjects painted on the trays often refer to fertility, birth, or good fortune. Birth scenes where the woman (sometimes Anne, the Virgin's mother) is holding her infant in bed were popular. Other subjects were more allegorical: putti fighting, figures of infants with inscriptions, and triumphs were only three of many subjects, some of which still defy interpretation. The sources of these paintings were often episodes from Petrarch, Boccaccio, and other contemporary writers. Whatever their story or shape, many of these charming trays, along with the *cassoni,* are among the finest products of Renaissance art. Indeed, some of them are minor masterpieces.

The *cassone* painters and other artists were occasionally commissioned to paint decorative panels for the Renaissance home. These works, called *spalliere,* were set into the wainscoting of rooms, where they provided decoration and protection from the cold stone. Like the

87. **Domenico Ghirlandaio,** *Birth of the Virgin,* **Florence, Santa Maria Novella. Fresco. c. 1490.**

Ghirlandaio has set the *Birth of the Virgin* in the bedroom of a large, elaborately decorated Florentine palace of the late fifteenth century. Note the carved columns, the intarsia inlay of the wainscot paneling surrounding the bed, and the painted panels *(spallieri)* of frolicking putti.

tapestries and other wall hangings of the period, they were both functional and pleasing to the eye. There seems to have been no traditional number of these panels in any one room, and again the subject matter was probably widespread, ranging from dancing putti to scenes of classical mythology.

Surviving *spalliere* seem to date no earlier than the last decades of the Quattrocento. It may well be that the type evolved as a sort of substitute for the painted *cassone* then being rapidly replaced by the unpainted, elaborately carved chest. Certainly, their iconography was drawn from the same texts of ancient history and contemporary literature.

Spalliere were also used to display the family coats of arms or devices, either directly or allegorically by figures or other subjects. Whatever was painted on the *spalliera* had to provide a pleasing but quiet pattern or shape. The function of the *spalliera* must have been something like that of wallpaper or inlay: to decorate a room without overpowering it.

Another type of painting also displayed in the home, the portrait, underwent a remarkable development during the Renaissance.[13] The earliest known portraits date from the late Duecento, but these are not portraits in our sense of the word. They do not, in fact, accurately depict the facial likeness of their sitter. Instead, they present types:

88. Botticelli, *Venus and Mars,* London, National Gallery, Tempera. c. 1485.

Here a spent Mars is playfully mocked by satyrs lost in his armor. From across the picture, the sensuous, comely Venus gazes at her conquest, the god of war. The wasps *(vespe)* buzzing near Mars' head are probably a reference to the Vespucci family, whose palace this panel may have graced. The shape of the painting and its large figures seem to indicate that it was once set in a wooden wainscoting, probably, as its subject suggests, in a bedroom.

young, middle-aged, old, the king, the soldier, the pope. The sitter's station, age, and idealized image were represented rather than his or her actual face. This same type of portrait characterizes the many saints seen in the Renaissance: there is, as we have seen, a firmly established type for each.

During the early years of the Quattrocento, this kind of portraiture started to give way to something closer, although certainly not identical to, our modern conception of the portrait. The actual, unidealized likeness of donors and their families were introduced in increasing numbers into the frescoes of their chapels. These same people also began to make numerous appearances on altarpieces, where they are seen in the company of the holy figures—this must have been very shocking at first. The desire to immortalize oneself, to leave one's image for posterity, while certainly not new to the West, intensified during the Renaissance. The writing of history, memoirs, biography, autobiography; the planning of churches and, indeed, whole towns to a human scale; and the commissioning of donor portraits in *Nativity* or *Adoration of the Magi* scenes are parts of the same whole. By the early sixteenth century, the trickle of portraits had become a flood, and the likenesses of men and women were a common sight in thousands of homes and public buildings. That this tradition survives today, although usually in a debased form, is proved by the scores of portraits still commissioned to immortalize (albeit in a small way) a statesman, chairman of the board, or sports hero.

Independent panel portraits first came into popularity around the 1430s. These are almost all profile, and show only the head or head and upper part of the torso. By selecting the profile, the artist and sitter have chosen, either consciously or subconsciously, to portray the face in the least revealing way. While these early profile portraits seem to be based on the sitter's face, unlike contemporary Flemish portraits they do not tell us much about his (most of the earliest are men) or her personality. They are, in fact, emblematic, almost heraldic, in their rigidity and style. They demonstrate the sitter's age, facial features, dress (often an indication of social standing), and sometimes surroundings; but they reveal none of the essential qualities of individuality and psychic life we so prize in portraits. They are, indeed, like human coats of arms—wonderfully formal, beautifully wrought, but somehow devoid of the sparks of life.

By the late fifteenth century, portraiture assumed a more personal, more insightful, and less emblematic nature. The sitter turned from pure profile to three-quarter and full face, thus making direct eye contact with the onlooker. Portraits, including those probing self-

89. Piero della Francesca, *Portraits of Federigo da Montefeltro, Duke of Urbino, and Battista Sforza, His Wife,* Florence, Uffizi. Tempera. c. 1470.

In this brilliant and original double portrait, Piero places the sitters so that they will forever look at each other. This delicate, daring arrangement offsets much of the coldness inherent in the profile portrait where no eye contact is made between sitter and spectator. The Duke, dressed in brilliant red, is shown warts and all. We are told much about the lands he rules (this is an early example of the use of extensive landscape in portraiture) and the social position he holds, but we sense little of his character.

portraits by artists, began to concern themselves with the sitter's personality, history, and world—the last clearly shown by the surroundings into which the sitter now was placed. Not only were occupation, social rank, family, and dress stressed, but there was a new emphasis on individuality. Sometimes more than one sitter was portrayed, and a type of dramatic portraiture developed in which a story was told, or at least suggested. The life of the mind was revealed through gesture and glance—a whole new world of portraiture began to unfold.

This was true in many places in the Italian peninsula, but the most profound and moving of these portraits (now very like our conception of the type) were done in Florence and Venice. These new portraits are among the earliest acute psychological studies; they are, it could be argued, harbingers of the increasing self-analysis so characteristic of modern European history.

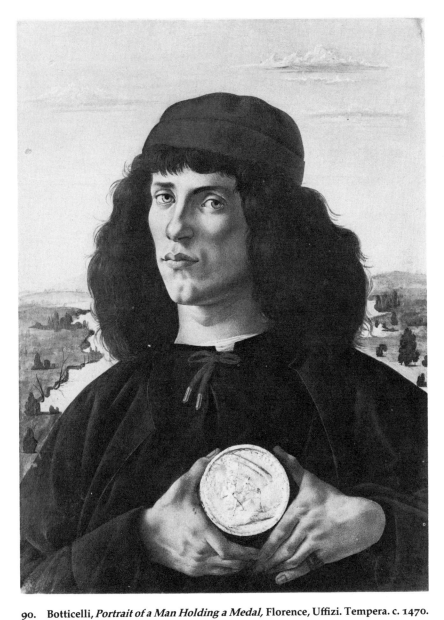

90. Botticelli, *Portrait of a Man Holding a Medal,* **Florence, Uffizi. Tempera. c. 1470.**
The identity of this young man is unknown, but it is possible that he is the author of
the medal he displays. This is an actual gilded stucco cast of a medal of Cosimo de'
Medici made around 1470 (see fig. 109). In three-quarter view before an extensive
landscape, the figure regards the spectator with a distant, melancholic gaze.

The Renaissance also witnessed the evolution of many types of fresco painting. This complex, demanding medium was used to decorate the large areas of wall created by the building boom of the cities. Hundreds of churches, town halls, and palaces provided artists decades of work in fresco. With its extensive wall space and host of private lay patrons, the church was one of the major locations for various fresco types.[14]

Fresco was especially well suited to the private chapel, where large areas of wall space could be decorated quickly and without enormous expense. The chapel covered with frescoes first became popular in the early Trecento; in fact, Giotto's Arena Chapel (c. 1310), often considered to be the greatest work in the medium, is among the very first of its kind. From the earliest examples onward, a more or less standard layout evolved.

Chapels were often divided into three large sections (see fig. 10). The vault, or ceiling, would be painted either with decorative motifs, such as gilded stars set against a blue field, or with saints or evangelists. This area of the chapel was usually purely decorative. The great exception is, of course, Michelangelo's Sistine ceiling. The decorative ceiling was the cap—the area that helped frame the narrative frescoes.

The lowest level of the chapel also had the same framing function. Often painted to look like marble (a technique that sometimes involved ironing the damp paint), this level extended from the floor to about waist height. It was the element from which the fresoces sprang.

Both the ceiling and the basement level were coloristically subdued. The ceiling's monochromatic blue served as a quiet foil for the frescoes. Even when the ceiling was covered with figures, they were carefully colored so as not to disturb the frescoes below. When the lower level was covered with the fictive marble decoration, its coloration was usually rather dark and monochromatic. Occasionally, small figures or objects were painted on the lower level, but these were also somberly colored.

Between the lower level and ceiling, a series of narrative paintings unfolded across the walls. The vast majority of chapels were covered with frescoes that together told a story—a fresco cycle. The arrangement of the frescoes, and their size and shape, were dependent on the site they were to cover. Sometimes the space was not ideal for painting, but the better artists were often able to overcome this difficulty with brilliant compositional solutions.

Usually separated by borders of geometric motifs or stylized leaf pattern, punctuated with busts of angels, prophets, and sibyls, the frescoes narrated their stories in several different fashions. But a verti-

cal development (up and down the walls) or a program carrying the story back and forth across the opposing walls were the most common schemes. Sometimes, the two methods were combined. There are many exceptions to these rules, for each chapel and each set of narrative frescoes had its own unique demands.

Most of the narrative scenes found on fresco cycles were drawn from the New Testament or from the many apocryphal legends circulating during the Renaissance. Occasionally, Old Testament stories are found, but these are rarer. The repertoire of stories became fixed by the fourteenth century; like technique and style, this repertoire was carried on, albeit with gradual modification, down to the sixteenth century and beyond. Artists and patrons alike thought in traditional patterns. When they imagined a fresco cycle, its iconography was the same as one of the scores of cycles they knew from childhood. When commissioned to paint a chapel, the artist responded in much the same way. From long experience he knew the basic compositional layout and figural arrangement of, say, a Baptism of Christ. He would repeat it by working within the traditional boundaries of that particular story. There was a mental set, encouraged by the workshop system, which demanded the transmission of a repertoire of accepted, but elastic, formal and iconographic conventions.

Many of the subjects chosen for the chapels were, as we have seen, concerned with death, resurrection, and salvation. Often the life and miracles of Christ were utilized to depict these great themes: the Baptism, the Resurrection of Lazarus, the Crucifixion, Christ's Resurrection, and the Last Judgment were just a few of the restorative narratives found in chapels all over the Italian peninsula. Often an altarpiece with the Virgin and Christ or with a scene from Christ's infancy would be placed on the altar as the centerpiece of the drama unfolding on the surrounding walls.

Sometimes there were more individual reasons for the stories chosen. As with panel paintings, frequently the patron wanted to honor the saint after whom he had been named. A Giovanni, for instance, might commission frescoes devoted to the life of St. John the Evangelist, while a cycle narrating St. Peter's legend could be the choice of a donor named Pietro. Patron saints were also honored; a person might have a special devotion for a saint who was believed to have worked in his or her behalf; other saints were chosen because they were the traditional patron of a guild, confraternity, or similar organization. On occasion, saints were depicted because they were venerated for more than one reason: St. John might be simultaneously a name saint, a protector of the city, and a patron of the guild.

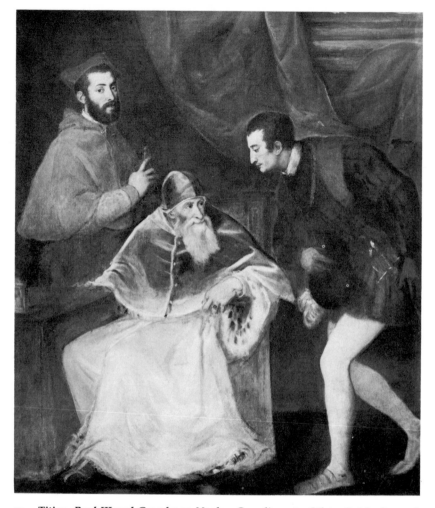

91. Titian, *Paul III and Grandsons,* Naples, Capodimonte. Oil (unfinished). 1546.

By the early sixteenth century, the portrait had achieved a psychological and dramatic depth unknown to the Quattrocento. Titian's great triple portrait of the silent dialogue between the withered but still cunning Pope and his fawning grandsons speaks volumes.

92. Paolo Uccello, *Monument to Sir John Hawkwood,* Florence, Duomo. Fresco. 1436.

When the soldier of fortune Sir John Hawkwood died in 1394, the Florentines wanted to honor him with a splendid tomb, but the English king requested that Hawkwood's remains be returned to his native country. Paolo Uccello's fresco, painted to imitate a marble monument, depicts Hawkwood and his stallion surmounting a sarcophagus placed on a stone table (very much like an altar table) supported by consoles.

IOANNES·ACVTVS·EQVES·BRITANNICVS·DVX·AETATIS·S
VAE·CAVTISSIMVS·ET·REI·MILITARIS·PERITISSIMVS·HABITVS·EST

·PAVLI·VCCELLI·OPVS·

Besides the chapel frescoes, there were other wall paintings in the churches. Most prominent of these were the large frescoes on the aisle walls. Sometimes these included cycles much like those found in the chapel, but there were also single frescoes, occasionally of considerable size. Less frequently found are the painted memorials. These are usually in the form of a fictive tomb surmounted by a depiction of the deceased. Exactly why these were commissioned is not known: perhaps they were a substitute for a real tomb, which could not be erected quickly enough to satisfy the commissioner; or perhaps they were painted just to save the expense of real marble or some other costly stone.

The plague saint was another image painted, both in fresco and on altarpieces, in considerable numbers during the Renaissance. Now surviving in only a few examples, large frescoes of these saints were painted in churches to ward off or stop a plague. These epidemics were a common and terrible feature of Renaissance life, their periodic sweeps claiming thousands. The Black Death of 1348 took nearly half the population of Florence, and many more thousands were killed throughout the Italian peninsula.[15] Certain saints (Sebastian foremost among them) were thought to protect against the plague, and during the sickness they were painted and carved with great frequency. Frontal, rigid, large, and static, these images must have seemed like potent protective icons. Countless painted and carved representations of Sebastian and other saints were carried in processions and displayed in church and home.

Images of other saints, painted in fresco, were also frequently found in the private home. Most prominent of these was a large St. Christopher, placed near the front door so that it would be seen every day and offer the inhabitants protection against sudden death. There were other sacred frescoes in the palaces of the wealthy—we know almost nothing about the wall decoration of the more humble dwellings. The Virgin and Christ were placed above doors in the hallways and in the living rooms, and additional saints were represented as well.

From the remaining evidence, which is far from definitive, it appears that only the more important rooms had walls covered with frescoes.

93. Benozzo Gozzoli, *St. Sebastian as Intercessor,* San Gimignano, Sant' Agostino. Fresco. 1464.

In this large fresco, the saint stands on a base covered with an inscription imploring him to protect the citizens of San Gimignano surrounding him. Angels placed around Sebastian's head break the plague spears thrown down by God the Father and an angelic host. Nowhere is the belief in the power of saints as intercessors more graphically shown than in this starkly iconic painting.

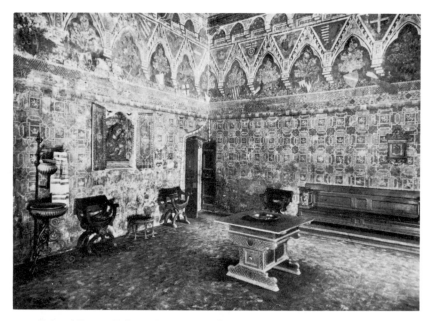

94. Painted Room, Palazzo Davanzati, Florence. Fresco. c. 1390.

This room in the Palazzo Davanzati, built in the fourteenth century, is covered from
floor to ceiling with contemporary frescoes. Below the fictive arches with trees and coats
of arms, the wall is painted to look like a tapestry suspended from a pole. Such decora-
tion must have been an inexpensive substitute for real, costly cloth hangings.

Thus the bedrooms and public areas might be painted, but walls in the
kitchen or servants' rooms were left blank. Often the painting con-
sisted of a decorative pattern that covered almost the entire wall. This
pattern was, in effect, not unlike a tapestry; indeed, it may have been
designed to be sort of fictive tapestry, a cheap, decorative wall cover-
ing.[16] Sometimes the tapestry pattern ends a meter or so below the
ceiling. The upper part of the wall is then given over to a painted loggia
through which trees and animals are seen, a scheme creating the illu-
sion that the room is open at the top.

Perhaps this type of wall painting was developed to provide a feel-
ing of openness and airiness to the inhabitants of rooms that had very
few windows and little natural light. On occasion, the entire wall was
painted with the representation of a forest where animals, hunters, and
flowers appear in profusion. These spectacular walls are now known
from only several examples, but there is good reason to suspect that
they were common during the Renaissance. Possibly influenced by
antique Roman frescoes known to the painters and patrons, they pro-
vide a tapestry-like pattern that enlivens the room.

Occasionally, the walls were painted with figures of the family and

their possessions, including, in Mantegna's famous Camera degli Sposi, horses and dwarfs. Other types of fresco painting surely existed in the thousands of palaces whose walls have either been destroyed or repainted since the Renaissance.

A great variety of fresco types was found in the town halls and the other civic buildings of the Renaissance.[17] Aside from the coat of arms and the city's other heraldic devices, there were also paintings that had a direct civic reference. One of these was the *Maestà:* the Virgin and Child enthroned surrounded by saints and angels. This type, which first came into popularity in the late Duecento, is not always infused with civic significance. But, the *Maestà,* especially in Siena, was often given a particular meaning by placing the city's patron saints in prominent positions. These beings were seen as special advocates, who would plead for the city's protection and well-being with the Virgin and her son.

95. **Agnolo Gaddi and Bartolomeo Bertozzo, Office Wall, Prato, Palazzo Datini.** **Fresco. 1391.**

Francesco di Marco Datini, a well-to-do merchant of Prato, a city near Florence, commissioned this extensive wall decoration for the office in his new palace. The expansive depiction of a forest imparts a spacious, open feeling to the room, while also serving as handsome decoration. Datini's large coats of arms are liberally placed around the room —he was a parvenu anxious for social standing. The Palazzo Datini is one of the few domestic structures of the fourteenth century to retain much of its original decoration.

Sometimes, as in the case of Simone Martini's fresco for the Sienese town hall, the *Maestà* was placed in a council chamber where those in charge of the government made their decisions. Inscriptions urged the governors to rule wisely so as to please the Virgin and her heavenly court, pictured in the painting. The power contained by every Renaissance image must have made the Virgin's exhortations impossible to dismiss lightly. In Siena, a similar image was placed on the high altar of the cathedral, the city's most important religious location. The fact that two such similar images were found in the key civic and ecclesiastic sites of the city demonstrates clearly the intermingling of the secular and sacred in the Renaissance.

Scenes of military exploits and pictures of captains of war on horseback, the famous *condottieri,* were also painted in the town halls. Feats of arms and generals played an important part in Renaissance life —warfare, like the plague, was endemic. Many of the cities were almost constantly at war, either to defend themselves from other territorial powers or because they wished to make their own conquests. It was, consequently, natural for them to memorialize these monumental martial events on the walls of their town halls: portraits of conquered towns (some of these seem to have been topographically accurate), frescoes of famous battles, and images of important, respected military men all appeared. The power of the city and its history of military success depicted on the walls of public buildings would, it was hoped, keenly impress citizen and visitor alike.

Contemporary events of a different nature were also seen on the outside walls of the town halls, where temporary paintings (their exact medium is unknown) portrayed the images of executed criminals. These paintings and others showing events in the life of the city, such as the expulsion of an evil ruler, acted as billboards, graphically advertising the more momentous deeds of the government.[18]

Models of civic virtue and heroic behavior in the ancient world were also illustrated. The Renaissance was keenly interested in antiquity; there was a strong desire to study it, to understand it, and to learn from it. Some scholars hunted in monastery libraries for undiscovered ancient works, while others began to remove the corrupting medieval accretions found, like barnacles, on most surviving ancient texts. A new historical awareness, both about the ancient world and its relation to contemporary society, arose. The concept of the Middle Ages—the dark period between antiquity and the Renaissance—was being born. One of the results of this new awareness was the revival of ancient mythology and a burgeoning interest in ancient history and art.[19]

In town halls and in many palaces, this new interest in antiquity was

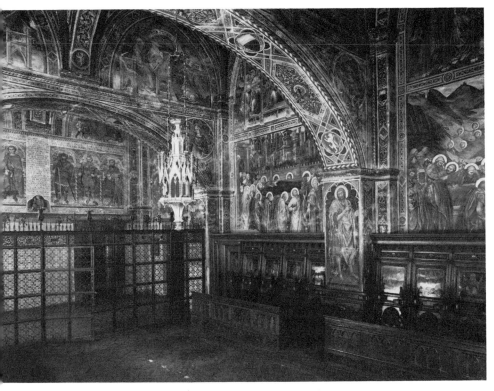

96. Taddeo di Bartolo and Others, Chapel, Siena, Palazzo Pubblico. c. 1410.

This large and sumptuously decorated chapel in the Sienese town hall demonstrates the close tie between Church and State in the Renaissance. The chapel's decoration—frescoes of the life of the Virgin, an altarpiece, inlaid choir stalls, and a gate—is similar to that found in scores of Sienese churches.

seen in frescoes of ancient heroes decorating the rooms and courtyards. These images—Old Testament and contemporary figures were sometimes included among them—acted as examples of civic and personal virtues. The loyalty, patriotism, and personal heroism prevalent in Roman history were inspirations to the Renaissance.

Complicated cycles of ancient history were also painted in the town hall and private home; these served as further examples of behavior considered ideal by the commune and the citizen alike. Other cycles and images were devoted to the city's ancestors—those Romans thought, rightly or wrongly, to have founded the place, or at least figured in its early history. (Of course, many cities in the Italian peninsula had no ancient origins, and it was therefore necessary to invent them, a task willingly accepted by the learned scholars and humanists.)

In the Renaissance, as we know, the image played a crucial role in society; this was perhaps the last period in which it was more powerful than the written word. But these images were not restricted to the insides of churches, private homes, and civic buildings. They were found in street tabernacles, structures of many sizes and shapes ranging from the humble and small to the expensive and grandiose. Almost all housed an image, sometimes an old, miracle-working one. Many were done in fresco, but they also existed in tempera, glazed terracotta, and other mediums. Often lit by votive lamps, these images of the Madonna, Christ, and the saints offered comfort to the passer-by. A quick prayer could be addressed to them, or a vow made. Today, their power survives; even the most casual visitor to an Italian town notices the bouquets of fresh flowers placed before these old images as tokens of gratitude. Their unswerving gazes are vivid reminders of the constant, powerful intercession of holy images in the life of the Renaissance.

Carved, modeled, and cast images were among the most potent of these. The volumetric, tactile objects reached an almost unparalleled level of quality and typology in the Renaissance as generations of talented, inventive sculptors succeeded one another. Large, stone statues, either full round or in niches, are found in numerous high places on the church: the facade, the sides of the building, and on the *campanile* (belltower).

Niche and free-standing statues charged with civic symbolism also appeared on or in front of public buildings. For instance, the Floren-

97. Simone Martini, *Guidoriccio da Fogliano,* Siena, Palazzo Pubblico. Fresco. c. 1330.

This large fresco depicts the soldier of fortune Guidoriccio da Fogliano riding before the two rebel towns he captures for his employer, the government of Siena. Feared, ruthless, and frequently duplicitous, military men like Guidoriccio were nevertheless often idolized during the Renaissance. Some of the finest works of art from the period commemorate such soldiers.

98. Street Tabernacle, Pisa.

Objects of special and often fervent devotion, street tabernacle were accessible at all times. These images of the Virgin and saints (which ranged from the humble to the grandiose) were often illuminated by oil lamps. This example, nearly covered with fresh flowers, reveals how important the type has remained.

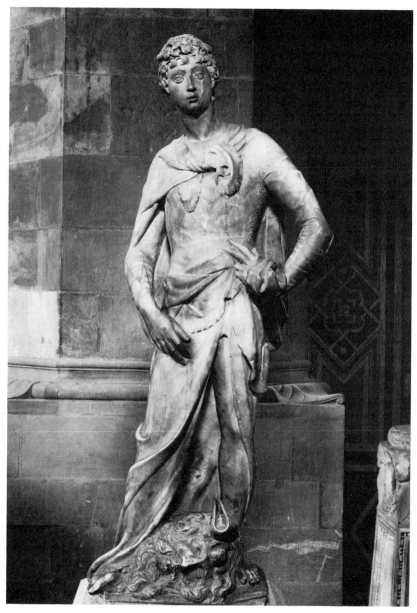

99. Donatello, *David,* Florence, Bargello. Stone. c. 1408.

Originally meant to be set on a buttress of the Florentine cathedral, Donatello's *David* was probably never put in place. Instead, it was installed in the town hall against a painted wall with the exhortatory inscription: "To those who strive bravely for their fatherland, the gods will lend aid even against the most fearful foes." The Florentines often thought of themselves as Davids facing gigantic foreign foes.

tines, who considered themselves republicans, were often engaged in wars with the noble rulers of Milan. This struggle against a much larger foe, whom they considered tyrannical, caused them to choose David as both their hero and symbol. What could be a more appropriate choice than the small, divinely guided shepherd boy who vanquished the evil giant Goliath? Other heroes from the Old and New Testament and ancient history were also carved and painted as symbols of Renaissance cities.

Statues were erected to honor contemporary heroes who had helped the cities preserve their independence. The most popular and influential type was the equestrian monument, a statue of a rider on horseback. Equestrian monuments were found in the ancient world, but they do not appear to have been made in great number after the collapse of Rome. Around 1400 the type reappears more frequently, although the earliest ones seem to have been made of rather impermanent material such as stucco or papier-mâché. These were probably used for official civic functions like state visits or funerals.

During the fifteenth century, perhaps under the influence of the two surviving Roman bronze equestrian figures, the Marcus Aurelius at Rome and the Regisole at Padua, there was a renewed interest in the type. Used mainly for monuments honoring *condottieri,* the Quattrocento equestrian figure found its most remarkable apex in the works of Donatello, Verrocchio, and Leonardo, although Leonardo's monument to Duke Francesco Sforza of Milan was never completed. This type was the direct ancestor of the thousands of mounted figures that still stand in parks from Sweden to South Africa. These stalwart men on their great horses (usually stallions) formed an image of virile heroism that was, until the very recent past, part of the visual vocabulary of millions throughout the world.

The difficult problem of designing, making, and combining man and horse was always a source of fascination for the sculptor. The horse, conceived of as a strong, noble, stately animal, was a constant inspiration to both Renaissance artists and their patrons, much the same way that we are attracted to sleek automobiles or jet planes. Many of the surviving equestrian figures, even the tiny bronze ones, are heroic conceptions, in which both rider and horse radiate a power and majesty seldom surpassed in the history of sculpture.

Throughout the Renaissance, the growing importance of individual personality also played a major role in the design and development of that final monument: the tomb. From the late Duecento to the sixteenth century, the tomb furnishes much information not only about the social status of its occupant (nearly always considerable), but also

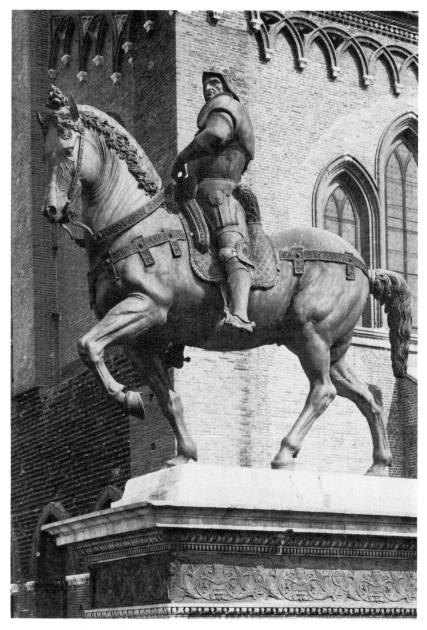

100. Verrocchio, *Colleoni Monument,* Venice, Campo SS. Giovanni e Paolo. Bronze. c. 1486.

Bartolomeo Colleoni spent much of his life as a soldier of fortune in the service of Venice. At his death in 1475, he bequeathed money for the erection of a bronze equestrian statue. On the basis of a wax model, the commission was given to Verrocchio, who created one of the most audacious and domineering of all such statutes.

about society's attitudes toward death. The statues and narratives carved by the sculptor are indicators of the patron's hopes and fears expressed in stone.

Many Renaissance tombs are wall tombs.[20] Set into or built against walls of churches, they are composed of the sarcophagus (sometimes influenced by Roman types) and ancillary figural and architectural decoration. From the earliest examples on, a nearly life-sized sculpture of the deceased was often placed on the sarcophagus. These images have an extremely interesting development: the first, which are not portraits in our sense, are, with a few startling exceptions, nearly all recumbent and obviously dead. But by the end of the fifteenth century, some of the sarcophagus figures are portrayed alive. These vigorous images echo the Renaissance's growing cults of personality and individuality, even after death.

Often, the sarcophagus itself is covered with relief sculpture illustrating scenes of Christ's resurrection, the *Noli Me Tangere* and other appropriate narratives, plus figures of virtues and saints. Infrequently, scenes from the life of the deceased are found as well.

Often the tombs were surrounded by an architectural framework, sometimes quite large and elaborate, that simultaneously set the tomb off from its surroundings in the church and called attention to it. In the case of outdoor tombs, found mainly in the north, a stone canopy was erected to protect the structure, which was sometimes furnished with a stone equestrian figure of the deceased. Marble of various textures and color, bronze, and glazed terracotta were employed for further decoration.

Like the tomb, the carved or cast portrait was meant to immortalize —to leave a record of the existence of the individual it represented.[21] The portrait bust first became popular around the middle of the Quattrocento. In ancient Rome, portrait busts of ancestors (many survived into the fifteenth century) were kept in the home, and this admired custom, along with the growing desire to memorialize the patron, was responsible for the production of many remarkable Renaissance busts, some of which were influenced by Roman examples. The same social circumstances that popularized the painted portrait created its sculptural equivalent.

The three-dimensional stone portrait bust was, however, somewhat more revealing of the sitter's personality. This was inevitable because the bust presented the sitter not only in two profiles but also full face, the most expressive view of the human head. Yet the dignified, stern faces of the men never became biographical. They were certainly portraits in the modern sense of the word and they presented the sitter

101. Andrea Sansovino, Tomb Design, London, Victoria and Albert Museum. Ink drawing. c. 1510.

This may be an early drawing for a tomb of a della Rovere cardinal in Santa Maria del Popolo, Rome. Attributed to Andrea Sansovino, the tomb, which bears the Rovere arms, was probably commissioned by Pope Julius II. The cardinal lies in the center; above and beside him are four Virtues and, at the top, the Madonna and Child. This highly finished and detailed drawing may have been the one on which the commission was awarded.

as an unique individual, warts and all—some were, in fact, remarkably realistic and forthright—but one still has to guess at the mind and soul that lies behind the face. There are certain notable exceptions to this rule, especially in busts of children and women, where the artist has animated the work, creating an inner life. But, on the whole, the portraits remain emblematic, rather like anthropomorphic coats of arms.

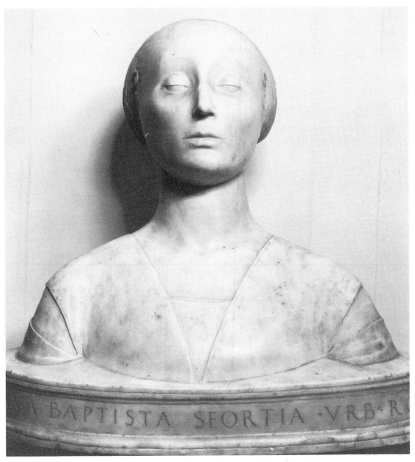

102. Francesco Laurana, *Battista Sforza,* Florence, Bargello. Stone. c. 1475.

This remarkable portrait of Battista Sforza, wife of Federigo da Montefeltro, is one of the treasures of Renaissance sculpture. Dressed in the elegant but severe fashion of the mid-fifteenth century, Battista is shown in the bust-length type popular at the time. Another image of this dignified woman appears in Piero della Francesca's dual portrait in the Uffizi (see fig. 89). It is possible that Battista was dead when Laurana was commissioned and that the portrait was made with the aid of a death mask.

Some of these busts, particularly those of women, are marvels of talented, subtle composition and carving. Executed by the most famous sculptors, they were often highly finished and carefully wrought, achieving a breathtaking delicacy. Facial features, hair, clothing, and hands (in the three-quarter-length busts) are of a remarkable refinement.

Other types of sculptural portraits were produced in considerable numbers during the Renaissance. One was posthumous: the death mask. The desire to record accurately the features of famous people in death seems to have taken root in the fifteenth century. Because of the custom of making death masks in plaster of Paris, we possess the exact likeness of—among others—Brunelleschi and Lorenzo de'Medici. Wax portraits were also known to the Renaissance. None has survived, although they appear to have been quite common. Placed in churches, and perhaps in homes, these objects were made in imitation of the ancient Roman practice of preserving ancestral portraits. Probably highly realistic, like heads in a wax museum, they must have been a striking, eerie part of many Renaissance churches.

Another class of full-round sculpture was found not in the Renaissance church but in the home. Small, free-standing bronze statues became extremely fashionable during the fifteenth and sixteenth centuries.[22] These little single statues or groups, usually depicting figures from classical mythology, or animals, were made for placement on the sideboard, table, or desk. The very fact that such objects were commissioned, collected, displayed, admired, and probably traded demonstrates that by the late Quattrocento a new attitude toward art had arisen. It was no longer simply to be worshipped, but now was bought and used to adorn the home, where it gave the owner pleasure, status, and prestige. This new attitude signals the advent of the modern conception of collecting.

Hundreds of these collectors' bronzes survive. Small Apollos, putti, sphinxes, Venuses, and satyrs by the score testify to the popularity of the type. Some have specific functions—bells, inkwells, candelabra, lamps—but most were made simply to be admired. They were picked up, held in the hand, touched, turned, and examined from many angles. Countless hands caressed the smooth, hard bronze, feeling the volumetric properties of the metal and shape through the fingertips. Intimate, sensuous works, with charming, exotic, whimsical, and often erotic subjects, they were almost more than anything else from the Renaissance, connoisseurs' things—objects for discerning eyes. Some were considered risqué, especially the scantily draped or nude figures of excited satyrs and voluptuous, enticing Venuses.

The conception and execution of these full-round bronzes differ greatly from the other major way of working sculptural material—relief.

One of the types to utilize relief most fully is the pulpit, a structure found in hundreds of Renaissance churches. Decorated pulpits, usually covered with abstract designs, were common until about the middle of the Duecento. This period saw the development of the pulpit equipped with narrative relief scenes of the life of Christ.[23] Raised on columns or attached to the wall, these structures had to be high enough to allow the crowd of listeners to see and hear the preacher. Entered by stairs, they contained room for just one or two people. The relief technique, which allowed the construction of a narrative with the inclusion of numerous figures and background space, was ideal for the crowded, complicated stories on these pulpits. Ancillary decoration, in the shape of small figures and carved architectural ornament, is also found.

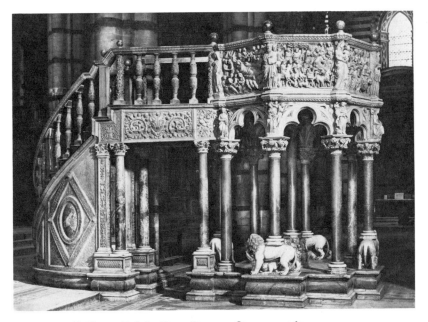

103. Niccolò Pisano, Pulpit, Siena, Duomo. Stone. c. 1265.
The pulpit, in wood or stone, was a fixture of many churches. Between 1260 and 1310 the father and son, Niccolò and Giovanni Pisano, executed four large, carved pulpits that are among the most remarkable of the type. This structure, intricately carved with episodes from the life of Christ, is supported by prowling animal caryatids. The fashion for such large, expensive pulpits seems to have faded after the early fourteenth century.

A number of imposing pulpits were created in many locations in the Italian peninsula. A series of these early marble pulpits by Niccolò Pisano and his son Giovanni set high standards both for brilliance of conception and skill of carving. Although mainly of marble, some pulpits of the period were cast in bronze. Many more of wood served as temporary platforms, used for preaching to great crowds outside the church or town hall. From the evidence of contemporary paintings, it appears that these wooden pulpits were undecorated things of a simple, almost rudimentary nature.

Closely related to the pulpit is another type of boxlike structure also raised above the floor level of the church: the *cantoria* or singing gallery. The two most famous examples of this type—by Luca della Robbia and Donatello—are large, rectangular objects, which held the singers who performed during the services. (We tend to forget at times that the many religious rituals of the Catholic Church were, and still are, always accompanied by music, the tinkling of bells, and the pungent smell of incense.) Often these singing gallerys were constructed out of wood and left unadorned. In the two costly marble examples by Luca della Robbia and Donatello, however, they are covered with high-relief sculpture of music-making and dancing angels. These two *cantorie* demonstrate a choice of design, subject, and technique perfectly suited to their function.

The understanding of the relation between function and design is nowhere more apparent than in the remarkable series of doors produced during the Renaissance. The large, sturdy portals of cathedrals, baptistries, and other religious structures had long provided a surface to be decorated by sculptors, and doors with wooden and bronze relief had been commissioned for several centuries before the Renaissance. Starting in the early Trecento, a number of extremely important bronze doors were executed, mainly in Florence, by sculptors of considerable talent.[24]

These sculptors understood that the basic function of the doors was to close off the structure, to make it safe by blocking entry from the street or piazza; they knew that the decoration could not contradict this function. Consequently, almost all the bronze doors, but especially those few produced before the first quarter of the Quattrocento, are decorated with figures and narratives that seem applied to the surface of the door. Large areas of fictive space are, for the most part, avoided or made unreal, so that the narratives never seem to penetrate the door and thus negate its solidity.

Moreover, this desire to harmonize compositional principles with function—a characteristic of all Renaissance art—was especially ap-

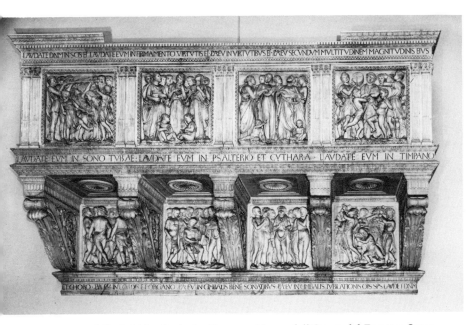

104. Luca della Robbia, Cantoria, Florence, Museo dell'Opera del Duomo. Stone. c. 1435.

Illustrating the 150th Psalm, Luca's cantoria depicts angels singing, playing musical instruments, and dancing. Originally placed high on the wall of the Florentine cathedral, it held a choir standing in the boxlike upper part. Although singing galleries were popular, very few were as finely carved or as expensive as this one.

propriate for the bronzes that were cast in parts, put together, and then actually bolted and screwed to the doors. Gilding parts of the bronze figures set them farther apart from their backgrounds, reinforcing the fact that they were entities applied to the door. Nearly all of the Renaissance bronze doors, each made at enormous expense, are marvels of sophisticated integration of form and function. This is amazing when one considers that they were huge projects, involving not only the master and his large shop but also a whole host of suppliers and foundrymen who did the actual casting. These high-quality doors stand as a monument to the perfection of the cooperative Renaissance artistic system.

Bronze, along with stone, was also the medium used for the decoration of baptismal fonts. Often located in baptistries separate from the church, the fonts had a civic as well as religious function, for baptism meant not only entry into the holy Church but also into citizenship. As in so many rituals of the Renaissance, there was here an inextricable blending of the sacred and the secular. Because of its dual function,

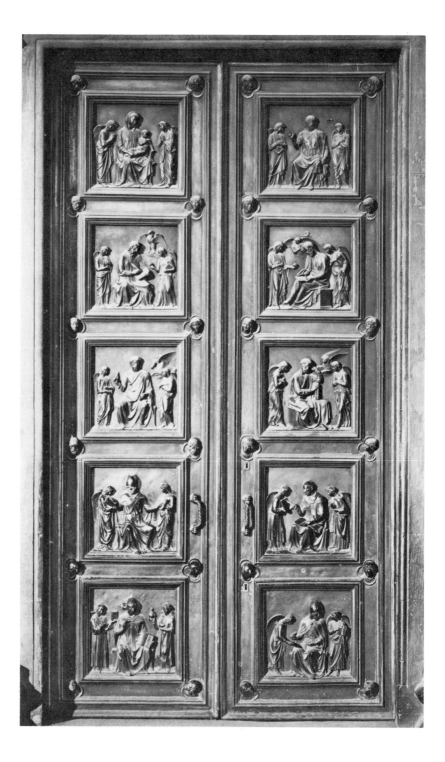

the font became an important monument that was often an object of pride to citizens and clergy alike.

Baptismal fonts, either round or faceted, might be decorated with considerable care and expense. Perhaps the most famous of these is in the Baptistry of Siena. Several of the most important Sienese and Florentine sculptors were commissioned to do a series of bronze reliefs of the life of St. John the Baptist, a subject common to many fonts. Ancillary bronze statues and stone architectural elements were also commissioned and set in place around the gilded bronze reliefs. Naturally, not all fonts are as glorious; in fact, the vast majority are much simpler objects, decorated with just a few stone reliefs or, in many cases, left plain.

Reliefs also appear on the fountains found in great number in the Renaissance city.[25] The construction of fountains, the principal water source, was often entrusted to sculptors. These men were responsible not only for the design and decoration but, frequently, for the supervision of the hydraulic system necessary to transport the water to the structure.

The location and use of a fountain often determined its size and decoration. Fountains in out-of-the-way locations used just by the neighborhood tended to be rather simply decorated or left plain. Those in the more important, visible locations—in front of the town hall or in important squares—were often the objects of much communal pride and expense.

In many of the hill towns of the Italian peninsula, water was scarce and could only be brought to the city with great difficulty. Consequently, the fountain was a sort of treasure house, as well as a source of civic pride. Each of these structures held a substance upon which the very existence of the city depended. The fountains were seen by the citizens with a perspective very different from our own.

Like almost all Renaissance objects, the fountain was a combination of elements that we consider both sacred and secular. No consistent, traditional iconography seems to have developed; rather, each fountain is nearly unique in its subject and decoration. One of the earliest and largest, created by Niccolò Pisano and his shop (c. 1278) in the Umbrian city of Perugia, contains reliefs and statues of fabulous animals, personifications of neighboring cities, saints, Old Testament

105. Luca della Robbia, Doors, Florence, Duomo. Bronze. c. 1469.
Luca's doors for the north sacristy of the Florentine Duomo are carefully designed to reveal much of the solid bronze fields on which the saints and angels are applied. The figures in the various panels are delicately adjusted to each other. The result is a door of both great visual strength and gracious decoration.

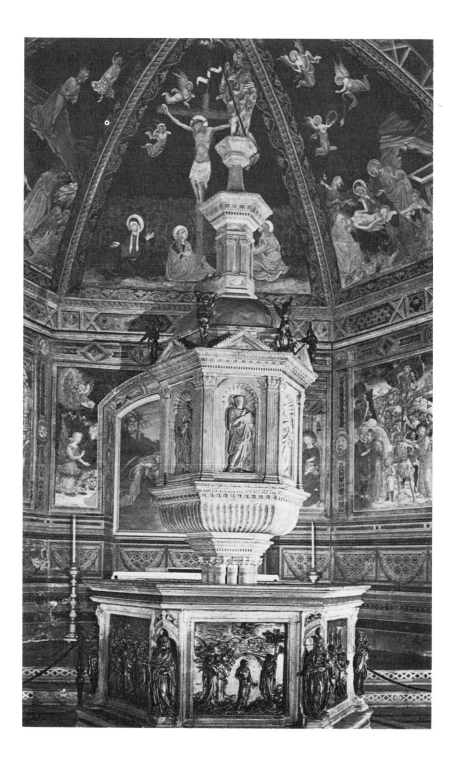

figures, and depictions of contemporary citizens. Made mainly of stone, but including also bronze figures, the Perugia fountain is a civic monument meant, like the cathedral or town hall, to impress citizen and visitor alike.

Fountains, many by famous sculptors, were constructed all over the Italian peninsula. Many are now lost, victims of the corrosive effects of water and time. Although frequently large, they were nearly always restrained in their design and in the delivery of water. The dramatic hydraulic displays of the Baroque fountains, which often replaced their calmer Renaissance predecessors, mark a new era in fountain design, one that was entirely appropriate to the larger, more grandiose visions of Baroque city planners.

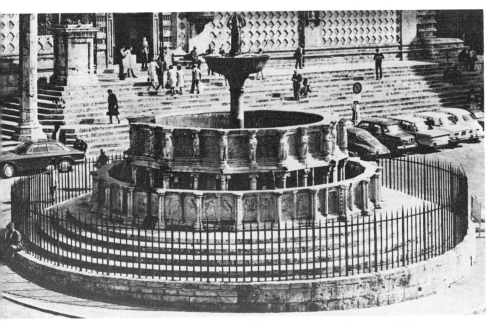

107. Niccolò Pisano and Shop, _Fontana Maggiore_, Perugia. Stone. c. 1275.

Water was a scarce and valuble commodity in Perugia and hundreds of other Italian hill towns. Often considerable expense was spent on the construction and decoration of fountains. Niccolò's grand structure, one of the largest, is carved with reliefs of the Labors of the Months, saints, the Liberal Arts, and historical and allegorical figures.

106. Baptismal Font, Siena, Cathedral. Bronze and marble. Early 15th century.

This font, begun in the teens of the fifteenth century, is one of the most elaborate and costly of its type. The bronze reliefs of the life of St. John the Baptist were commissioned from famous artists of the early Quattrocento: Jacopo della Quercia, Donatello, and Lorenzo Ghiberti, among others.

108. Riccio, *A Satyr Family,* Washington, D.C., National Gallery of Art. Bronze. c. 1500.

This charming plaquette shows a family of satyrs—lusty mythological figures often found on Renaissance bronzes. Spirits of the woods and mountains, they were endowed with a highly lecherous nature evident in this bronze plaquette, which was probably appreciated as much for its skillful modeling as for its mild eroticism.

There exists a number of relief plaquettes of varying size which, like many of the small bronze statues, were meant to decorate, among other objects, lamps, tabernacles, inkstands, and even hats.[26] These extremely lively depictions of sacred narratives, battles, and classical stories (to mention just three subjects), often have a sketchy, unfin-

ished quality that reveals much about the processes and art of bronze casting. Others are finely finished, delicately chased, and altogether polished performances. This range indicates that the small bronze, whether a statue or relief, was often destined for the connoisseur-collector—that new breed of patron who first made his or her appearance in the late Quattrocento.

To these collectors, material and process were probably as important as subject. They were, to put it another way, extremely interested in the formal properties of works of art. Color, shape, surface, light, and many other qualities were appreciated in their own right; the act of creation and the aesthetic of the work were now of considerable importance. Of course, throughout the entire Renaissance there were always some people who responded to art like this, but toward the sixteenth century their number increased and their admiration became formalized in the acts of buying, collecting, and writing about art.

Some of these collectors—they included humanists and princes, and hundreds of lesser figures, both men and women—were immortalized in another form of bronze relief, the medal.[27] Medals, which could usually fit into the palm, were probably first made in imitation of ancient coins bearing the portraits of rulers. Some so-called proto-medals were made in the north of the Italian peninsula during the late Trecento, but the real era of medal production begins only around the middle of the Quattrocento.

Made mainly of bronze, medals were used for many purposes. For example, they were worn around the neck or on one's hat or cloak, collected and hung in medal cabinets, scattered in the foundations of buildings to commemorate the start of construction, and sent as gifts.

Most medals were worked on both sides: the obverse and reverse. On the front was, most often, the head of the person commemorated by the medal. (Infrequently, buildings or other subjects appeared on the front.) These heads, often lively and wonderfully designed, are among the most remarkable profile portraits of the Renaissance. The portrait medal must have served much as an official photograph does today. Because medals were usually made in more than one example —sometimes dozens were produced—the sitter's image could be circulated. Indeed, the medal probably furnished for many a fascinating, unique glimpse of the political, dynastic, and military celebrities of the Renaissance.

On the back of the medal the sitter's device, or emblem, was often found. Occasionally a building or, more interestingly, one of the sitter's famous deeds appeared. The front gave the image, but the back often made a point or told a story.

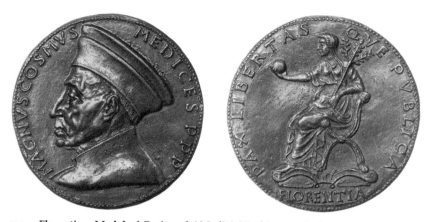

109. Florentine, Medal of Cosimo de' Medici, Washington, D.C., National Gallery of Art. Bronze. c. 1470.

This medal of Cosimo de' Medici (1389–1464) appears in Botticelli's portrait of an unknown man (fig. 90). The medal's obverse shows the aged Cosimo; the reverse displays a figure of Florence holding both orb and olive branch. From other portraits we know that the image of Cosimo is indeed accurate.

Of course, the medal is a relatively flat object, made in quite low relief. It was meant to be picked up, held in the hand, and touched. The finest medalists realized that everything about the medal—its images, texture, size, and weight—had to be geared to this sort of appreciation. Space was held to a minimum, and a harmonious balance of image and lettering was one of the principal goals.

The lettering of the inscriptions on medals, an important part of the identification of the sitter and his or her deeds, is among the most remarkable in the history of European art. Strongly influenced by Roman inscriptions, the shape and size of the individual characters are often remarkably fine. The rhythm of letters and words—which frequently run around the medal, surrounding the images on the front and back—is particularly stately and measured.

Like the equestrian statue, the commemorative medal has outlasted the Renaissance. That it is still a popular art form is proved by the many advertisements for medals in gold and silver in popular magazines today. Related to coins bearing portraits of the king, emperor, or president, the medal still contains some of the old iconic power of the image, although the dies from which modern medals are made make them stiff and mechanical compared to their cast Renaissance ancestors.

The medal is a typical Renaissance work of art. The product of both sculptor and bronze caster, the medal took shape in a collective artistic environment. Although a replicated type, almost all surviving medals

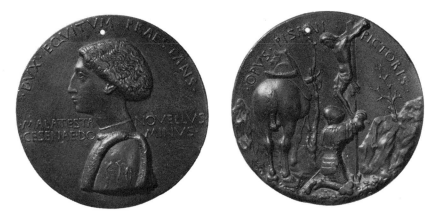

110. Pisanello, Medal of Domenico Novello Malatesta, Washington, D.C., National Gallery of Art. Bronze. c. 1445.

Domenico Novello Malatesta (1418–1465) was the Lord of Cesena, a city in central Italy. Pisanello, the most accomplished medalist of the fifteenth century, has depicted him twice: on the obverse, in profile, and on the reverse, in full armor kneeling before a crucifix. The haunting, enigmatic scene on the reverse, the fine profile portrait, and the splendid lettering, all testify to Pisanello's remarkable imagination and skill.

show a degree of craftsmanship that testifies to the success of the artistic education their creators received.

The very fact that the medal often carries an actual portrait, usually of its patron, indicates the growth of the fascination with the individual and his deeds. But it was not only the sitter's identity that interested those who collected medals and other small bronzes, for many of these men and women were also connoisseurs, who appreciated the medal both as a record of its sitter and as a work of art in the most formal sense. Moreover, the medal's appeal was heightened by the fact that it was derived, so the collectors thought, from an antique type and because it bore inscriptions, most often in Latin, inspired by Roman lettering.

All forms of Renaissance art from the giant fresco to the desk-top bronze belong to types. These types lasted for a century or more and characterize Renaissance art, just as their material and style characterize them. The world of the Renaissance artist was distinguished by the skill, appropriateness, and utility of what he made, as we have observed throughout this book. Nowhere can this be seen better than in the clearly defined typological structure of Renaissance artistic production, in which established categories existed, each with its specific function and form. In almost all facets of his work, the Renaissance painter or sculptor met with a stability, tradition, and certainty that we find hard to imagine, but that was to him the bedrock of his art and life.

NOTES

Introduction

1. The rise of the cities and communal Italy: D. Waley, *The Italian City-Republics*, London, 1969; J. Hyde, *Society and Politics in Medieval Italy: The Evolution of the Civic Life, 1000–1350*, New York, 1973; J. Larner, *Italy in the Age of Dante and Petrarch 1216–1380*, London, 1980.

2. Early town life: D. Herlihy, *Pisa in the Early Renaissance*, New Haven, Conn., 1958; J. Hyde, *Padua in the Age of Dante*, Manchester, 1966; D. Herlihy, *Medieval and Renaissance Pistoia*, New Haven, Conn., 1967; J. Hook, *Siena: A City and Its History*, London, 1979.

3. Renaissance mercenary: G. Trease, *The Condottieri*, New York, 1971; M. Mallett, *Mercenaries and Their Masters*, Totowa, N.J., 1974.

4. Renaissance families: R. Goldthwaite, *Private Wealth in Renaissance Florence*, Princeton, N.J., 1966; F. Kent, *Household and Lineage in Renaissance Florence*, Princeton, N.J., 1977.

5. Renaissance Florence: M. Becker, *Florence in Transition*, 2 vols., Baltimore, 1967–68; G. Brucker, *Renaissance Florence*, New York, 1969; G. Holmes, *The Florentine Enlightenment 1400–1450*, New York, 1969.

6. The Renaissance palace: A. Schiaparelli, *La casa fiorentina e i suoi arredi nei secoli XIV e XV*, Florence, 1908; G. Chierici, *Il palazzo italiano dal secolo XI al secolo XIX*, Milan, 1964; R. Goldthwaite, "The Florentine Palace as Domestic Architecture," *American Historical Review*, 77(1972), 977–1012; R. Goldthwaite, *The Building of Renaissance Florence*, Baltimore, 1980.

7. Renaissance occult beliefs: W. Shumaker, *The Occult Sciences in the Renaissance*, Berkeley, 1979.

Chapter I: The Artist in Society

1. Workshop: M. Wakernagel, *Der Lebensraum des Künstlers in der florentinischen Renaissance*, Leipzig, M. Wackernagel, *The World of the Florentine Renaissance Artist*, trans. A. Luchs, Princeton, N.J., 1981; U. Procacci, "Di Jacopo di Antonio e delle compagnie di pittori del Corso degli Adimari nel XV secolo," *Rivista d'arte*, 35 (1960); 3–70; A. Chastel, *Studios and Styles of the Italian Renaissance*, New York, 1966; J. Larner, *Culture and Society in Italy 1290–1420*, New York, 1971, 285–309.

2. Work done without commissions: B. Cole, "The Interior Decoration of the Palazzo Datini in Prato," *Mitteilungen des Kunsthistorischen Institutes in Florenz,* 13 (1967), 61–82. See also H. Lerner-Lehmkuhl, *Zur Struktur und Geschichte des florentinischen Kunstmarktes im 15. Jahrhundert,* Wattenscheid, 1938.

3. Apprentices: Larner, 285–297; V. Ottokar, "Pittori e contratti d'apprendimento presso pittori a Firenze alla fine del dugento," *Rivista d'arte,* 19 (1937), 55–57; D. Chambers, *Patrons and Artists in the Italian Renaissance,* Columbia, S.C., 1971, 188–189.

4. Roles of master and apprentice in one fresco: B. Cole, "Some Sinopie by Taddeo Gaddi Reconsidered," *Pantheon,* 24(1976), 99–102.

5. Working relation between painters and sculptors: J. Pope-Hennessy, "The Interaction of Painting and Sculpture in Florence in the Fifteenth Century," *The Journal of the Royal Society of the Arts,* 117 (1969), 406–424; U. Middeldorf, "Some Florentine Painted Madonna Reliefs," *Collaboration in Italian Renaissance Art,* New Haven, Conn., 1978, 77–84.

6. Window painting: H. Van Straelen, *Studien zur florentiner Glasmalerei des Trecento und Quattrocento,* Wattenscheid, 1938; G. Marchini, *Italian Stained Glass Windows,* London, 1957.

7. The architect: Larner, 303–309.

8. Number of artists in Siena: J. Hook, *Siena: A City and Its History,* London, 1979, 111.

9. Artists' families: Larner, 289–290.

10. Artists' guilds: R. Ciasca, *Statuti dell'Arte dei medici e speziali,* Florence, 1922; Larner, 298–303.

11. Confraternities: G. Monti, *Le confraternite medievali dell' alta e media Italia,* 2 vols., Venice, 1927.

12. Neri's commissions: Neri di Bicci, *Le ricordanze,* ed. B. Santi, Pisa, 1976.

13. The wealth of some Florentine artists: M. Becker, "Notes on the *Monte* Holdings of Florentine Trecento Painters," *Art Bulletin,* 46 (1964), 376–377.

14. Florentine tax returns: G. Brucker, *The Civic World of Early Renaissance Florence,* Princeton, N.J., 1977, 403–406, 444–447; G. Brucker, *The Society of Renaissance Florence,* New York, 1971, 1–13; D. Herlihy and C. Klapisch-Zuber, *Les toscans et leurs familles,* Paris, 1978.

15. The will and other legal documents: Brucker, *Society,* 49–61.

16. See note 12.

17. Cennini's book: Cennino Cennini, *The Craftsman's Handbook,* trans. D. V. Thompson, New York, n.d.

18. Neroccio's inventory: G. Coor, *Neroccio de' Landi,* Princeton, N.J., 1961, 152–159.

19. Jacobello's possessions: C. Gilbert, *Italian Art 1400–1500,* New York, 1980, 28.

20. Artists' writings: J. Schlosser Magnino, *La letteratura artistica,* ed. O. Kurz, Florence, 1964.

21. Alberti: Andrea di Tommaso, "Alberti," *Dictionary of Italian Literature,* ed. P. and J. Bondanella, Westport, Conn., 1979, 4–6; L. B. Alberti, *On Painting and on Sculpture,* trans. C. Grayson, London, 1972.

22. Ghiberti: R. Krautheimer, *Lorenzo Ghiberti,* 2 vols., Princeton, N.J., 1970.

23. Vasari: T. Boase, *Giorgio Vasari: The Man and the Book*, Princeton, N.J., 1979.

24. Cellini: B. Cellini, *Autobiography*, trans. G. Bull, Harmondsworth, Middlesex, 1977.

25. Michelangelo's letters: *Letters of Michelangelo*, trans. E. Ramsden, 2 vols., London, 1963.

26. Leonardo's Notebooks: *The Notebooks of Leonardo da Vinci*, ed. J. P. Richter, 2 vols., New York, 1970.

27. For Cennini, see note 17.

28. The rise of the art academy: N. Pevsner, *Academies of Art Past and Present*, Cambridge, 1940.

29. Concepts of artistic creativity: R. and M. Wittkower, *Born Under Saturn*, New York, 1963; E. Kris and O. Kurz, *Legend, Myth and Magic in the Image of the Artist: A Historical Experiment*, New Haven, Conn., 1979.

30. The Mass: J. Jungmann, *The Mass of the Roman Rite*, New York, 1959; J. Jungmann, *The Eucharistic Prayer*, London, 1966.

31. Florentine churches and their furnishings: W. and E. Paatz, *Die Kirchen von Florenz*, 6 vols., Frankfurt-am-Main, 1940–54.

32. Renaissance wrought iron: G. Ferrari, *Il ferro nell'arte italiana dal medio evo al neoclassico*, Milan, 1909; G. Marangoni, *Il ferro battuto*, Milan, 1926.

33. Communal buildings: W. Braunfels, *Mittelalterliche Stadtbaukunst in der Toskana*, Berlin, 1966; E. Southard, *The Frescoes in Siena's Palazzo Pubblico, 1289–1539: Studies in Imagery and Relations to Other Communal Palaces in Tuscany*, New York, 1979.

34. Renaissance palaces: See Introduction, note 6.

35. Popular painting: B. Cole, "A Popular Painting from the Early Trecento," *Apollo*, 101 (1975), 9–13.

36. *Cassoni:* P. Schubring, *Cassoni, Truhen und Truhenbilder der italienischen Frührenaissance*, 2 vols., Leipzig, 1915; E. Callmann, *Apollonio di Giovanni*, Oxford, 1974.

37. Communal sponsorship of churches: Hook, 53–70.

38. Purchase of finished panels: See note 2.

39. Artists' contracts: Larner, 335–348; D. Chambers, 9–16; Gilbert, 21–35.

40. Matteo's contract, trans. by C. Gilbert: Gilbert, 38–40.

Chapter II: The Materials of Renaissance Art

1. Tempera painting: C. Cennini, *The Craftsman's Handbook*, trans. D. V. Thompson, New York, n.d.; D. V. Thompson, *The Practice of Tempera Painting*, New Haven, Conn., 1936; D. V. Thompson, *The Materials and Techniques of Medieval Painting*, New York, 1956; N. Brommelle and P. Smith, *Conservation and Restoration of Pictorial Art*, London, 1976.

2. On panels, frames, and frame types: see M. Cämmerer-George, *Die Rahmung der toskanischen Altarbilder im Trecento*, Strasbourg, 1966; C. Gilbert, "Peintres et menuisiers au début de la Renaissance en Italie," *Revue de l'Art*, 37 (1977), 9–28.

3. Important exhibitions of restored pictures: U. Baldini and P. Dal Poggetto, *Firenze restaura*, Florence, 1972; *Mostra di opere d'arte restaurate nelle province di Siena e Grosseto*, Genoa, I, 1979; II, 1981.

4. Oil painting: C. Eastlake, *Methods and Materials of Painting of the Great Schools and Masters*, 2 vols., New York, 1960; A. Laurie, *The Materials of the Painter's Craft*, London, 1910; M. Doerner, *Materials of the Artists and Their Use in Painting*, trans. E. Neuhaus, New York, 1949; Brommelle and Smith, *Conservation*; B. Chaet, *An Artist's Notebook: Technique and Material*, New York, 1979.

5. Fresco: Cennini, *Handbook*, 42–64; Thompson, *Materials and Techniques*, 69–73; G. Vasari, *Vasari on Technique*, trans. L. Maclehose, New York, 1960, 221–225; U. Procacci, *Sinopie e affreschi*, Milan, 1961; *The Great Age of Fresco*, New York, 1968; U. Procacci and L. Guarnieri, *Come nasce un affresco*, Florence, 1975; E. Borsook, *The Mural Painters of Tuscany*, Oxford, 1980.

6. The problem of master and apprentice working on the same fresco: B. Cole, "Some Sinopie by Taddeo Gaddi Reconsidered," *Pantheon*, 24 (1976), 99–102.

7. Drawing: J. Watrous, *The Craft of Old-Master Drawings*, Madison, Wis., 1967; B. Degenhart and A. Schmitt, *Corpus der italienischen Zeichnungen*, 7 vols., Berlin, 1968– ; C. De Tolnay, *History and Technique of Old Master Drawings*, New York, 1972; J. Meder (with W. Ames), *The Mastery of Drawing*, 2 vols., New York, 1978; F. Ames-Lewis, *Drawing in Renaissance Italy*, New Haven, Conn., 1981.

8. Illumination: Thompson, *Materials and Techniques*, 50–64; M. Salmi, *Italian Miniatures*, London, 1956; D. Diringer, *The Illuminated Book*, London, 1958.

9. History of the woodcut: A. Hind, *An Introduction to a History of Woodcut*, New York 1963; W. Ivins, *How Prints Look*, Boston, 1958.

10. Niello: A Hind, *Nielli*, London, 1936.

11. Engraving: A Hind, *A History of Engraving and Etching from the Fifteenth Century to the Year 1914*, New York, 1963; J. Levenson, K. Oberhuber, and J. Sheehan, *Early Italian Engravings from the National Gallery of Art*, Washington, D.C., 1973.

12. Introduction to Italian sculpture: J. Pope-Hennessy, *Italian Gothic Sculpture*, London, 1972; J. Pope-Hennessy, *Italian Renaissance Sculpture*, London, 1971; J. Pope-Hennessy, *Italian High Renaissance and Baroque Sculpture*, London, 1970.

13. Italian stone: F. Rodolico, *Le pietre delle città d'Italia*, Florence, 1953; C. Klapisch-Zuber, *Les Maîtres du marbre: Carrara, 1300–1600*, Paris, 1969.

14. Painter furnishing designs for sculpture: B. Cole, *Agnolo Gaddi*, Oxford, 1977, 57–59.

15. Technique and history of Renaissance stone carving: R. Wittkower, *Sculpture: Process and Principles*, New York, 1977, 79–145.

16. Study of process deduced from unfinished sculpture: J. White, *Art and Architecture in Italy, 1250–1400*, Harmondsworth, Middlesex, 1966, 291–298; Wittkower, 79–145.

17. *Rilievo schiacciato*: Pope-Hennessy, *Renaissance*, 13–22; L. Rogers, *Relief Sculpture*, London, 1974.

18. Bronzes: J. Montague, *Bronzes*, London, 1963; G. Savage, *A Concise History of Bronzes*, New York, 1968; B. Cellini, *The Treatises of Benvenuto Cellini on Goldsmithing and Sculpture*, trans. C. Ashbee, New York, 1967.

19. Renaissance pottery: B. Rackham, *Italian Maiolica*, London, 1963.
20. Terracotta: A. Adams, *Terra Cotta of the Italian Renaissance*, New York, 1925.
21. Wood sculpture: E. Carli, *La scultura lignea italiana*, Milan, 1960.

Chapter III: The Types of Renaissance Art

1. Evolution of the altarpiece: H. Hager, *Die Anfänge des italienischen Altarbildes*, Munich, 1962; M. Cämmerer-George, *Die Rahmung der toskanischen Altarbilder im Trecento*, Strasbourg, 1966.
2. Diptych: E. Garrison, *Italian Romanesque Panel Painting: An Illustrated Index*, Florence, 1949.
3. Custodials: M. Eisenberg, "A Late Trecento *Custodia* with the Life of St. Eustace," *Studies in Late Medieval and Renaissance Painting in Honor of Millard Meiss*, New York, 1977, I, 143–151.
4. Saints in Italian painting: G. Kaftal, *Iconography of the Saints in Tuscan Painting*, Florence, 1952; G. Kaftal, *The Iconography of the Saints in Central and South Italian Schools of Painting*, Florence, 1965; G. Kaftal, *The Iconography of the Saints in the Painting of North-East Italy*, Florence, 1978.
5. The predella: R. Salvini and L. Traverso, *The Predella from the XIIIth to the XVIth Centuries*, London, 1960; A. Preiser, *Das Entstehen und die Entwicklung der Predella in der italienischen Malerei*, Hildesheim, 1973.
6. Taste for Renaissance pictures: G. Reitlinger, *The Economics of Taste: The Rise and Fall of the Picture Market, 1760–1960*, New York, 1961; G. Previtali, *La fortuna dei primitivi dal Vasari ai neoclassici*, Turin, 1964.
7. Archaism: B. Cole, "Old in New in the Early Trecento," *Mitteilungen des Kunsthistorischen Institutes in Florenz*, 17 (1973), 229–248.
8. Painted crosses: E. Sandberg-Vavalà, *La Croce dipinta italiana e l'iconografia della Passione*, Verona, 1929.
9. Humanized Christ: B. Cole, *Giotto and Florentine Painting 1280–1375*, New York, 1976, 20–39.
10. Religious spectacle: A. D'Ancona, *Origini del teatro italiano*, 2 vols., Rome, 1891; V. De Bartholomaeis, ed., *Laude drammatiche e rappresentazioni sacre*, 3 vols., Florence, 1943.
11. *Cassoni:* P. Schubring, *Cassoni, Truhen und Truhenbilder der italienischen Frührenaissance*, 2 vols., Leipzig, 1915; E. Callmann, *Apollonio di Giovanni*, Oxford, 1974; J. Pope-Hennessy and K. Christiansen, *Secular Painting in Fifteenth-Century Tuscany*, New York, 1980.
12. Trays: Pope-Hennessy and Christiansen, 6–11.
13. Renaissance portrait: J. Pope-Hennessy, *The Portrait in the Renaissance*, Princeton, N.J., 1966; J. Alazard, *The Florentine Portrait*, New York, 1968.
14. Fresco types: U. Procacci, *Sinopie e affreschi*, Milan, 1961; M. Meiss, *The Great Age of Fresco*, New York, 1970; E. Borsook, *The Mural Painters of Tuscany*, Oxford, 1980.
15. Art and the plague of 1348: M. Meiss, *Painting in Florence and Siena After the Black Death*, New York, 1964; Cole, *Giotto and Florentine Painting*, 121–145.

16. Palazzo decoration: A. Schiaparelli, *La casa fiorentina e i suoi arredi nei secoli XIV e XV,* Florence, 1908; G. Chierici, *Il palazzo italiano dal secolo XI al secolo XIX,* Milan, 1964; B. Cole, "The Interior Decoration of the Palazzo Datini in Prato," *Mitteilungen des Kunsthistorischen Institutes in Florenz,* 13 (1967), 61–82.

17. Town hall decoration: N. Rodolico and G. Marchini, *I palazzi del popolo nei comuni toscani del medio evo,* Milan, 1962; A. Cairola and E. Carli, *Il Palazzo Pubblico di Siena,* Rome, 1963; E. Southard, *The Frescoes in Siena's Palazzo Pubblico, 1289–1539: Studies in Imagery and Relations to Other Communal Palaces in Tuscany,* New York, 1978.

18. Images of execution: H. Wieruszowski, "Art and the Commune in the Time of Dante," *Speculum,* 19 (1944), 14–33.

19. The Renaissance and antiquity: R. Weiss, *The Dawn of Humanism in Italy,* London, 1947; P. Kristeller, *The Classics and Renaissance Thought,* Cambridge, Mass., 1955; R. Weiss, *The Renaissance Discovery of Classical Antiquity,* Oxford, 1969; W. Sheard, *Antiquity in the Renaissance,* Northampton, Mass., 1979.

20. Renaissance tombs: E. Panofsky, *Tomb Sculpture,* New York, 1964, 67–96; J. Pope-Hennessy, *Italian Renaissance Sculpture,* London, 1971, 34–45; J. Pope-Hennessy, *Italian Gothic Sculpture,* London, 1972; J. Pope-Hennessy, *Italian High Renaissance and Baroque Sculpture,* London, 1970, 54–64.

21. On carved portraits: see Pope-Hennessy, *Portrait;* Pope-Hennessy, *Renaissance Sculpture,* 45–52.

22. Renaissance bronzes: W. Bode, *The Italian Bronze Statuettes of the Renaissance,* 3 vols., London, 1907–12; J. Pope-Hennessy, "An Exhibition of Italian Bronze Statuettes," *Essays on Italian Sculpture,* London, 1968, 172–198; M. Ciardi Dupre, *Small Renaissance Bronzes,* Milan, 1966.

23. Pulpits: Pope-Hennessy, *Gothic Sculpture,* 169–179; Pope-Hennessy, *Renaissance Sculpture,* 266–268.

24. Florentine doors: R. Krautheimer, *Lorenzo Ghiberti,* Princeton, N.J., 1970, I, 101–134, 157–202; Pope-Hennessy, *Gothic Sculpture,* 190–191.

25. Fountains: A. Colasanti, *Le fontane d'Italia,* Milan, 1926; M. Ayrton, *Giovanni Pisano Sculpture,* New York, 1969, 44–55.

26. Bronze plaquettes: E. Bange, *Die italienischen Bronzen der Renaissance und des Barock, II: Reliefs und Plaketten. Staatliche Museen zu Berlin,* Berlin, 1922; J. Pope-Hennessy, *Renaissance Bronzes from the Samuel H. Kress Collection,* London, 1965; J. Pope-Hennessy, "The Italian Plaquette," *The Study and Criticism of Italian Sculpture,* New York, 1980, 192–222.

27. Renaissance medals: G. Hill, *Medals of the Renaissance,* Oxford, 1920; G. Hill, *A Corpus of Italian Medals of the Renaissance before Cellini,* 2 vols., London, 1930; U. Middeldorf and O. Goetz, *Medals and Plaquettes from the Sigmund Morgenroth Collection,* Chicago, 1944.

ILLUSTRATIONS

22. Parmigianino, *A Painter's Assistant Grinding Pigments,* London, Victoria and Albert Museum. Red chalk drawing. c. 1535.

23. Pesellino, *Mystic Marriage of St. Catherine of Alexandria,* Florence, Uffizi. Pricked cartoon. Pen and bistre wash. c. 1450.

24. Florentine, *Madonna del Giglio,* Florence, San Giuseppe. Tempera. Early 16th century.

25. Sassetta, *St. Francis Before the Cross,* Cleveland, Cleveland Museum of Art. Tempera. 1444.

26. Florentine, *The Virgin Adoring the Christ Child with the Young St. John,* Bloomington, Indiana University Art Museum (detail). Tempera. c. 1475.

27. Pigment Cross Section.

28. Andrea del Sarto, *Holy Family with the Infant St. John,* New York, Metropolitan Museum of Art. Oil. c. 1530.

29. Palma Giovane, *St. John the Baptist Preaching* (detail). Bloomington, Indiana University Art Museum. Oil. c. 1595.

30. Girolamo del Pacchia, *Mystic Marriage of St. Catherine of Alexandria,* (detail) Siena, Pinacoteca Nazionale. Oil. c. 1520.

31. Benozzo Gozzoli, *Construction of the Tower of Babel* (detail of a now destroyed painting), formerly Pisa, Camposanto. Fresco. 1467–84.

32. Masolino, *Saint* (detail), Empoli, Sant'Agostino. Sinopia. 1424.

33. Bicci di Lorenzo, *Madonna with Four Saints,* Ponte a Greve. Fresco and sinopia. c. 1430.

34. Veronese, Sinopia Studies, Verona, Arco di Aventino Fracastoro. c. 1400.

35. Giotto, Arena Chapel, Padua. c. 1305.

36. Jacopo Pontormo, *Angel of the Annunciation,* Florence, Uffizi. Black and red chalk drawing. c. 1528.

37. Andrea del Castagno, *The Resurrection,* Florence, Sant'Apollonia. Sinopia. c. 1450.

38. Piero della Francesca, *Dream of Constantine,* Arezzo, San Francesco. Fresco. c. 1455.

39. Central Italian, *Rea Silvia Buried Alive,* Foligno, Palazzo Trinci. Fresco. c. 1430.

40. Giotto, *Scenes from the Life of St. John the Evangelist,* Peruzzi Chapel, Florence, Santa Croce. Fresco. c. 1330.

41. Removal of a Fresco from the Wall.

42. Ambrogio Lorenzetti, *Annunciation,* Montesiepi, Oratory of San Galgano. Fresco and sinopia. c. 1340.

43. Tuscan, *Figures and Decorative Motifs,* New York, Pierpont Morgan Library. Ink drawing. c. 1350.

44. Pisanello, *Studies of Hung Men,* New York, Frick Collection. Pen and ink. c. 1440.

Cherubs, London, Victoria and Albert Museum. Painted terracotta. c. 1490.

67. Shop of Andrea della Robbia, *Adoration of the Magi,* London, Victoria and Albert Museum. Glazed terracotta. c. 1500.

68. Jacopo della Quercia, *Virgin,* San Gimignano, Collegiata. Polychromed wood. c. 1420.

69. Duccio di Buoninsegna, *Crevole Madonna,* Siena, Museo dell'Opera del Duomo. Tempera. c. 1280.

70. Master of the St. Peter Dossal, *St. Peter and Six Scenes,* Siena, Pinacoteca Nazionale. c. 1285.

71. Duccio's Shop, Diptych, New York, Metropolitan Museum of Art, Lehman Collection. Tempera. c. 1310.

72. Taddeo Gaddi, Triptych, Berlin, Staatliche Museen. Tempera. 1334.

73. Giovanni da Milano, Polyptych, Prato, Galleria Comunale. Tempera. c. 1355.

74. Andrea di Niccolò, Altarpiece, Siena, Santa Mustiola alla Rosa. Tempera. 1510.

75. Bicci di Lorenzo, *Nativity,* Florence, San Giovannino dei Cavalieri. Tempera. 1435.

76. Fra Bartolomeo, Altarpiece, Florence, Museo di San Marco. Oil. 1510.

77. Cimabue, *Crucifix,* Arezzo, San Domenico. Tempera. c. 1280.

78. Antonio Veneziano, *Flagellation of Christ,* Palermo, San Niccolò Reale. Tempera. 1388.

79. Niccolò da Foligno, Plague Standard, Kevelaer, Presbytery. Tempera (?). c. 1470.

80. Sodoma (?), Bierhead, Siena, Pinacoteca Nazionale. Oil. c. 1500.

81. Florentine, Trebizond *Cassone,* New York, Metropolitan Museum of Art. Tempera. c. 1475.

82. Fucecchio Master, *Cassone* Panel (detail), Waltham, Mass., Rose Art Museum. Tempera. c. 1470.

83. Shop of Apollonio di Giovanni, *Story of Esther, Cassone* Front, New York, Metropolitan Museum of Art. Tempera. c. 1460.

84. Beccafumi, Part of a Painted Bed (?), Birmingham, Art Gallery. Oil. c. 1540.

85. Florentine, Birth Tray *(Desco da Parto),* Berlin, Staatliche Museen. Tempera. c. 1430.

86. Bartolomeo di Fruosino (?), Birth Tray *(Desco da Parto),* New York, Metropolitan Museum of Art. Tempera. c. 1428.

87. Domenico Ghirlandaio, *Birth of the Virgin,* Florence, Santa Maria Novella. Fresco. c. 1490.

88. Botticelli, *Venus and Mars,* London, National Gallery, Tempera. c. 1485.

INDEX

Page numbers in **boldface** denote illustrations.